THE FANTASY ARTIST'S
FIGURE DRAWING BIBLE

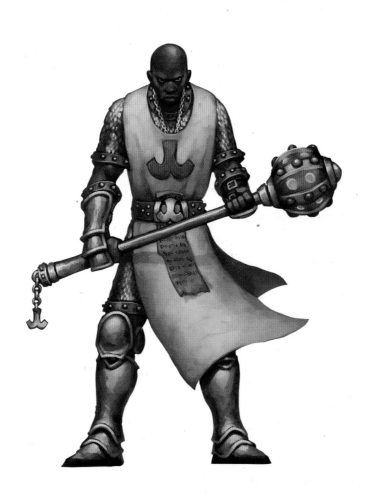

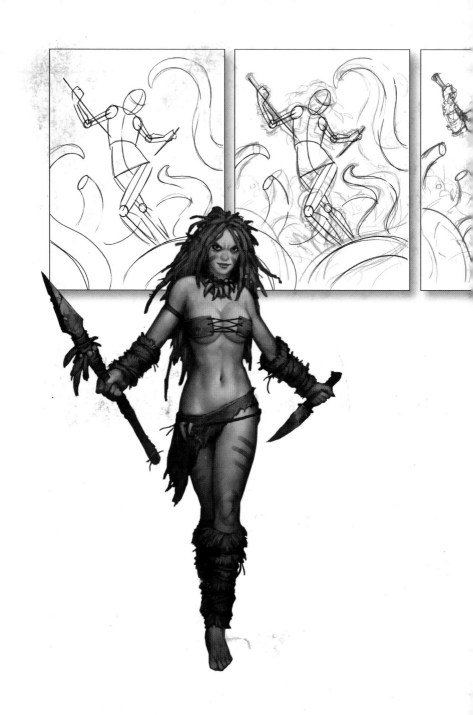

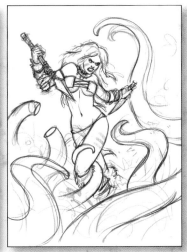
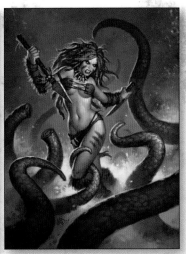

THE FANTASY ARTIST'S
FIGURE DRAWING BIBLE

Matt Dixon

BARRON'S

All inquiries should be addressed to:
Barron's Educational Series, Inc.
250 Wireless Boulevard
Hauppauge, NY 11788
www.barronseduc.com

ISBN-13: 978-0-7641-6114-8
ISBN-10: 0-7641-6114-8
Library of Congress Control Number:
2008924879

QUAR.FDR

Conceived, designed, and produced by
Quarto Inc.
The Old Brewery
6 Blundell Street
London N7 9BH

Project editor: Rachel Mills
Assistant editor: Chloe Todd Fordham
Art editor: Emma Clayton
Designer: Paul Griffin
Copy editor: Matt Ralphs
Art director: Caroline Guest

Creative director: Moira Clinch
Publisher: Paul Carslake

Manufactured by
Picadigital (PTE) Ltd., Singapore
Printed in China by
Midas International Printing Ltd.

9 8 7 6 5 4 3 2 1

CONTENTS

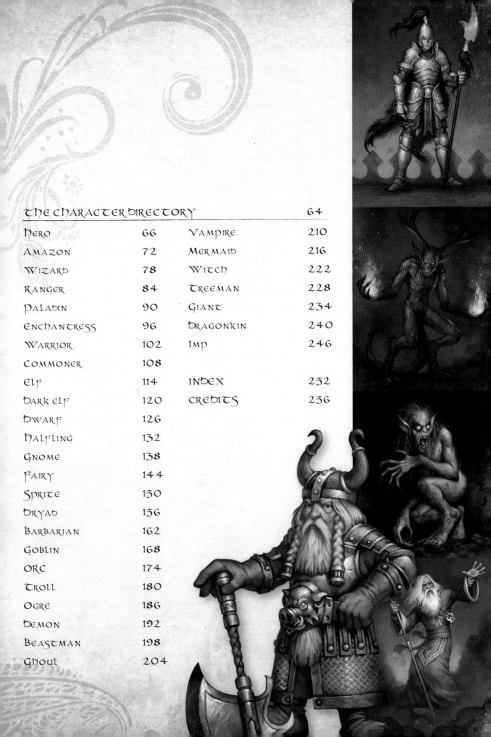

FOREWORD

I've been attracted to fantasy art for as long as I can remember. I would gaze at artwork for hours on end, imagining myself in the worlds that the artists had created. It was as if each artwork opened a door on another reality. Sometimes awesome and beautiful, sometimes frightening and dangerous, but always more exciting, and infinitely cooler, than the real world.

Always it was the characters that caught my attention. I think a part of me may have been envious of the inhabitants of these wonderful landscapes, but I soon came to realize that they were the most important things in the paintings.

It's through the characters—their expressions, actions, and interaction with their surroundings—that we, the audience, experience the fantasy worlds with which we are presented most vividly. They are the real doors through which the reality flows, and through which we can pass to experience the fantasy firsthand.

ABOUT THIS BOOK

The contents of this book provide an insight into the techniques employed in the successful creation of convincing and dynamic fantasy characters.

GETTING STARTED (PAGES 16–27)

Suggestions for where you might find inspiration and ideas, as well as demonstrations of different media techniques. Anatomy and picture-making are explored.

DIRECTORY OF CHARACTERS (PAGES 64–251)

Dealing with all the popular fantasy archetypes, in addition to some unusual and original creations, this section allows the reader to peek over the shoulder of a working artist, following the conceptual process from first sketch to final painting.

Linework is provided to clearly show the finished concept. Beginners may copy the linework or use it as a template for their own creations.

Final painting—a full-color painting of each character is presented.

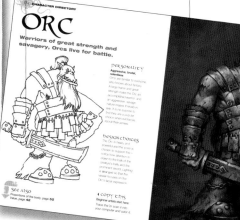

ORC

Warriors of great strength and savagery, Orcs live for battle.

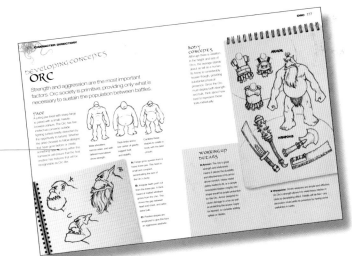

Concept pages show the artist exploring possibilities for the character's appearance. Many ideas are included that may be useful in your own fantasy creations.

The development of appropriate and convincing poses. Again, the artist provides commentary.

Practical information about drawing and painting each character, including drawing the head in rotation.

Tips are provided for various expert techniques, including rendering different materials and creating lifelike skin tone.

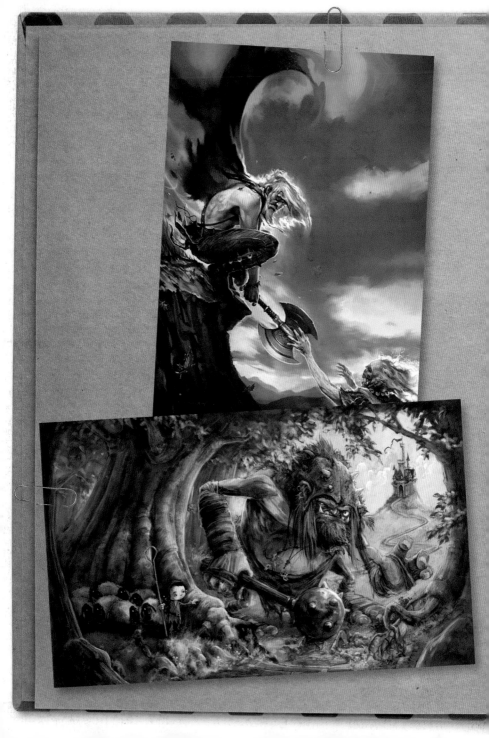

THE GALLERY

In this chapter, you'll find inspirational examples of fantasy art by established artists working in the field.

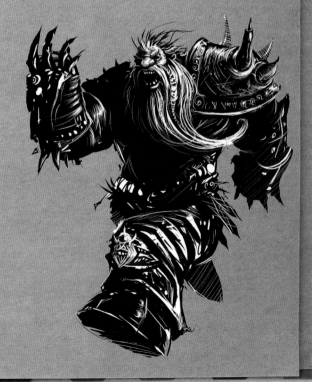

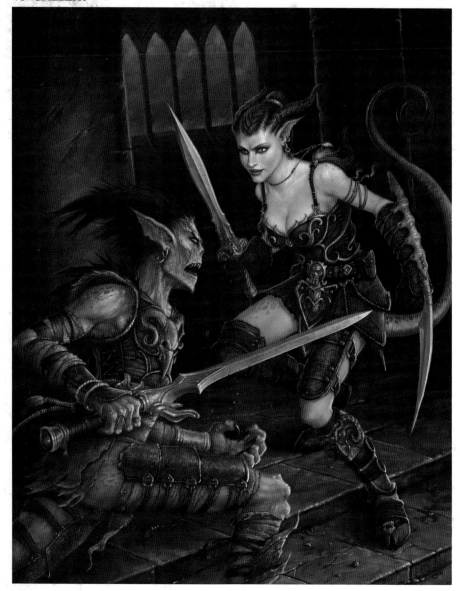

Into the Depths
Howard Lyon

A classic fantasy scene. The appearance of the protagonists suggests a
clash between good and evil. Note the intricate details that the artist has
applied to the costuming.

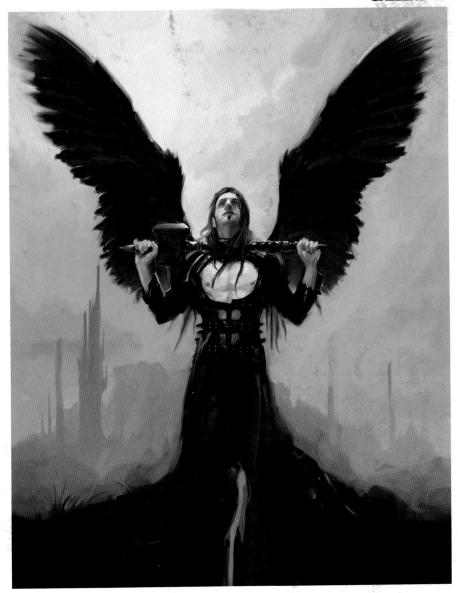

Daniel
Kieran Yanner

Lighting and palette conjure a serene mood in this painting. In sharp contrast to the image on the facing page, this scene is rendered with bold, economical brush marks for clarity and dynamism.

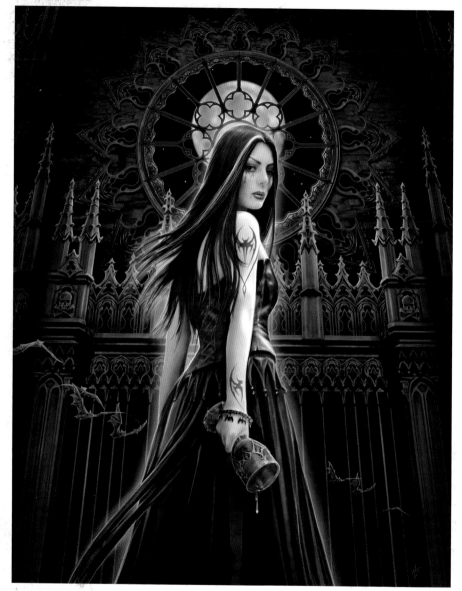

Gothic Siren
Anne Stokes

Bats heighten the gothic atmosphere surrounding this Vampiric
female. Notice the subtle repetition of the bat motif in the figure's
jewelry and tattoos.

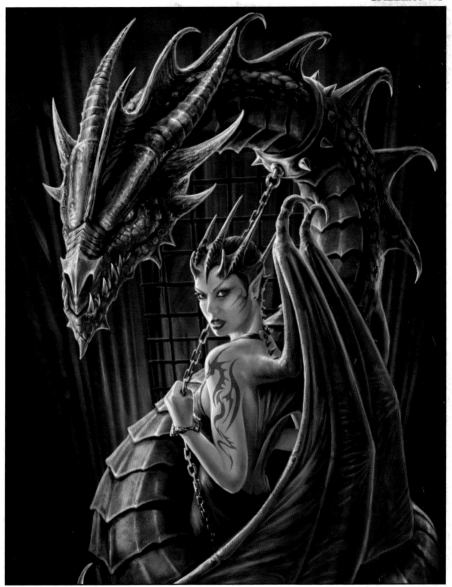

The Controller
Anne Stokes

Powerful female characters are popular in fantasy art. This woman's
potency is implied in her expression, while her physical strength is
demonstrated, quite literally, by her mastery of the monster she controls.

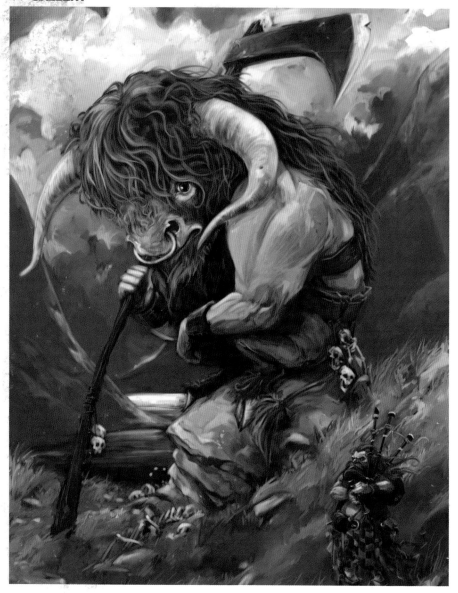

The Highland Minotaur
Jonny Duddle

Gentle stylization and clever character design accentuate the expression
in this piece. A muted color scheme helps to set the mood further.

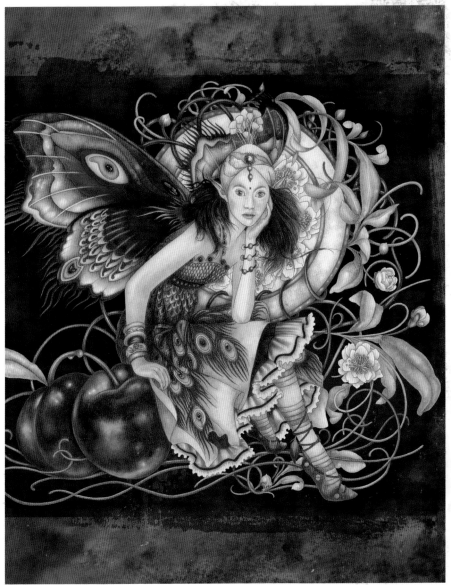

Sugarplum Fairy
Myrea Pettit

Vivid colors and elegant patterns are woven around this fantasy character
for an attractive, graphic look.

GETTING STARTED

Finding good sources of inspiration and reference, selecting the proper techniques, and gathering appropriate tools and materials are important first steps for any artist.

SOURCES OF INSPIRATION

ILLUSTRATORS

1 Arthur Rackham
Victorian illustrator Arthur Rackham provided artwork for many classic fairytales and other fantasy works. His sensitive line work and subtle, subdued watercolors produced evocative and distinctive illustrations that continue to influence artists in the fantasy genre.

2 Frank Frazetta
Frazetta can rightfully claim to be the father of modern fantasy art, and practically defined the genre with his dynamic book cover illustrations in the 1960s and 70s.

3 N. C. Wyeth
Newell Convers Wyeth produced artwork for many classic stories, including *Treasure Island* and *Robinson Crusoe*. Characterized by a bold use of color and powerful compositions, his work retains a contemporary style.

4 Gerald Brom
Brom is a modern master with a long career in fantasy art. His works are distinctive both for their finely rendered style and strong design sense, which frequently draws upon dark, gothic themes.

5 Justin Sweet
Concept artist and illustrator Justin Sweet carries the torch of fantasy art into the modern era. Working in watercolor, oils, and digitally, Justin combines modern media with his significant talent to emerge at the forefront of contemporary fantasy illustrators.

ARTISTS

1 Salvador Dali
Dali's flawless painting technique and vivid imagination have produced some of the most famous artworks of the last century.

2 Gustav Doré
Doré's work is notable for its striking compositions and dynamic values. His illustrations for *Fables de la Fontaine* and *The Divine Comedy* are considered among his masterpieces.

3 Hieronymous Bosch
In addition to many artworks in the classical tradition, Bosch produced numerous paintings with fantastic, almost surreal elements, depicting monsters, demons, and other strange apparitions. These images are disturbing, sometimes comical, yet always beautifully detailed.

4 Francisco de Goya
All of Goya's work is superb. Following an illness which left him deaf in 1793, his art began to reveal darker themes. The expressive, imaginative works of the Caprichos and the Black Paintings are of particular interest.

5 John Singer Sargent
Sargent was a master of portraiture, and his subjects are realized with breathtaking technique, both sensitive and bold.

LITERATURE

1 The Hobbit, by J. R. R. Tolkien
Tolkien's Middle Earth is almost certainly the most influential work of fantasy fiction. *The Hobbit* references all the characters, races, and themes which we recognize as fantasy archetypes today, and is the most accessible of his works.

2 The Color of Magic, by Terry Pratchett
Although humorous in tone, the Discworld novels are delightfully imaginative, adding new and surprising twists to many fantasy standards.

3 Conan, by Robert E. Howard
It is difficult to recommend a single Conan title, as Howard's original works are published as collections under different names, and many other authors have written stories about the Cimmerian Barbarian. All fantasy artists should seek to read at least one work of Conan fiction to familiarize themselves with this iconic and enduring character, and the world in which he adventures. Robert E. Howard's original writings are recommended.

4 Elric of Melnibone, by Michael Moorcock
Moorcock's Elric is a tragic hero, in many ways the opposite of the traditional fantasy male personified by strong masculine characters such as Conan. Elric, and the world he inhabits, are intelligent, inventive takes on traditional fantasy.

5 The Call of Cthulhu, by H. P. Lovecraft
Fantasy does not have to exist in a separate reality. Lovecraft's settings may be founded in realism, but the fantasy present in his writings is undeniable. The juxtaposition between the familiar and the fantastic make the horrors all the more terrifying.

MOVIES

1 The Dark Crystal,
directed by Jim Henson and Frank Oz
Particularly notable for outstanding creature and character designs by Brian Froud, and performed entirely by puppets, *The Dark Crystal* offers up rich, detailed visuals.

2 Jabberwocky, directed by Terry Gilliam
Inspired by the Lewis Carroll poem of the same name, Terry Gilliam's solo directorial debut shows us a vivid, often grotesque, imagining of medieval life. Eccentric costumes and sets, exquisite lighting, a humorous script, and some great acting performances make this one of Gilliam's best. Watch *Time Bandits* and *The Adventures of Baron Munchhausen* for similarly original imagery.

3 Legend, directed by Ridley Scott
A fairytale land is beautifully visualized by Ridley Scott in this movie. Lighting is spectacular throughout, with brilliant makeup and fantastic sets adding to the attraction. The director's cut is the preferred version.

4 The Seventh Voyage of Sinbad,
directed by Nathan Juran
Released in 1958, this tale of the swashbuckling Captain Sinbad still stands up today. A classic fantasy adventure, the creature effects provided by legendary special effects creator Ray Harryhausen are of particular interest.

5 The Wizard of Oz,
directed by Victor Fleming
Often overlooked as "fantasy," this classic tale is a reminder that the genre is not solely concerned with sword-wielding heroes battling fearsome beasts.

PLACES

1 Museums
Museums are a great source of reference for all kinds of subjects. Fantasy artists will be most interested in displays of costumes, armor, and weapons. Natural history displays are inspirations for creature design.

2 Caves
As well as providing direct reference for subterranean locations—a popular fantasy setting—caves have an otherworldly atmosphere that can be inspirational.

3 Castles
Castles and other historical structures can help the artist visualize fantasy locations more vividly. Visiting a site will give you a better sense of scale and space than simply viewing photographs.

4 Forests
Few experiences can be more evocative than a long walk through a forest. The sights, sounds, and smells of a forest in each season can really help to fuel your imagination.

5 Public parks
A trip to a public park may provide useful contact with unusual fauna and flora, but the best reason to seek out busy public areas is to observe people. By carefully observing human behavior you gain insights that can help you create convincing figures.

TOOLS AND MATERIALS

A wide variety of art materials are available, and many can be purchased quite cheaply. Take time to try out different tools to discover those that feel most natural.

Media are handled in different ways, and you may find control of some comes more easily than others. Find time to explore the potential of a new medium before discounting it. The choice can be quite bewildering. Consult other artists, and talk to art supply staff for advice. The following pages cover everything you need to get started, including the basic tools which accompany all artists throughout their careers. Beginners should be comfortable with pencil and paper, and confident with basic sketching skills, before progressing to more advanced materials.

SKETCHBOOK

The serious artist should have a sketchbook with them at all times. Inspiration can strike anytime, and you will want to nail your idea to the page there and then. Sketchbooks are available in many shapes and sizes. Hard covers offer the best protection, and ringbound spines provide a convenient place to clip a pen. Choose a pocket-sized book for easy transportation.

PENCILS

The most basic art tool, the pencil, is your best friend. Experiment with hard and soft pencils to find which is most comfortable for you. Mechanical pencils give a consistent line weight, and don't need sharpening. Some artists prefer the waxy feel of colored pencils for sketching.

PENCIL SHARPENER

Some artists choose to sharpen pencils with a craft knife or scalpel, to sculpt the tip to the exact shape they require. If you choose to do this, always cut away from the body with light strokes. A pencil sharpener is less dangerous. Keep a saucer handy for the pencil shavings, to keep your workspace clean. Mechanical or electrical sharpeners give a consistent shape to the tip.

ERASER

Erasers aren't just for correcting mistakes! They can be used to refine pencil lines, and even to "draw" into shaded areas. Plastic erasers lift the most graphite, but can also damage the paper if used with excessive force. Clean your erasers regularly; dirty areas can be cut away with a craft knife, or rubbed against a clean sheet of paper. Putty erasers can be molded into different shapes.

COLORED PENCILS

Beginners find colored pencils particularly easy to adopt. They are clean, easy to use, and provide a relatively inexpensive way to introduce color to your work. Try combining with acrylic paint, to add fine detail and color.

WATERCOLORS

Watercolors can be a difficult medium to control, but the results are unique and spectacular, with bright, vivid colors, and wonderful texture. This medium can be employed in many different ways, making it extremely flexible. Watercolor does not combine well with other media, although colored ink gives very similar results, and can be used in mixed media work.

PASTELS

Pastels create different effects depending on the binder used to hold the color pigment. This can range from dry and chalky, through to oily, including water soluble pastels, or pencils for detailed work.

ACRYLIC PAINTS

Acrylic paints are the traditional media choice for most fantasy artists, due to their flexibility and low cost relative to oil paints. Acrylic paints provide bright, easily mixed colors, with low odor and easy cleaning. Acrylics dry very quickly; this can be positive or negative, depending on your working method. Retarders are available to prolong drying time, and gels can be mixed with acrylics to change their appearance.

OIL PAINTS

Oil paints are expensive, require the use of toxic solvents, and can be awkward to manipulate as they take a long time to dry. However, oils are still regarded as the premier choice for many artists, not least because of the long tradition of oil painting, dating back to before the fifteenth century. Water-soluble oils are also gaining popularity.

AIRBRUSH

A tool rather than a medium, an airbrush uses compressed air to spray paint in a fine mist. The atomized medium can be applied in thin layers, allowing very subtle gradients of color—a very useful tool for retouching photographs. The airbrush can cover large areas quickly, but often requires masking fluid or film to achieve hard edges, and protect any fine detail.

MARKERS

Ink contained within the marker pen is delivered through a porous tip of felt or nylon. The ink may be opaque or transparent, and tips come in various sizes and shapes. All marker pens give the artist convenient access to bright, mess-free, consistent colors, making them particularly suitable for concept work. Permanent black markers are a popular choice for line work and sketching.

INSPIRATION

Surround yourself with inspirational images. Collect reference material, photographs, books; anything that interests you. Catalog and organize your collection to ensure that appropriate material can be retrieved quickly.

MIRROR

A mirror is an invaluable item, instantly transforming you into your model. Facial expressions and anatomy can be easily referenced using an adjustable shaving mirror—those including a magnifying mirror are preferable for close study. A full-length mirror is a great way to explore potential poses for your characters.

CAMERA

Use a camera to take reference photographs. A cheap digital camera is portable, and will provide adequate resolution along with the convenience of quick access to the images. Combine with a tripod and timer to take self-portraits for anatomy or poses when models are not available.

MP3 PLAYER

Music is a source of inspiration for many artists. It can also provide a useful energy boost, or help to calm the nerves. If your studio space is in a noisy environment, a pair of headphones is a great way to cut yourself off from the distractions around you, and aid concentration.

MANNEQUIN

Wooden mannequins can be purchased cheaply from art supply stores and are a useful way to experiment with poses. More expensive mannequins, showing accurate anatomical details can help you visualize characters in 3D. Articulated action figures are an inexpensive alternative, but anatomy will be stylized, so these should be used only for pose references.

LIGHTING

Choose a studio space with flexible lighting that is appropriate to your chosen media. Daylight is best, although good artificial light should be available for dull days and nocturnal work. If working digitally, ensure your display is free from glare. Consider installing light curtains, which allow natural light in, while reducing direct glare from the sun on bright days.

COMPARING TECHNIQUES

Many techniques are available to the fantasy artist. Only through experimentation will you settle upon an approach which you feel fully comfortable with. Examine the works of fantasy artists for inspiration. Here are some examples of popular styles.

 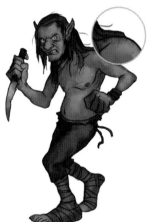

SKETCH

The fastest and simplest way to render an image, the spontaneous lines of a good sketch can suggest energy and life effectively.

Use: pencil, marker, ballpoint pen, digital

Good for: exploring concepts, studies from life, documenting ideas

LINE

A bold stroke is applied over the sketch to define important lines clearly. The sketch may be allowed to show through to add texture and interest, or it can be erased to leave a clean, neat line. Hatching or varied line weight may be employed to suggest form.

Use: marker, ballpoint pen, ink, digital

Good for: presenting sketches, comics, small illustrations

TINTED

A transparent wash of color is applied over a sketch or line work to add color. This is an efficient way to add color and texture to a drawing. An opaque medium may be used to pick out details or highlights once the wash is dry.

Use: watercolor, ink, thinned acrylic, digital

Good for: quick coloring, introducing texture, exploring color schemes

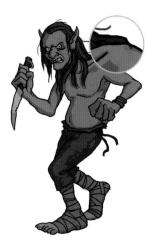

MONOTONE

The sketch is rendered with an opaque medium. Monotone color is used to focus on the form of the piece. Note that monotone means a single tone, not necessarily gray.

Use: acrylics, oil, marker, digital

Good for: limited-color printing, conceptual design, studies

COMIC

Solid opaque color is added to line work. Colors may be flat, or may indicate form and texture with varied tone or gradients. This is a popular digital technique.

Use: digital, acrylic, ink

Good for: comics, web graphics, limited-color printing

FULLY RENDERED

The image is rendered with an opaque medium using a full range of color and tone. This approach gives the most realistic and interesting results, and is by far the most popular choice for fantasy illustrators.

Use: acrylic, oil, colored pencil, digital

Good for: full-color printing, portfolio work

WORKING DIGITALLY

Computers and computer software offers the artist a wide range of powerful and convenient tools.

Computers have transformed the commercial art world. Less than a decade ago, art created using a computer was unusual. Now it is commonplace and fast becoming the standard. Many young artists find the digital environment more familiar and comfortable than traditional media. Even work created using traditional media becomes digital before publication, because almost all printing processes are now digital. It is important to recognize that a computer is merely a tool, and although computer software gives access to many new ideas for the creation of art, the principles of art still apply; you must understand these foundations if your work is to be successful, whatever medium you choose.

Laptop computer

For artists who do not make daily use of a computer, a laptop is a good choice. It occupies a minimum of desk space, and can be easily folded away when not in use. A large amount of system RAM will give the best performance. The portability of laptop computers makes them ideal as digital sketchbooks—consider carrying spare battery packs if you use your laptop in this way, and invest in a sturdy carrying bag with storage for extra equipment.

Desktop computer

Art software is not demanding, and most modern desktop computers will happily run a painting application. A quality graphics card is important. System RAM has the greatest bearing on the performance of art packages. Look for a minimum of 1GB.

Monitor

Your monitor is the interface between you and your art. Choose the best quality display you can. CRT displays offer the best level of contrast, but LCD panels may be preferable because they take up less space. Whatever you choose, ensure that your display is properly calibrated to ensure colors are displayed as accurately as possible.

Scanner

Whether you simply wish to scan pages from your sketchbook as a starting point for a digital piece, or you want to digitize a finished traditional artwork to adjust ready for print, a scanner is essential equipment for the digital artist.

Graphics tablet

A graphics tablet is the most natural input device for a digital artist. A stylus (or "pen") is used to draw on the tablet in the same way as you draw on paper. Depending on the hardware, the tablet can read pressure, angle, rotation, and other parameters from the stylus and feed this information to the art software. Tablets are available in a variety of sizes. Any artist looking to create art digitally should consider investing in a graphics tablet. Hardware is also available that integrates this technology with a flat panel display, allowing the user to draw directly onto the screen.

Printer

Good quality inkjet photo printers can be purchased cheaply. Experiment with different papers to get results you like. If you intend to sell prints of your work, you may find professional reproduction more economical.

Organization

Many files may be created during the production of a digital artwork. It is important to organize your files carefully to avoid losing or accidentally deleting important data. Keep a consistent folder structure and use a sensible naming convention for your files so that your work can be easily identified.

Security

Make frequent backups of your digital work and store them safely. Ensure you have up-to-date antivirus software installed.

SOFTWARE

Adobe® Photoshop www.adobe.com	Photoshop is the longest-established and probably best-known digital art software. A simple yet powerful set of drawing and painting tools is complemented by a versatile, comprehensive suite of image adjustment tools, making this the first choice for many professional artists.
Corel® Painter www.corel.com	Painter excels in the emulation of natural media effects, and the sophisticated painting engine gives you almost limitless possibilities when creating your own brushes and effects. Very popular with digital artists of all kinds.
Paint Shop Pro www.corel.com	With many similarities to Photoshop, Paint Shop Pro also provides a collection of powerful image adjustment tools. Drawing and painting tools are limited.
ArtRage www.ambientdesign.com	ArtRage's simple, clean interface hides some very clever painting tools. The toolset is small when compared to some other art software, but the focus here is simply on painting, and the results are excellent, with some very pleasing natural media effects. A competitively-priced introduction to digital painting.
Autodesk® SketchBook Pro www.autodesk.com	An economically-priced application, providing responsive drawing and painting tools and an elegant interface, which keeps the focus firmly on the artwork. This software is particularly suited to sketching and line-drawing.

TECHNIQUES

Bring your characters to life on the page, and learn how to entertain, involve, and effectively communicate with your audience.

VISUAL LANGUAGE

Just as a writer uses words to describe a story, an artist is able to communicate with his or her audience using visual language.

We all have shared visual experiences. We learn at an early age that the sky is blue and grass is green, for example. As we progress through life, each of us constantly absorbs visual stimuli and attaches information to this remembered imagery. This is the key to the concept of visual language in art: the idea that the artist may influence the viewer's perception with the careful use of specific imagery.

Visual language is shaped not only by our personal experiences, but is also strongly influenced by popular culture. Media informs and reinforces our understanding of visual language every day. Just as we learn that the sky is blue, our TV screens show that bad guys wear black.

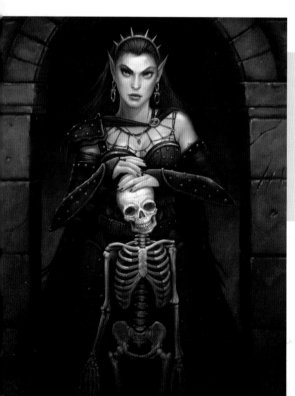

Tenebrous Apostate
Howard Lyon

Bones are a strong visual key, suggesting death and evil; they impart a dark atmosphere to any artwork. Dark colors similarly suggest a negative aspect to a character's personality. Both are combined in this artwork by Howard Lyon to give the female character a sinister, chilling appearance.

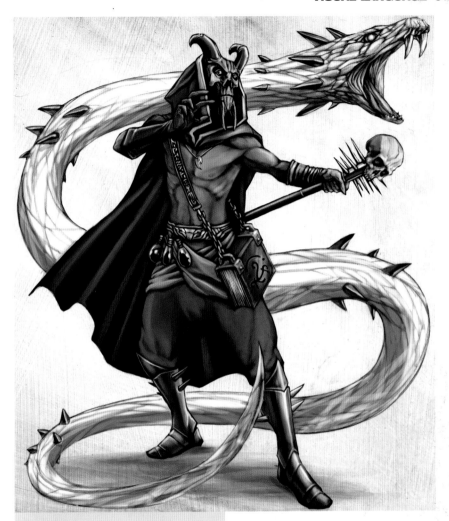

The Summoner
Grey Thornberry

Grey makes excellent use of visual language in this artwork. The skull-topped staff and skeletal face of this character give the audience a strong negative feeling. The sharp shapes of spikes and horns in the design add to this impression, while the appearance of a snake coiling around the figure evokes feelings associated with dark or negative actions or intent.

All perceived visual signs make a connection somewhere in the mind. Some signs are very simple, such as the connection between color and mood. Some are extremely complex, such as the expression shown in a face or body, or the interaction of one figure with another. You should consider the significance of every element in the artwork.

Naturally, the precise response to a
particular visual key is dependent
on personal experience and is
therefore unique to each individual,
but the general reaction is
predictable and provides you with
an extremely powerful tool,
especially in the communication
of personality and character.

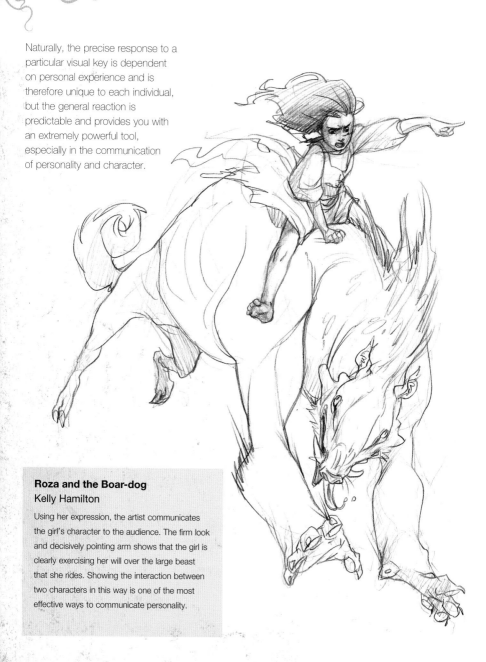

Roza and the Boar-dog
Kelly Hamilton

Using her expression, the artist communicates
the girl's character to the audience. The firm look
and decisively pointing arm shows that the girl is
clearly exercising her will over the large beast
that she rides. Showing the interaction between
two characters in this way is one of the most
effective ways to communicate personality.

PRACTICAL APPLICATION AND STEREOTYPES

So how can the concept of visual language be used in practice? First and foremost is the awareness that everything in your artwork will speak to the viewer. Some elements speak more loudly and clearly than others, but every aspect has something to say. Knowing this should encourage you to make careful and deliberate choices about the visual keys to include in your artwork. Think about each element as you place it—what does it say to the viewer?

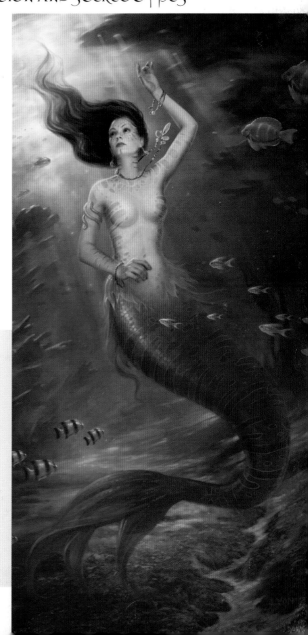

Underneath it All
Howard Lyon

In the hands of a skilled artist, even subtle visual clues can be very powerful. The shape and presentation of the hair, fins, and jewelry of this Mermaid are all chosen to help the viewer establish that she is underwater. Note the color of the background—where many artists would automatically choose blue to paint an aquatic scene, Howard deliberately avoids it, choosing instead to render the scene in green and yellow. This clever manipulation of visual language makes the scene interesting and atmospheric.

Warrior
Scott Purdy

This deceptively simple image is very evocative. The viewer is left to perceive the character almost by silhouette alone and, although Scott provides many interesting details to steer our imagination, we're forced to "fill in the blanks" ourselves. As a result, we get the impression of a mysterious, secretive figure. Leaving freedom for your audience to use their own imagination in this way is a very powerful device.

Being aware of visual language means that you can build your character's story. Consider their personality, lifestyle, and history and select visual keys that support those aspects of your creation. How do you want the viewer to perceive your character? Place elements that tell a single story in your artwork to show a simple, straightforward personality, or present a complex character by including visual keys to reveal different facets of your creation. The latter approach is an excellent way to give a real depth of personality to your work.

Visual language works because it employs clues that prompt a particular reaction. The most effective of these devices are, by definition, familiar and widely used, which can lead to potential stereotyping or cliché. This occurs when a design uses elements or a combination of elements that we have seen before, or a single device that has been used many times in a similar context. Whether an artwork is a cliché is subjective—depending as it does on the viewer's own opinion and experiences—and there may be situations where the artist deliberately seeks to stereotype, in order that there is no ambiguity in the audience's perception of the character. You are the best judge. You know what you're trying to achieve—does your creation speak to you?

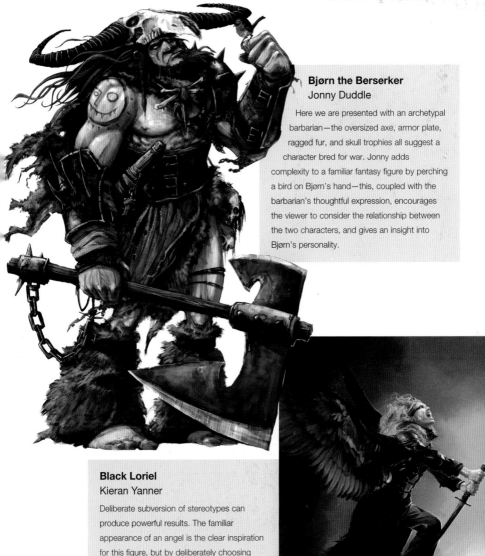

Bjørn the Berserker
Jonny Duddle

Here we are presented with an archetypal barbarian—the oversized axe, armor plate, ragged fur, and skull trophies all suggest a character bred for war. Jonny adds complexity to a familiar fantasy figure by perching a bird on Bjørn's hand—this, coupled with the barbarian's thoughtful expression, encourages the viewer to consider the relationship between the two characters, and gives an insight into Bjørn's personality.

Black Loriel
Kieran Yanner

Deliberate subversion of stereotypes can produce powerful results. The familiar appearance of an angel is the clear inspiration for this figure, but by deliberately choosing color and expression in sharp contrast to that of a traditional angel, Kieran depicts a far deeper and more engaging character.

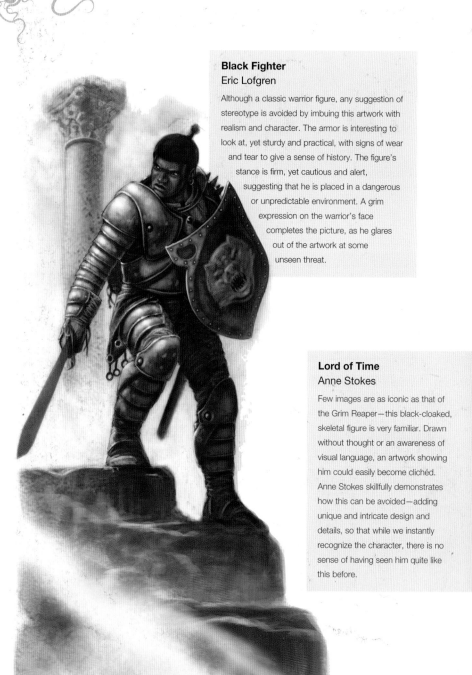

Black Fighter
Eric Lofgren

Although a classic warrior figure, any suggestion of stereotype is avoided by imbuing this artwork with realism and character. The armor is interesting to look at, yet sturdy and practical, with signs of wear and tear to give a sense of history. The figure's stance is firm, yet cautious and alert, suggesting that he is placed in a dangerous or unpredictable environment. A grim expression on the warrior's face completes the picture, as he glares out of the artwork at some unseen threat.

Lord of Time
Anne Stokes

Few images are as iconic as that of the Grim Reaper—this black-cloaked, skeletal figure is very familiar. Drawn without thought or an awareness of visual language, an artwork showing him could easily become clichéd. Anne Stokes skillfully demonstrates how this can be avoided—adding unique and intricate design and details, so that while we instantly recognize the character, there is no sense of having seen him quite like this before.

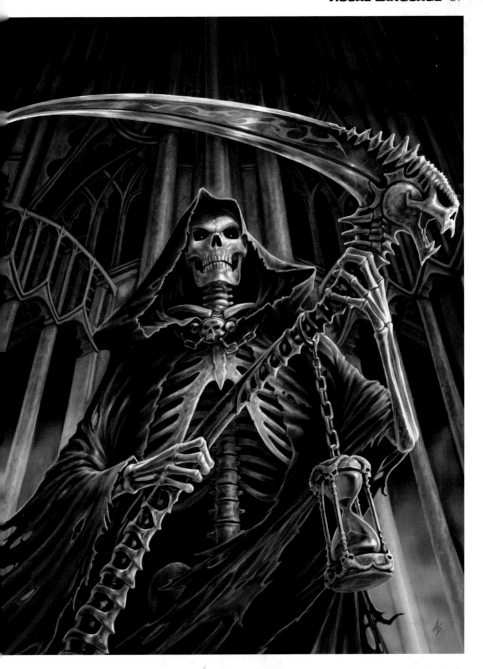

BEFORE YOU BEGIN

The picture-making process is unique and personal to every artist. Observing the work of others can be informative and inspirational.

Creating a successful work of art begins even before you pick up a pencil. The first and most important part of the process is thought.

Think about the image you want to create. What do you want to represent? Does your image need to tell a story? How do you want the audience to respond? What are the necessary elements needed to achieve the results you desire? Your ideas will evolve as you work, but defining a clear goal before you begin will concentrate your efforts.

The most important elements are the figures. The emotions displayed by your characters, and how they react to the situations they find themselves in, will influence how the audience perceives your art.

Consider your characters. Do not concentrate solely on the split-second of time represented in your artwork. What motivates your characters? What are their desires? How might their past experiences affect

Sketch, sketch, sketch! This way your sketchbooks will become a mine of reference for future creations.

their reactions to their situations? Develop an intimate relationship with your characters. This adds believability.

Some artists act out the scene they intend to paint. Get out of your chair, imagine yourself as the character, and play the scene. This can suggest interesting, unexpected poses and expressions. A full-length mirror is useful here.

The conceptual process is the best way for you to become intimate with a character. Developing characters before you touch the paper will give them depth. The directory starting on page 64 outlines this process further.

Showing details that suggest a character's history and lifestyle are key to the portrayal of an engaging figure.

COMPOSITION

Composition is the organization of shapes. You should arrange the shapes in your image in a way that is attractive and sensible. Define the important elements in your artwork: this piece depicts an Amazon in battle with an unseen beast with tentacles.

TIPS FOR GREAT COMPOSITIONS

- Many artists first define a frame, and then compose the elements of their picture within it.

- Another approach is to freely draw out the scene, applying a frame only once all the elements are in place. This allows freedom to experiment with different compositions.

- Look for balance in your compositions. This is most easily achieved with centrally-placed elements. This can be effective, especially for the presentation of single characters or static scenes. However, it is predictable and unexciting.

- Elements offset from the center create compositions with energy and movement, which will engage the audience more effectively.

- Be aware that the viewer's eyes tend to travel along any strong lines—straight or curved—that appear in your work. This can guide the eye toward focal points or redirect the audience away from the edge of the image. Consider this when developing a composition.

- **The Amazon**
- **The tentacles**
- **The relationship between the two**

Clearly defining the relationship between the Amazon and the tentacles is as important as the objects themselves. Quick sketches are perfectly adequate to explore composition because no detail is required. Fast, small sketches help to focus the mind on clear, definite shapes.

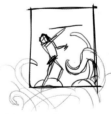

The weapons and tentacles are effectively captured in swift compositional sketches.

Sketching

With the composition decided, you should begin to sketch. Refine the composition, make sense of any abstract shapes, and add significant details.

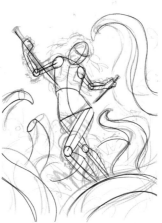

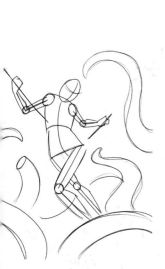

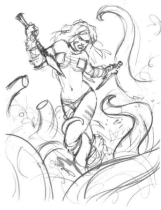

First, the figure is established using the simple mannequin described on page 53. Add definition to the abstract shapes of the tentacles.

Do not attempt to proceed directly from the compositional sketch to a final sketch. Doing so is difficult, and you lose the opportunity to refine the elements of your work carefully. Sketching allows you to explore an image thoroughly by identifying and solving any problems. Unresolved issues will be more difficult to correct during the later stages, so take your time.

Using the first simple sketch as a frame, the image is refined further, adding mass and detail to the Amazon and the tentacles. The sketching is loose and free, giving the piece energy.

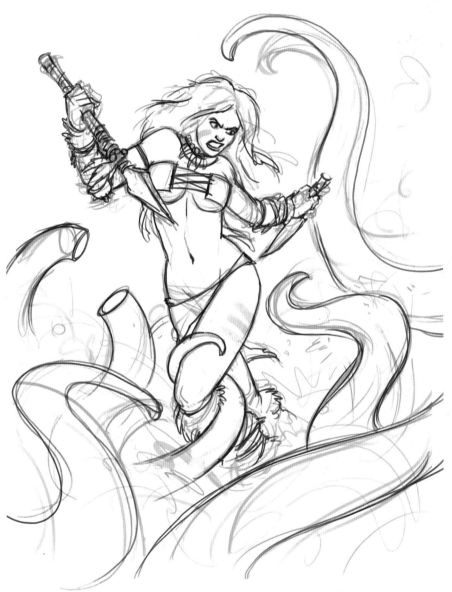

The sketch is finalized. Strong, clear outlines are
established from the loose sketches opposite to form a
solid guide for painting. At this stage, you have your first
indication of how the completed artwork will appear.

VALUE

The next step is to establish the artwork's values.
Value—also referred to as tone—is a more important
aspect of the artwork than color. Value defines form,
separates shapes and planes, imparts depth, and
controls focus; these are all essential elements in the
construction of a successful image.

HIGHLIGHTS

MIDTONES

DARK

Use value to separate shapes and
planes. To achieve this, place obviously
different values adjacent to each other.
Elements that share the same value will
seem to merge, even if they are different
colors or separated by an outline.

High value contrast controls focus. The
eye is drawn to areas of high contrast
first, so reserve the brightest and darkest
values for principal focal points.

Controlled values give depth. Value
range, and therefore contrast, should
recede from the main subject or
foreground. On the whole, areas with low
value contrast will always be less
emphasized than those of high contrast.

Value defines form. Important elements
should be well lit so their volume and
shape may be clearly seen.

Value is governed by lighting. The lighting
in your scene should be chosen to
support values, rather than color, so
place your lighting accordingly. Begin by
placing a primary light source. Establish
further sources as necessary.

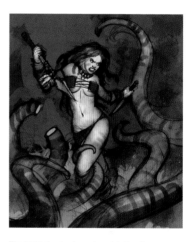

The highest value is assigned to the Amazon.
This works to establish her as a focal point,
but the overall values in this image are
fragmented. The scene, particularly the
massed tentacles, is confusing.

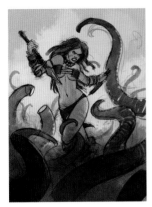

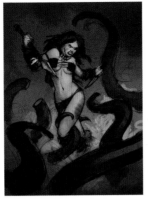

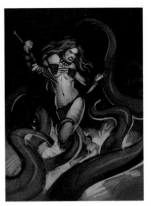

A bright background throws the foreground into partial silhouette. This emphasizes the bold shapes of the tentacles, and the Amazon's weapons; both are key compositional elements.

The lighting here focuses the attention on the Amazon. The water at her feet is illuminated, with the brightest area deliberately placed to draw attention to the tentacle she is preparing to spear.

Dramatic lighting once again concentrates the viewer's attention on the Amazon. A secondary light source provides up-lighting, which adds interest to the scene as well as bringing added definition and separation to important elements.

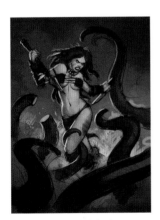

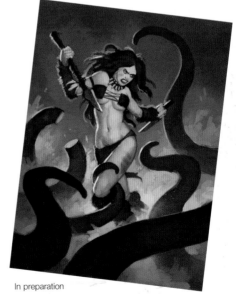

Focused directional lighting is combined with a strong, shape-separating backlight, to produce the final arrangement of values.

In preparation for the application of paint, the sketch is rendered out in neutral tones to firmly establish value placement. Line work is painted out to give a clean surface to work against.

COLOR

While the placement of value has a dramatic impact on any artwork, color has a subtle yet significant influence on the mood and emotion of an image.

COLOR WHEEL

The relationship between colors is shown using the color wheel. Red, yellow, and blue are the primary colors (marked "**P**" on the diagram). When two of these pigments are mixed together, they produce the appropriate secondary colors (marked "**S**"). Red and yellow make orange. Red and blue make purple. Blue and yellow make green. The colors in between, created by mixing varying amounts of any two primary hues, are the tertiary colors.

COMPLEMENTARY COLORS

Complementary colors lie opposite each other on the color wheel. They enhance each other's brightness and create a dynamic effect when used adjacent to each other.

Look at the finished character illustrations in the Character Directory on pages 64 to 251. Notice that they all use a color scheme based around two complementary colors.

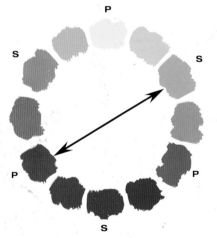

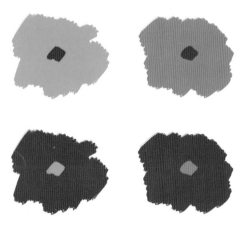

Note that the color wheel is valid for digital artwork as well as traditional media. Digital color models may vary, but colors can be "mixed" with predictable results by overlaying hues with varying levels of opacity. Be aware that this method can lead to a reduction in the saturation of the resulting color.

Compare the red mark in the green and orange swatches (top). Notice that the red appears more vibrant when surrounded by green, its complementary hue. The same is true when the colors are reversed (bottom).

MOOD

Colors have strong symbolic meanings, and make a powerful contribution to the mood and atmosphere of an artwork. For example, red is often associated with danger or conflict. Green and blue can impart a calm, tranquil atmosphere. Colors also have an association with temperature: red, orange, and yellow are warm colors; blue, cyan, and green are cool. See Visual Language on page 30 for more on the symbolism of color.

COLOR SCHEMES

Think about your image. What will the viewer expect to see? Even from a monotone value sketch, certain assumptions about a color scheme can be made—the flesh of the Amazon, or the blue of the churning water at her feet, for example. The artist must choose whether to work with the audience's expectations, or attempt to shock them with a surprising scheme. Ask yourself how this decision might influence the viewer's initial reaction to the artwork.

The light source may influence the color scheme. Neutral light reveals a surface's natural (or "local") color. A strongly colored light will visibly tint all the surfaces it illuminates. Consider how perceived colors are different during bright daylight or a vivid sunset, for example.

If you have a strong feeling for the color you wish to apply to a particular element of your artwork, choose other colors which work well alongside it. A complementary background color is always a good choice.

Working digitally has a distinct advantage, because color can be applied without damaging the sketch. Many digital art packages also allow for the speedy adjustment of colors. This is useful when you want to make alterations to your color scheme.

Work out color combinations as small thumbnails to see what works. This is an efficient way of experimenting with many schemes.

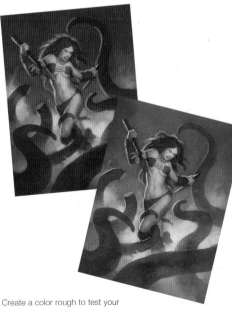

Create a color rough to test your chosen or favorite schemes.

RENDERING

Thorough preparatory work gives you a solid understanding of the art in progress, and the confidence that all the available options have been completely explored. It is now time to bring all these elements together, and paint the final piece.

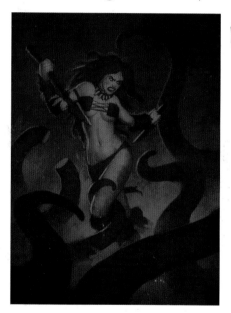

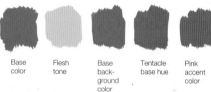

| Base color | Flesh tone | Base background color | Tentacle base hue | Pink accent color |

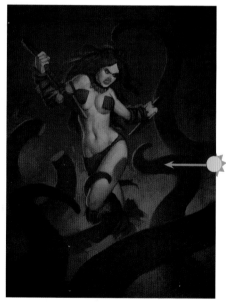

1 To begin, examine your chosen color scheme. Identify the dominant hue. Select a complementary color to act as a base. By applying this color to the value sketch as a wash, or as a separate layer if working digitally, you create an underpainting upon which to work. Where this underpainting shows through the rendering in the final artwork, it will add vibrancy to the complementary color scheme, and help to unify the overall scheme.

2 Add bright flesh tones to the Amazon's body to define form and establish the focal area. Note the direction of the primary light source, indicated above.

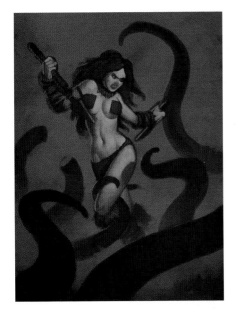

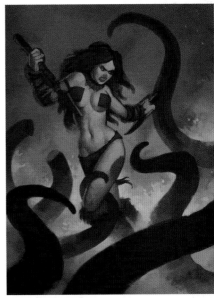

3 Add the base background color. Get the main colors of your chosen scheme onto the canvas at the earliest possible stage.

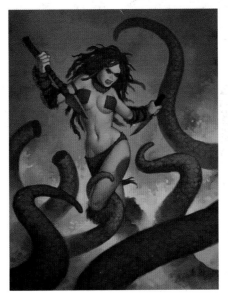

4 Add bright values to the background. This further establishes the focal areas of the piece.

5 Apply base color to the tentacles. The basic color scheme is now in place, with the values established. Now refine any untidy edges.

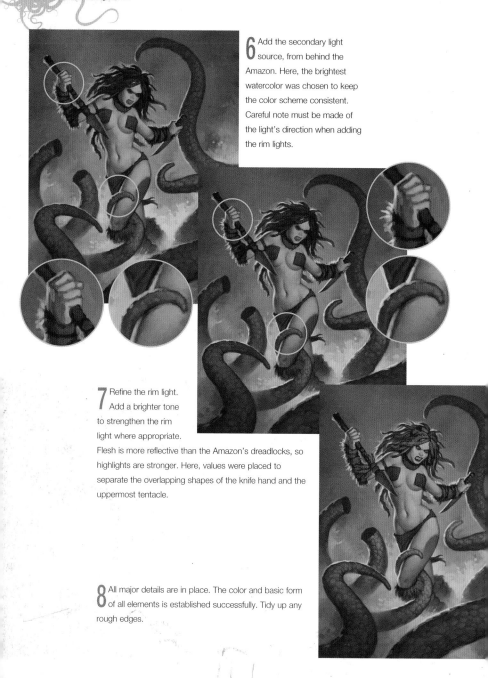

6 Add the secondary light source, from behind the Amazon. Here, the brightest watercolor was chosen to keep the color scheme consistent. Careful note must be made of the light's direction when adding the rim lights.

7 Refine the rim light. Add a brighter tone to strengthen the rim light where appropriate. Flesh is more reflective than the Amazon's dreadlocks, so highlights are stronger. Here, values were placed to separate the overlapping shapes of the knife hand and the uppermost tentacle.

8 All major details are in place. The color and basic form of all elements is established successfully. Tidy up any rough edges.

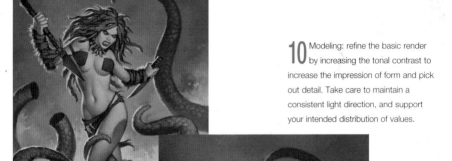

10 Modeling: refine the basic render by increasing the tonal contrast to increase the impression of form and pick out detail. Take care to maintain a consistent light direction, and support your intended distribution of values.

9 Add small details. Intricate elements, such as the Amazon's necklace, would be distracting to paint around in the earlier stages of the work. It is best to add small details once the broad placement of color and form is concluded.

11 Add a final round of highlights and details. It is vitally important to be aware of the intended focal points at this stage of the painting. Introduce highlights to further the contrast in these areas. The painting is almost complete.

GENERAL TIPS

• A highlight is light reflecting back from a surface. Therefore, the light's color determines the highlight's color. Where all objects are illuminated by the same light source, the highlight color should be broadly consistent. In this image, illuminated areas tint toward the color of the light, which is a warm, yellow hue.

• Layer slightly different colors onto each other to add depth and interest to surfaces. Note the subtle differences of the hues used on the Amazon's flesh.

• Do not focus on small areas. Work up the image as a whole. This allows you to carefully manage the relationship between the points of interest in the artwork.

• If working digitally, take advantage of the ease with which artwork can be flipped or "mirrored." This allows you to observe the image from a fresh perspective, and can reveal problem areas that would otherwise be missed.

• Concentrate details on the focal points. Too much detail is unnecessary, distracting, and lessens the impact of the artwork.

FINISHING TOUCHES

With the painting almost completed, it is time to take stock. Compare the image against the early sketches to check that composition, value, and color scheme have been realized effectively.

This is the last opportunity to make final adjustments. Resist temptations to tweak unnecessarily. Hours may be lost forcing late ideas into the scene. Discipline yourself, making sure you can justify changes you make at this stage.

Digital art software presents many opportunities for adjustment. Analyze the image carefully before tampering with it. Your adjustments will be more efficient and focused if you have a clear idea of the results you are aiming for.

Compare the very earliest sketches—compositional thumbnails—to the final image. Observe how the elements established there remain in the foundations of the painting.

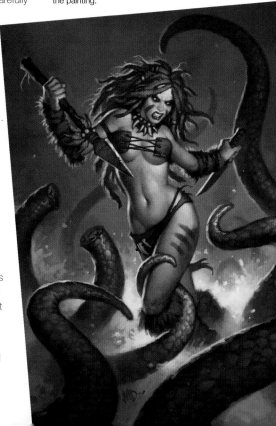

ANALYSIS

Looking at the process of this painting, the importance of good preparatory work can be seen clearly. Creating a successful piece of art is a journey requiring effort and determination. Solid preparation provides a clear map for that journey; you know where you are on the journey, and what to expect next. This helps to maintain momentum and prevents distraction or deviation from the intended goal.

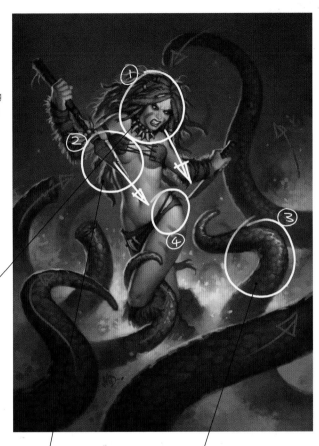

See how the focal points developed in the value sketch draw the eye. The Amazon's face pulls the viewer in (1), followed by the bright head of the spear (2), which then directs the eye to the tentacle (3). An area of contrast on the Amazon's hip (4), draws the eye back toward the center of the image. The artist has imposed a deliberate hierarchy so that the image reveals itself to the audience in a logical order.

The strong line of the weapon directs the viewer toward the tentacle that is about to be speared. The Amazon's gaze also directs the eye to this area.

The audience's eye is further guided by the placement of the tentacles. The red arrows show how they direct the viewer away from the edge of the canvas and inward to the focal points.

PROPORTIONS OF THE BODY

"Head units" are used to measure the height and relative proportions of the artistic figure. An artistically proportioned adult human stands eight heads tall, with major anatomical details easily located using the horizontal divisions created by each head.

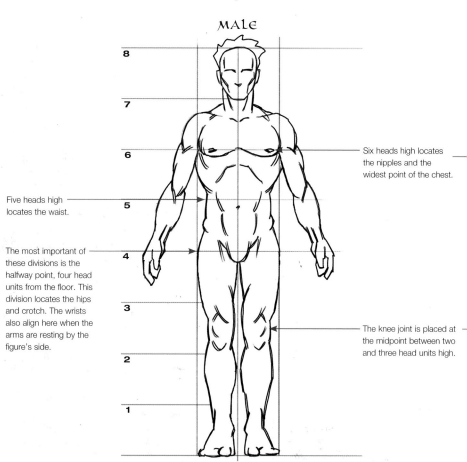

MALE

8

7

6

Six heads high locates the nipples and the widest point of the chest.

Five heads high locates the waist.

5

The most important of these divisions is the halfway point, four head units from the floor. This division locates the hips and crotch. The wrists also align here when the arms are resting by the figure's side.

4

3

The knee joint is placed at the midpoint between two and three head units high.

2

1

THE DIFFERENCES BETWEEN MALE AND FEMALE FIGURES

- Males and females share the same vertical proportional measurements, but the female form is narrower horizontally.

- The most significant anatomical difference between the sexes is the pelvis. In women, the pelvic bone is larger in relation to the rest of the skeleton. This results in wider hips and a more pronounced waist.

- Notice the relationship between the hips and shoulders. A vertical line drawn through the figure at the outer edge of the hips on male and female figures passes through the shoulder at different points. In the male, the shoulders are much wider, placed outside the line. Females have narrower shoulders and wider hips, placing the shoulders inside the line.

- To accentuate the feminine form, the artist may choose to further stylize the proportions. Lengthening the legs increases the figure's elegance. Narrowing the wrists, ankles, and waist exaggerates the curves of the hips, legs, and bosom; all of which may be deliberately drawn with a dramatic curve to push this impression further. This should always be performed with care, and with a sound knowledge of correct artistic proportion, in order to avoid an unrealistic or cartoon-like figure.

- It is important to recognize the distinction between realistic and artistic proportions. In reality, most human beings are between six and seven heads tall. These proportions look stunted and unexciting on the page. Artists generally accept a figure standing about eight heads tall as the standard. These idealized proportions are more attractive and dynamic on the page, and are ideal for fantasy artists.

FEMALE

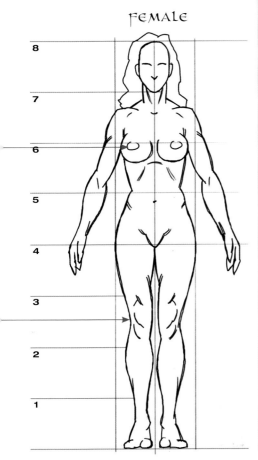

RELATIVE PROPORTIONS

The illustrations on these pages show the relative proportions of some popular fantasy characters. Compare the figures against the standard human proportions on page 52, and note the differences.

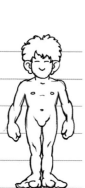

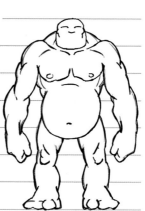

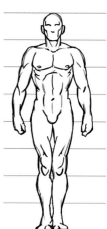

Dwarf: The Dwarf is extremely stocky. This figure is almost as wide as it is tall. Note the long, powerful arms reaching down to the knees.

Halfling: Five head units give the Halfling distinctly childlike proportions. This impression is further enhanced by playing down the muscle masses, giving a rounded, well-fed appearance. Note that proportions are measured only to the top of the scalp—hair, however bulky, is not included in these proportional measurements.

Orc: Broad and powerful, the Orc's squat posture is offset by a frame that is seven head units tall.

Human: The eight-head-tall human frame is the standard against which other fantasy characters are measured.

Note that proportion is a relative measure. The head unit is used to measure proportion alone, and is no indication of a figure's actual height—a character described as "six-heads-tall" is not necessarily any taller than a character described as "four-heads-tall." The number of heads refers simply to how their height breaks down proportionally. As an example, the Halfling (five heads tall proportionally) is generally a shorter character than the dwarf (four heads tall proportionally). The Dwarf is exceptionally broad and stocky, and this is reflected in the low number of heads that describe his proportions.

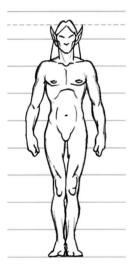 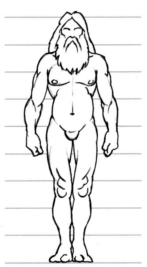 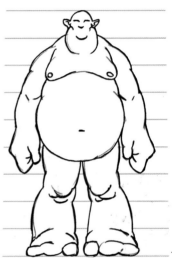

Elf: The Elf stands a little taller than the eight-head-tall Human, but with a more slender frame suggesting elegance and grace. The longer proportions offset the light frame to prevent the Elf appearing weak or overly thin.

Barbarian: Although the Barbarian is bulkier and more muscular than a standard human, the impression of power in this figure comes largely from the long, athletic proportions in a nine-head-tall frame.

Ogre: Bulk characterizes this figure. Much of the muscle mass is buried beneath a thick layer of fat, revealing very little definition of anatomical detail.

CONSTRUCTING THE FIGURE

A simple mannequin is the best way to begin the figure's construction and develop a convincing pose.

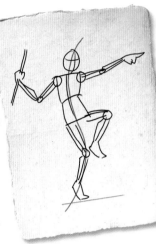

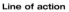

Line of action

A dynamic pose is effective when it expresses a simple "line of action." A bold curve, or elongated S-shape along the trunk of the body, works best.

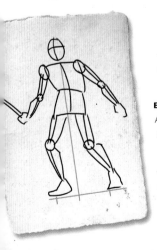

This mannequin conforms to the artistically-proportioned eight-head-unit-tall figure, with all the major anatomical details clearly indicated. Although the mannequin is simple, maintaining correct proportion is essential, as this drawing will be the foundation for the finished artwork.

The mannequin's simplicity allows you to experiment quickly with different poses. Weapons and other props may be included in the drawing to help with composition.

Balance

A pose which locates the figure's head between the feet will be balanced, lending stability and weight to your character.

A strong line of action should run through a natural pose. Trace a line from the top of the mannequin's head, along the spine, and down the leg to the floor. This line should be simple and elegant; anything more complex than the S-shaped curve above may look awkward.

The mannequin also helps you place the figure in three dimensions. First, place the hands and feet in their desired position. Then link them to the body with the limbs. This is an easy method of establishing which parts of the body are hidden or foreshortened.

Consider balance when developing a pose. Placing the head directly between the feet balances the character and provides stability. When the pose places the head beyond the feet, the distribution of weight is off center — this can be a very effective method of suggesting movement.

Practice drawing the mannequin. First, concentrate on establishing the correct proportions, then on developing convincing, expressive poses. If the mannequin does not look natural, neither will the finished figure.

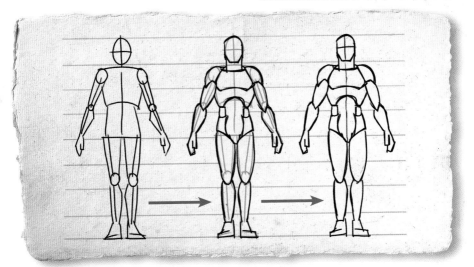

BUILDING MASS

The character's proportion and pose are established with a correctly-drawn mannequin. Next add mass.

Simplified muscle masses are drawn over the mannequin's frame. These masses can be refined as the artwork progresses; the goal here is to clearly define the figure's volume.

Think in three dimensions when adding mass to the mannequin. Separate muscle masses overlap and intersect rather than sitting adjacent to one another. Think of the mannequin as the skeleton—the masses attached to this frame define the outer contours of the body. A center line drawn along the torso can help to visualize this when the body is in rotation.

Practice makes perfect

Practice building mass with simple, neutral poses. Establish the correct proportions by measuring in "heads"—draw against these guidelines if necessary.

The posed figure

When constructing a posed figure, masses will overlap. Try to "feel" the form and draw with loose, repeated strokes. Don't worry if there are too many lines—it can be cleaned up later!

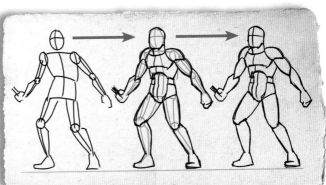

BODY

Here you can see the superficial (or "visible") anatomy necessary to develop a convincing torso, and its relationship with the simplified anatomy used to add mass to the mannequin.

These drawings mark the location of significant anatomical details which the viewer expects to see when looking at a normal human body. The correct addition of these points will lend a surprising realism to the mannequin.

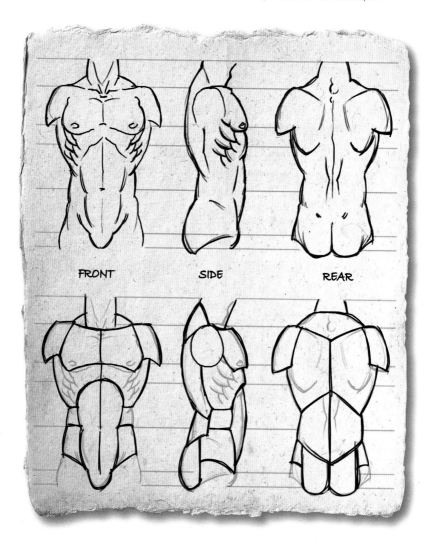

FRONT SIDE REAR

ARMS

Correct placement of the elbow joint is of the utmost importance when refining the arm. An error here will result in an incorrectly-portioned limb, that will significantly damage your figure. Poor proportion is far more obvious to the viewer than inaccurate masses; proportions must be correct.

The masses of the arm are relatively simple. The forearm and wrist are bony, so their shape and volume are consistent. The upper arm is surrounded by large muscles, which must be drawn carefully.

Drawing contour lines across the surface of your drawing can help to visualize form.

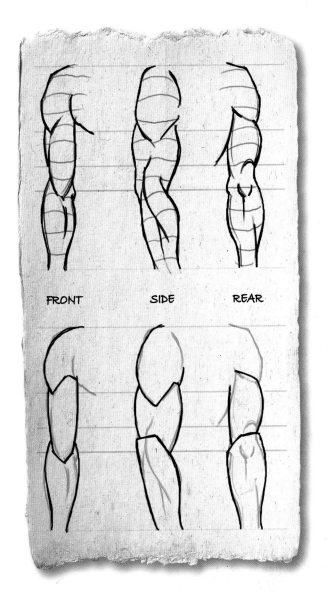

FRONT SIDE REAR

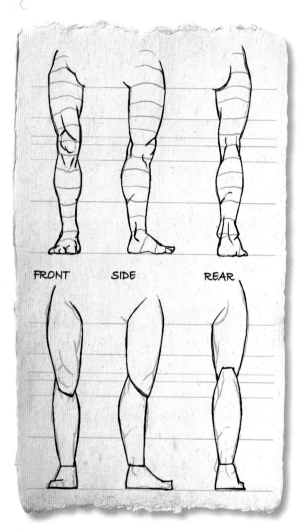

FRONT SIDE REAR

Legs

Placing the knees in the correct location is also of paramount importance. Notice the perceived angle of this joint when viewed from the side—the rear join, where the tapering calf inserts into the thigh, is higher than the front join, where the fleshy kneecap wraps over the knee joint.

Note the similarity to the arm in the distribution of hard and soft masses. The shin and ankle are mostly bony, and the upper leg is a mass of muscle tissue.

Simple shapes

Though they lack the expressive quality of the arms, legs are no less important in the construction of a convincing figure. Apply the same care to all elements of your figure when establishing accurate proportions.

ĐANĐS

Hands are frequently cited as one of the most difficult aspects of human anatomy to draw. The concentration of joints in the hand means that they can form many complex shapes, making simplification of hand anatomy a difficult proposition.

The hand's mobility means that it is the most expressive part of the body apart from the face. No artist wanting to construct successful figures should ignore the value of a well-drawn hand.

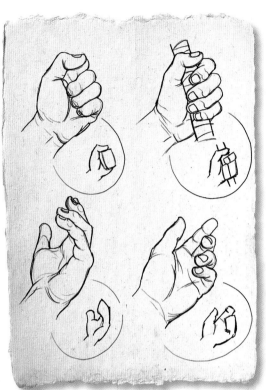

Hand gestures

Hands often assume familiar positions—clenched, gripping, or relaxed. Learning to draw these basic gestures is a good place to start.

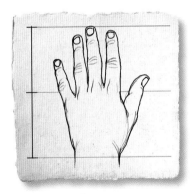

Hand proportions

The fingers here occupy about half the length of an open hand. The thumb and little finger are the same length at the knuckle, where they extend from the hand.

To begin, imagine the hand as a mitten. Place the thumb first, then the fleshy mass at its base. Against this, draw in the fingers as a single mass. The index finger may have to be separated out, depending on the gesture. Add "corners" to this mass at the knuckles, where the hand clenches or grips.

The mitten defines the hand's mass, and may now be refined to add the details as necessary.

CONSTRUCTING THE HEAD

The face is the most expressive part of the human body, and the success of any character is measured by the artist's visualization of the head and face.

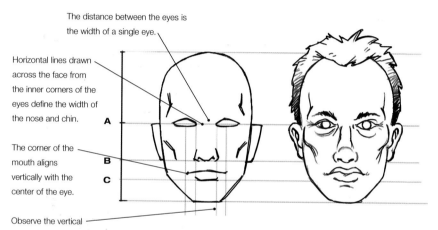

The distance between the eyes is the width of a single eye.

Horizontal lines drawn across the face from the inner corners of the eyes define the width of the nose and chin.

The corner of the mouth aligns vertically with the center of the eye.

Observe the vertical alignment of features.

A few simple measurements allow accurate location of the facial features:

Split the mass of the head in half with a horizontal line: **A**. The division positions the eyes and the top of the ears.

Divide the lower half of the head in half again: **B**. This line locates the base of the nose and the lower edge of the earlobes.

Halve the section below this line once more: **C**. The lower lip rests on this division. Note the position of the mouth, midway between the other lines. The jaw turns inward to taper toward the chin at a point horizontally aligned with the mouth.

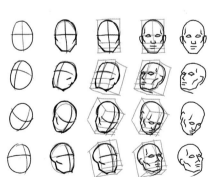

The head in rotation

A simple "cage" drawn around the head allows the proportions of the face to be easily measured in three dimensions.

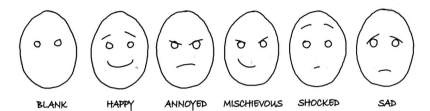

BLANK HAPPY ANNOYED MISCHIEVOUS SHOCKED SAD

EXPRESSION

Expression is the most powerful aspect of figurative art. A character may be beautiful, perfectly proportioned, adorned with fabulous costume, and exquisitely rendered—but without expression it sits lifeless on the page. An effective expression shows your character's thoughts, reveals something of the figure's soul, and stirs the viewer's emotions. Expression breathes life into your figures.

Three lines hold the key to facial expressions. See how the addition of a mouth and eyebrows transform one large and two small circles into a simple face with expression. This simple shorthand of expressions is as effective for a realistic head as it is on these naive drawings.

Exaggerated expressions are easily understood by the audience, and this approach is often suitable in fantasy art, which is a genre full of extremes and exaggerations. However, use extreme expression with caution; the more exaggerated the expression, the less subtle the emotion. This can give an unwanted comical result, or give the impression that the character is emotionally shallow.

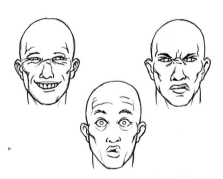

Practice expressions in front of a mirror

Watch how your face distorts, what muscles move, and how masses change, especially around the brow and cheeks. Observe the whole face, not just the brow and mouth, for subtle movements that can be used to add realism to expressions. Think in terms of the emotion you want to express, rather than the name of the expression—there is a distinct difference between a smiling face and a face displaying happiness.

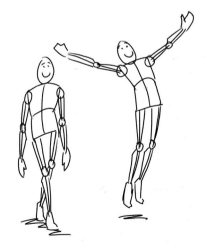

Body language

Expression is most clearly recognized in the face, but a truly convincing expression is seen in the whole body. Note how the poses of the grinning mannequin make subtle changes to the expressed emotions.

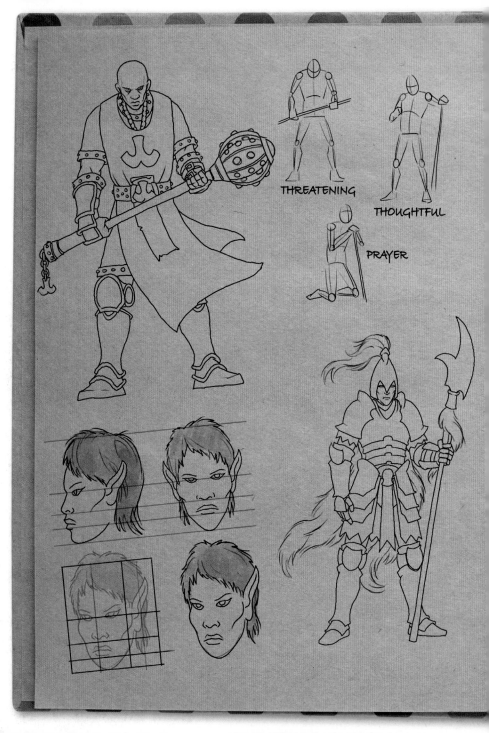

THREATENING

THOUGHTFUL

PRAYER

The Character
Directory

**From first concepts through
to final art, the creative process
for 31 fantasy archetypes
is explored in detail in
these pages.**

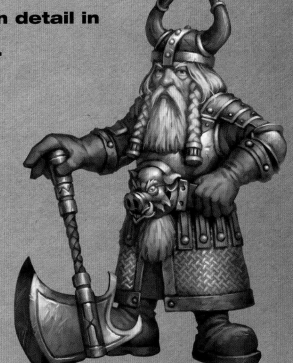

HERO

Slayer of dragons and rescuer of maidens. The legendary Hero!

COPY THIS ▶

Beginner artists start here:

Trace this or scan it into your computer and color it.

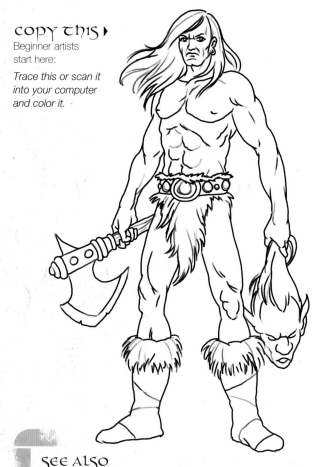

PERSONALITY

Powerful, courageous, enigmatic

A Hero's deeds inspire songs, stories, and art. So what better character is there to examine first? Heroes come in all shapes and sizes, so you must choose carefully whether to play to the viewer's expectations or against them. Here, the Hero is cast in the classic mold; he must look the part visually, as he has no song or story to back him up.

DESIGN CHOICES

A proud, confident pose projects the Hero's personality, while the minimal costume shows off his muscular physique and affirms his physical prowess. The viewer is in no doubt of the character's heroic status—only a warrior of truly legendary strength and ability would venture into battle with so little protection. The severed head of a recent victim further emphasizes the Hero's dominance in combat.

SEE ALSO
Proportions of the body, page **52**

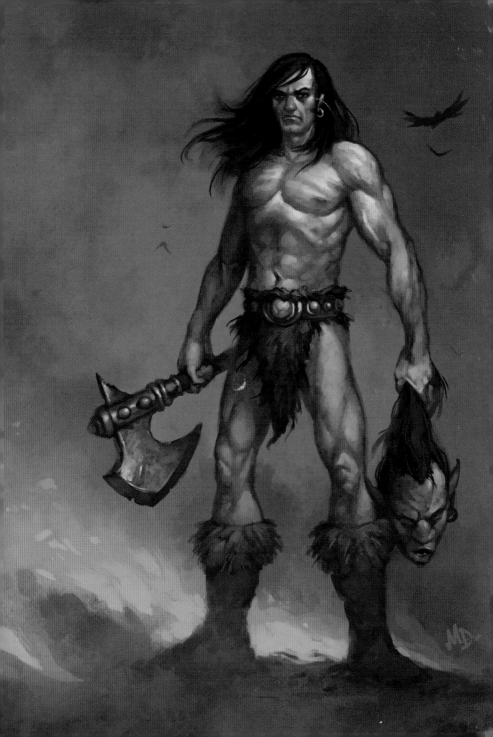

DEVELOPING CONCEPTS
HERO

Infused with legendary power, the Hero commands a confidence and purpose beyond the reach of mere mortals—his self-assured nature should drive the design.

FACE

In a fantasy tale, the Hero is the star. Think about the appearance of leading men in action movies to get an idea of the Hero's face: defined bone structure, a strong jaw, and a determined expression help to define the masculine ideal. You could use a favorite movie star as a starting point.

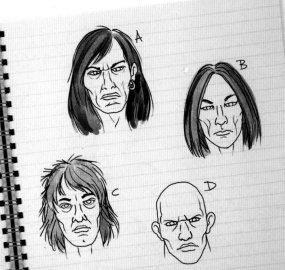

A: Perhaps handsome once, this rugged face is now contorted in a dismissive scowl.

B: Here, the features are sharper and more delicate, though the narrow eyes and straight, centrally-parted hair create a severe demeanor.

C: Heavy bones feature here, with a thick brow and long, jutting jaw.

D: Without hair to soften the strong features, this bald character has great intensity.

BODY SHAPE

Our Hero's body helps convey to the viewer the character's confidence. Muscles should be well defined, but be wary of over-definition—a zero-fat bodybuilder's physique can look artificial when presented in a gritty fantasy environment. Physical power is best communicated with a broad frame and a solid stance.

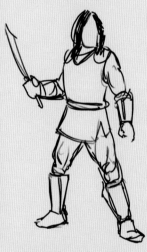

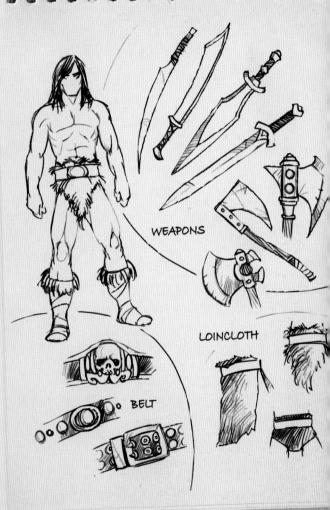

WEAPONS

LOINCLOTH

BELT

WORKING UP DETAILS

- **Weapons:** The Hero's weapon should be practical. Realistic proportions and some light wear and tear lend believability, further reinforcing the Hero's inner power— he has no need for an elaborate or magical blade to secure his triumph!

- **Belt:** With such a minimalist costume, even a trivial detail like the belt buckle can become a focal point. The design should be simple, to avoid detracting from the Hero himself.

- **Loincloth:** So certain in his purpose and ultimate victory, our Hero eschews armor, and ventures into battle with the minimum amount of clothing and equipment.

CONSTRUCTION AND DRAWING GUIDE
hERO

Minimal costume and a powerful, athletic frame make the Hero an ideal character on which to practice bodily and facial construction and proportion.

CONSTRUCTION

The Hero is a perfect human specimen and it's no surprise to find that he conforms exactly to the standard human construction measurements. What may be surprising as you progress through this book is how the basic human measurements remain true across a wide range of characters, and form the basis for all but the most extreme fantasy archetypes.

Split the cage in half horizontally (line **A**) to form the eye line. This locates the character's eyes. Draw another horizontal to split the cage in half below the eye line (line **B**) and another to halve the resulting space (line **C**). Note how the features are contained—the nose and ears by lines **A** and **B**, the mouth by lines **B** and **C**.

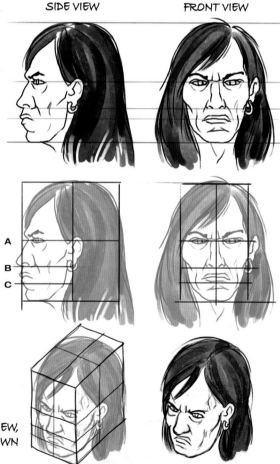

SIDE VIEW FRONT VIEW

A
B
C

THREE-QUARTER VIEW,
LOOKING DOWN

POSE

Posing the Hero correctly is crucial. Dressed as he is, the character must look confident and comfortable in his surroundings; the wrong stance could make the Hero look weak, even comical. Indicate leadership with a commanding pose. Demonstrate the character's prowess in battle by showing him in action. The iconic Hero's stance best displays the enigmatic qualities of this character.

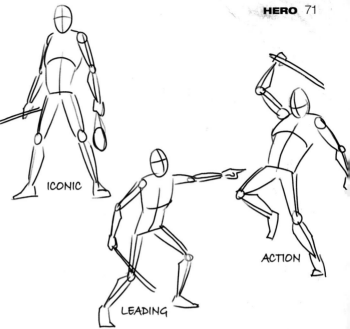

ICONIC

ACTION

LEADING

ARTIST'S TIP: SKIN TONE

Reproducing convincing skin tone is a key aspect in presenting a believable character—it imparts life and realism. Flesh can display a surprisingly wide range of hues.

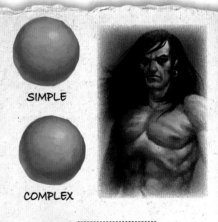

SIMPLE

COMPLEX

Understanding the makeup of flesh helps to make sense of skin tone. Skin is translucent, which means it will show something of whatever lies beneath it—extremities and joints of the body will flush with increased blood flow, increasing the saturation of the flesh in those areas. Hair growth will darken and cool skin tone. This can be demonstrated simply by looking at the subtle changes in tone in a male face, which splits roughly into three bands: the brow shows the basic flesh tone; the cheeks, nose, and ears are flushed with blood, adding extra color to the skin; and hair growth beneath the scalp and beard area cool the hue and darken the tone of the skin.

The translucency of the skin produces a very complex interaction with light, which passes into the surface. A simple gradient between one dark and one light skin color looks hard and lifeless. Variations in the hue and saturation of flesh help to breathe life into your character.

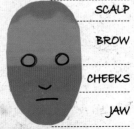

SCALP

BROW

CHEEKS

JAW

AMAZON

A ferocious female warrior with great skill and cunning.

PERSONALITY

Savage, proud, confident

The Amazon is a strong riposte to the passive female characters occasionally portrayed in fantasy; the sort imprisoned in lonely towers, awaiting rescue by a handsome prince. This character is the opposite of these stereotypes, possessing fighting abilities and bravery to match any man. The skill lies in portraying such traits while retaining the Amazon's femininity.

DESIGN CHOICES

Wild hair and an unsophisticated costume show the primitive nature of the Amazon. Her desire for combat and confidence in her fighting skills are suggested by her provocative pose and expression. That she wields two weapons is a clear indication that her confidence is justified.

COPY THIS ▶

Beginner artists start here:

Trace this or scan it into your computer and color it.

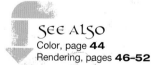

SEE ALSO

Color, page **44**
Rendering, pages **46–52**

DEVELOPING CONCEPTS
AMAZON

Her savage, powerful nature should be evident in the design, but you must take care to balance this against the character's essential, feminine qualities.

FACE

Less is more when dealing with the female face. The Amazon needs to look tough. However, a weathered, lined face loses femininity. Instead, keep the features soft, and use her hair and expression to project her personality. Eyelashes— often best expressed simply as a heavier line on the upper eyelid—a narrow jaw, and a small, soft nose help to distinguish the female face from the male. Paying particular attention to these features will pay dividends.

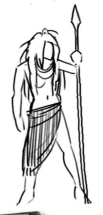

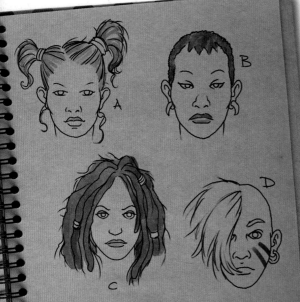

A: Hair is gathered in untidy asymmetrical bunches, indicating that the Amazon cares little for her appearance. Strands falling around her face soften the jawline.

B: Cropped hair is shaped at the front, and ears are pierced with bone, suggesting tribal or religious rituals.

C: Her dreadlocks could be a mark of the Amazon's tribe. They suit her savage image.

D: Face paint and a half-shaved head suggest the Amazon's primitive culture.

COSTUME

Details are not important at this stage. Think about the sort of clothing that will reflect the Amazon's personality. A savage warrior fighting with speed and agility is unlikely to wear heavy armor. Light clothing would be best, and will suggest a primitive background. Flowing fabric adds elegance. Tight-fitting garments will show off her curves, greatly enhancing her femininity.

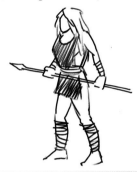

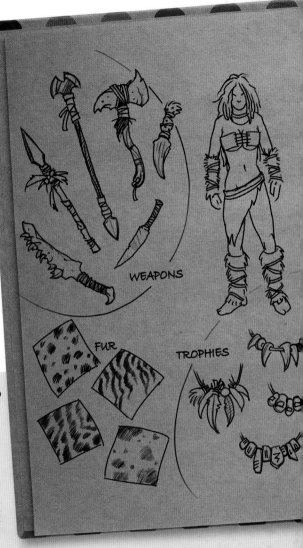

WEAPONS

FUR

TROPHIES

WORKING UP DETAILS

- **Weapons:** Show the Amazon's primitive nature in the construction of her weapons. Alternatives to metal can produce interesting results: a dagger fashioned from obsidian or a jawbone used as a sword, for example. Keep her weapons small and light, as this will reinforce her fast, ferocious fighting style.

- **Fur:** Although surface area is limited, the Amazon's costume provides potential for interesting patterns on fur or leather. By experimenting on swatches, you are not restricted by her small garments.

- **Trophies:** Jewelry adds interest and femininity to the Amazon. What she chooses to display on her body tells us more about her character. Feathers and beads soften her warlike appearance. Carved bones and stones imply religious or cultural significance. Ornamental teeth and fangs give her a hunter's appearance. A necklace strung with severed toes gives her a frightening, gruesome quality.

CONSTRUCTION AND DRAWING GUIDE
AMAZON

Fierce yet feminine, the Amazon is the archetypal fantasy female. Lean, lithe limbs should balance against womanly curves when you construct her figure.

CONSTRUCTION

Despite having a very different appearance from the Hero, you can use an identical cage to aid construction. It's the appearance of the features, not their placement, that gives human faces character.

Note that the construction cage fits to the limits of the head only, with the hair moving outside the cage boundary. This allows measurements to remain consistent between characters, as hairstyles can dramatically change the overall shape of the head. Once the facial features and mass of the head are in place, hair can easily be added on top.

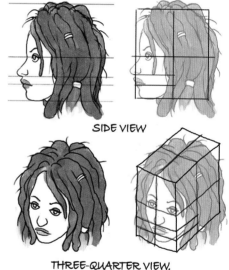

SIDE VIEW

THREE-QUARTER VIEW,
LOOKING DOWN

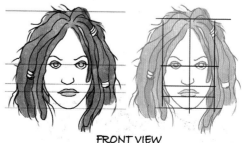

FRONT VIEW

pose

The Amazon looks fierce and agile. She wears the trophies of a capable hunter, and carries weapons that she can use to deadly effect. Her pose must support all these aspects. She could be following prey—reading tracks on the ground, or sniffing the air. As an alternative pose, imagine how she might react if startled: like an animal preparing to strike. A confrontational stance might suit her: approaching the viewer with one foot placed gracefully in front of the other, weapons gripped in both hands, her arms wide open exposing her torso, and her head cocked inquisitively. In this pose, the Amazon is inviting her adversary to take his best shot, and the subtle smile playing across her lips tells us she is looking forward to it!

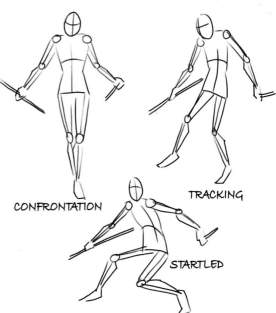

CONFRONTATION

TRACKING

STARTLED

ARTIST'S TIP: GENDER

A character's gender should affect how the artist approaches the rendering. Men acquire character and masculinity with added detail. Women achieve femininity and sensuality with simplified detail.

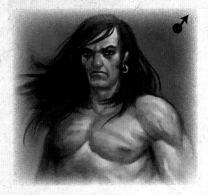

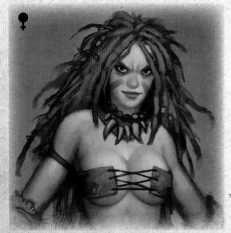

Compare the Hero and Amazon characters in the example images. Both have similar personalities, and their costume and attitude give them a superficially similar appearance. Take note of how their faces are painted, however. The forms of the Hero's face are clearly defined with strong variations both in color and value. The Amazon's face is much softer, with almost no detail beyond her eyes, mouth, and subtly defined nose. Notice the same differences visible in the rendering of the body.

WIZARD

Be he wizard, sorcerer, or magician, this guardian of arcane knowledge is a classic fantasy archetype.

COPY THIS ▼

Beginner artists start here:

Trace this or scan it into your computer and color it.

PERSONALITY

Mysterious, intelligent, powerful

Fantasy Wizards have a well-established appearance, and you may choose to avoid what has been done before. However, exploring a classic character's look can be an interesting exercise; you may find that playing to the viewer's expectations can be a useful tool.

DESIGN CHOICES

Despite his aged appearance, the Wizard adopts a strong, commanding pose, confirming to the viewer that this is no frail old man. Instead, his age suggests wisdom and knowledge, fitting traits for a follower of magical arts. Gathering clouds of vapor add atmosphere to the finished art, hinting at the conjuring of some powerful spell.

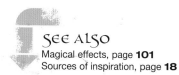

SEE ALSO

Magical effects, page **101**
Sources of inspiration, page **18**

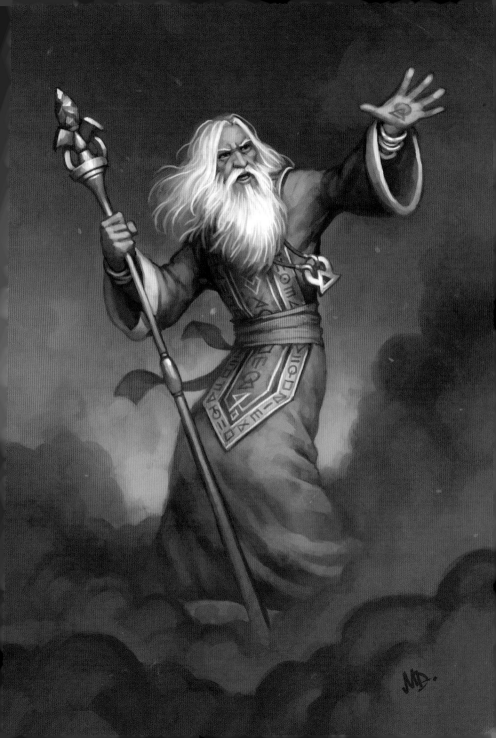

DEVELOPING CONCEPTS
WIZARD

Established parameters are not a shortcut to effective design. Think carefully about how best to use the robes, staff, and beard associated with the Wizard archetype.

FACE

Wizards are usually portrayed as old men with beards. Consider why this might be. Their venerable age implies experience, knowledge, and wisdom. A beard reinforces this impression and, when it is an odd shape, adds a touch of the exotic. The beard also covers part of the face—a subtle way of suggesting a mysterious or secretive nature.

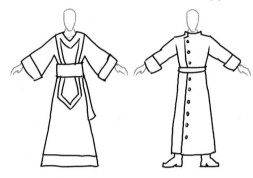

A: A youthful take on the classic look. The hair and beard are neatly groomed, and the face free of lines.

B: The bushy eyebrows and long, curling beard are slightly exaggerated, suggesting something supernatural in this careworn face.

C: The thin face, narrow eyes, and flamboyant facial hair give this character an exotic air. Notice how the repeating angular shapes give a hard, almost sinister impression.

D: Curly hair and a round face give this magic-user a friendly appearance.

COSTUME

Robes that hide a character's body can create problems for the artist—the body's form beneath the fabric may become indistinct. However, this can be used to draw attention to more important design aspects. Use a front view of a simple pose to develop the Wizard's attire, and focus on creating interest in specific areas.

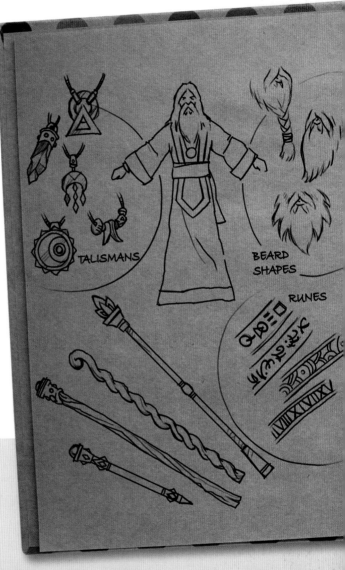

TALISMANS

BEARD SHAPES

RUNES

WORKING UP DETAILS

● **Staffs:** The Wizard's staff is more than just a prop for age; the object's design tells a story about its owner. A wooden staff indicates a magician in tune with nature; a black rod with pointed finials gives the sorcerer a sinister edge; an elaborate gold wand suggests a wizard in a position of authority.

● **Talisman:** A mystical talisman hangs from the Wizard's neck. Small accessories like this make the viewer wonder about their purpose, giving the character depth.

● **Beard:** The beard is a significant feature of the character. Consider different ways that it might be shaped or dressed for extra interest.

● **Runes:** Strange runes and arcane script add detail to the costume.

CONSTRUCTION AND DRAWING GUIDE
WIZARD

An agile body helps to avoid the suggestion of weakness or fragility that might otherwise be associated with an obviously venerable character.

CONSTRUCTION

Much of the Wizard's head is hidden beneath thick hair and beard. This makes the job of constructing the head fairly difficult, as there are fewer rigid features to locate using the cage.

Remembering that the cage should always be drawn to the limits of the character's head without any hair, construct the head as normal, locating eyes, nose, and mouth using the horizontal lines **A**, **B**, and **C**.

The chin is hidden beneath the Wizard's beard. As the hair here is close to the face, it can be considered as rigid and therefore should be included in the construction cage—extend a diagonal from line **C** (or **B** if your Wizard has a particularly thick moustache) to help locate the limits of the beard.

SIDE VIEW FRONT VIEW

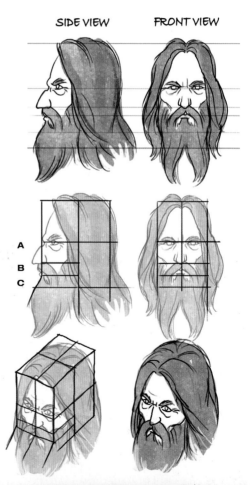

A
B
C

THREE-QUARTER VIEW,
LOOKING DOWN

pose

A strong pose is an effective way to project the Wizard's power, and is particularly important when so much of his body is hidden beneath robes. Show the Wizard displaying unexpected energy and mobility for a man of his age; his body twists, the staff is held firmly as a weapon, his face is fierce, and his arm is thrown out as he prepares a spell. You can show the Wizard's energy in a defensive stance by showing his staff held with confidence and strength. Contrast this with the weary pose, where the staff is only used as a prop.

DEFENSIVE

CASTING

WEARY

ARTIST'S TIP: COMPOSITION

Composition is about balancing the negative and positive spaces in your artwork for a pleasing effect. This is most challenging when presenting a simple image, as you have fewer elements to arrange. A single character against a simple background can be particularly problematic.

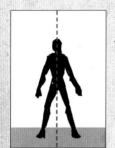

Symmetrical

Obvious symmetry is very dull. It can be useful if you wish to present a very calm, quiet piece, but it should generally be avoided.

Static

This shows poor composition. Simply breaking the symmetry does not work unless the composition is balanced.

Dynamic pose

Turn the body away from the viewer. This pose is balanced against an angled center line running through the body. The background is angled against this line.

Balanced

Atmospheric perspective balances the composition, and the strong angle of the sword blade is balanced by an opposing angle in the background.

RANGER

Rangers wander alone, traveling the wilderness on unknown missions.

COPY THIS ▼
Beginner artists
start here:

*Trace this or scan it
into your computer
and color it.*

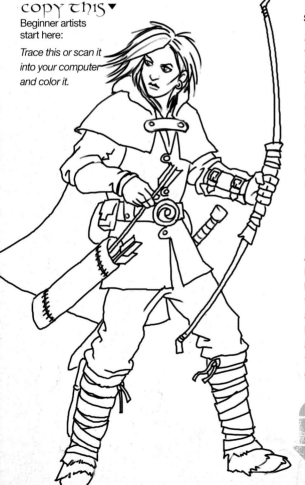

PERSONALITY
Secretive, stealthy, agile

A practical, self-sufficient character, with a wide skill range learned from journeys in the wilderness. This kind of multitalented individual, without a single, obvious skill or occupation to base a design around, can be a complicated prospect. Our Ranger is female, and this character demonstrates that fantasy females do not have to expose flesh and a heaving bosom to be feminine.

DESIGN CHOICES
A practical costume in earthy colors immediately suggests a capable, hardy character. This impression is further supported by showing wear and tear in the detail of the Ranger's clothing. Her head is angled, and her eyes locked in a focused gaze which shows this character is alert and perceptive.

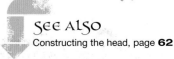

SEE ALSO
Constructing the head, page **62**

DEVELOPING CONCEPTS
RANGER

An outdoor life has made this character adaptable.
She should appear well-equipped and capable.

FACE

Take care to emphasize the feminine qualities of the Ranger's face. She will be clothed in a practical manner for her outdoor existence and carry plenty of equipment, which will hide her curves; thus the face is crucial to establishing her gender. Youthful, soft features work best. Consider how the Ranger's lifestyle might influence how she wears her hair.

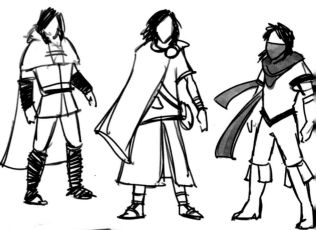

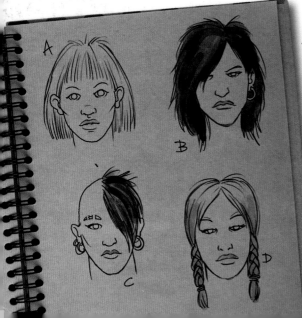

A: Rounded features and large eyes suggest youthfulness. The hair is styled simply, cut to a practical length, with a short fringe to keep it out of her eyes.

B: Here the features are a little sharper, hardening the Ranger's demeanor, and adding a suggestion of determination. Wavy hair falls across her eye, softening the angular face.

C: A tribal look, suggesting an interesting cultural background.

D: Long hair is braided to be manageable. Narrow eyes suggest cunning.

COSTUME

Think about the outdoor life the Ranger copes with: wet weather, high winds, cold, and heat. Several light clothing layers seem most practical. Robes to hide her body, and a scarf or hooded cape that obscures her face would be appropriate as it helps support her secretive personality. Flowing material suggests grace and femininity.

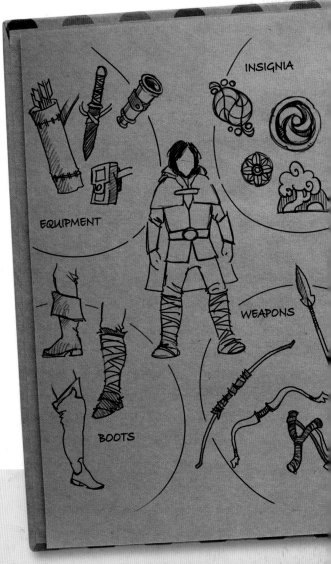

INSIGNIA

EQUIPMENT

WEAPONS

BOOTS

WORKING UP DETAILS

- **Equipment:** Think about items that the Ranger might use: a hunting knife, telescope, or tinderbox.

- **Weapons:** This is a stealthy character; she would favor a long-range weapon.

- **Boots:** Long legs are a subtle way to demonstrate the Ranger's gender and suggest that she possesses a long stride, suitable for a traveler. Emphasize this with tall boots, or wrappings extending to or beyond the knee.

- **Insignia:** Natural objects such as leaves or flowers might be incorporated into the Ranger's costume. You may choose to invent your own symbols, perhaps representing the wind or sun. Even simple insignia can add depth and interest.

CONSTRUCTION AND DRAWING GUIDE
RANGER

Stealth and agility suggest a slim, athletic body. A dynamic pose emphasizes strength and confidence.

CONSTRUCTION

This character has potential "problem hair." Here, the shaggy fringe of the Ranger's hair falls into her face, obscuring one eye.

If a character's hair causes you real difficulty, use the cage to construct a bald head. You can then be absolutely sure that all the features are correctly located before adding hair. This is particularly useful in cases such as this, where parts of the face are hidden beneath hair.

SIDE VIEW FRONT VIEW

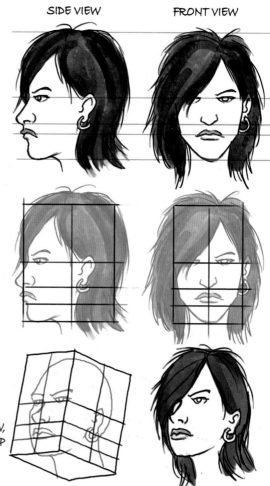

THREE-QUARTER VIEW,
LOOKING UP

pose

There are many options when posing such an interesting character. You could choose to demonstrate the Ranger's strength and weapon skill by showing her with a drawn bow. She could be crouched on the floor examining animal tracks, showing off her hunting skills and affinity with nature. However, these poses favor just one of her skills; a stance anticipating action is more interesting. The stable placement of her feet indicates strength, her head is turned away from the body's center line, suggesting that she is surveying her surroundings and, despite the arrow being taken from the quiver—which implies some imminent peril—the face shows that she is calm and collected.

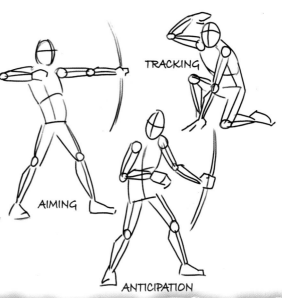

TRACKING

AIMING

ANTICIPATION

ARTIST'S TIP: value

Value is of far greater importance than color in your artwork. It refers to the relative brightness of a tone. White is the highest value, black the lowest, with grays occupying the scale between. These examples demonstrate the importance of value. Notice how the placement of light and shadow—and therefore the impression of form and differing surface properties—is controlled entirely by the values in your work.

SEE ALSO
Value, page **42**

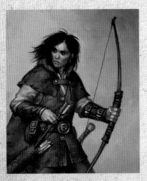

Original image with value and color included.

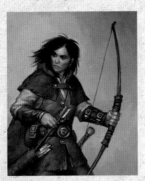

Shown in its original form, with color removed leaving only value.

Shown with value removed to demonstrate color alone.

PALADIN

A soldier driven by his religious beliefs: the holy warrior.

COPY THIS ▶

Beginner artists start here:

Trace this or scan it into your computer and color it.

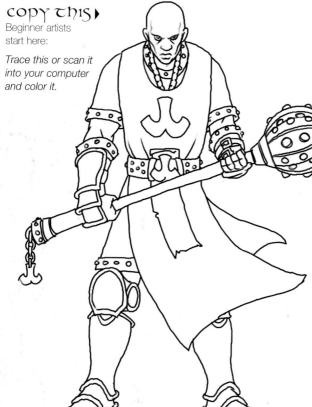

PERSONALITY

Pious, disciplined, compassionate

The Paladin shows how color and shape can influence the viewer's perception of a character. First impressions are important in character design, so it is imperative that you understand how you can direct your viewer to perceive your character the way you intend. Although he is a warrior, the viewer should be able to tell that this is a good character.

DESIGN CHOICES

Placing the Paladin centrally in the frame, facing the viewer in an almost symmetrical pose, gives the character significance and stability. This, combined with his determined and serious expression, shows off the Paladin's personality.

SEE ALSO

Composition, page **39**
Constructing the figure, page **56**

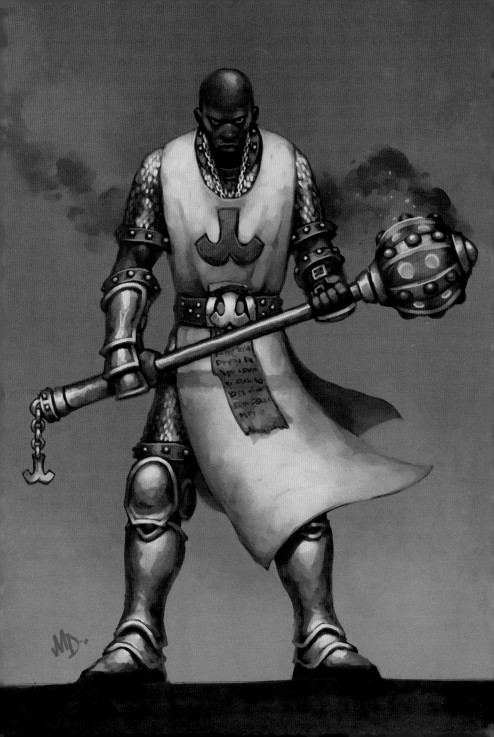

DEVELOPING CONCEPTS
PALADIN

Good characters do not have to be soft and fluffy. The Paladin seeks to battle the unjust and forces them to see the error of their ways. For the design to be convincing, he must look like an effective warrior.

FACE

The Paladin is motivated by blind faith. He knows his purpose is just and his demeanor should reflect this. Imagine how that could be manifested, especially in the character's face. He draws his strength from within, so there is no absolute requirement for aggressive features—a kindly face could be appropriate.

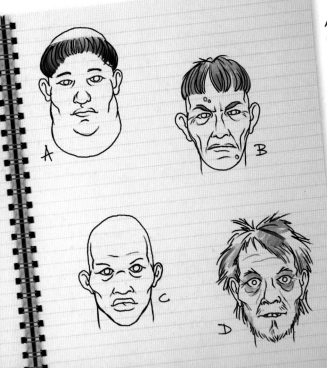

A: Referencing stereotypes can be useful. Here, the distinctive hairstyle and chubby face call to mind a medieval Friar.

B: An older face. The expression is twisted, perhaps with disdain at the decadence he sees around him.

C: Strong bone structure and a thick neck suggest a powerful character, but the rounded features show the Paladin's softer side.

D: The wild eyes and unkempt hair tell us that this character's mind has been affected by his faith—or perhaps by too much holy incense!

WORKING UP DETAILS

● **Icons:** The holy warrior wears the badge of his faith with pride. Gently rounded shapes suggest an alignment to good. Simple iconography will be most effective and can be incorporated into the costume in different ways.

● **Artifacts:** What might the Paladin carry to maintain his spirit in battle? Holy books, a prayer scroll, or perhaps holy water could be used as weapons against his foes.

● **Weapons:** Consider references you can make to familiar religious objects: the incense censer or Bishop's crook, for example.

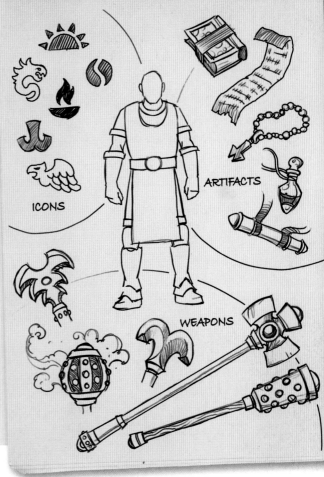

ICONS

ARTIFACTS

WEAPONS

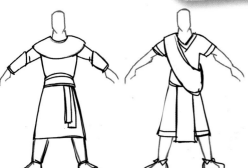

COSTUME

Consider modern and historical religious dress when designing the Paladin's costume. Referencing shapes or garments that could be associated with religion is a good way to tell your character's story. The Paladin may wear armor beneath his robes, or fight in simple vestments, protected only by his faith.

CONSTRUCTION AND DRAWING GUIDE
PALADIN

A broad, solid frame will show not only the Paladin's physical capabilities in combat, but also the confidence he feels from the holy fire burning within him. A powerful body gives him presence.

CONSTRUCTION

Hairstyle can create problems for the artist when attempting to construct a character's head, but a bald scalp can be just as challenging.

Note that the cranium is not simply a dome. The eye line (**A**) indicates where the upward arc of the head begins at the back of the skull. At the back and sides, the cranium rises almost vertically along the outer walls of the construction cage before curving toward the center in the upper quarter of the cage.

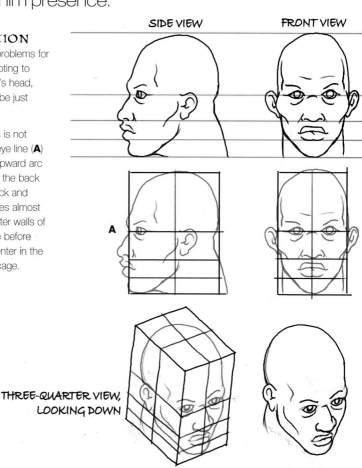

SIDE VIEW

FRONT VIEW

A

THREE-QUARTER VIEW, LOOKING DOWN

pose

Notice how the light-gold color of the Paladin's tabard, and the use of rounded shapes throughout the design, give the impression that he is a good character. The viewer will form this opinion about the Paladin before the eye is drawn to the grim face and heavily armored frame.

The pose could reinforce the Paladin's good nature by showing him in prayer or a less aggressive stance. However it is not necessary, if color and shape are employed effectively, to tell us about the character. This gives you the freedom to draw your Paladin in a threatening pose, showing that he is a fearsome adversary.

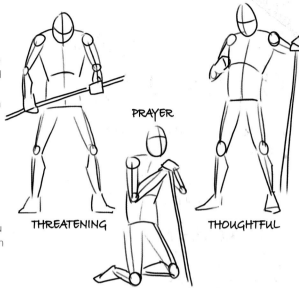

PRAYER

THREATENING

THOUGHTFUL

ARTIST'S TIP: Shadow

Understanding shadow is essential to creating believable lighting in your artwork.

Shadow is the absence of direct illumination, but that does not mean that a shadowed area contains no light. Any environment containing light will have a degree of ambient illumination, and it is this that determines the color and value of a shadow.

Direction of light source

Ambient light

There is no direct light falling on this object. It is illuminated purely by ambient light. Because ambient light is extremely diffused, there is little indication of form.

Direct light

Direct light falls on this object. The form is clearly described in the illuminated area. Note that shadowed areas are still quite flat—areas untouched by the direct light are unchanged.

Incorrect

Correct

Overlapping shadows

Shadows are simply the absence of direct light, so they will not deepen where they overlap.

ENCHANTRESS

Mistress of the black arts—the cold-hearted Enchantress.

COPY THIS ▶

Beginner artists start here:

Trace this or scan it into your computer and color it.

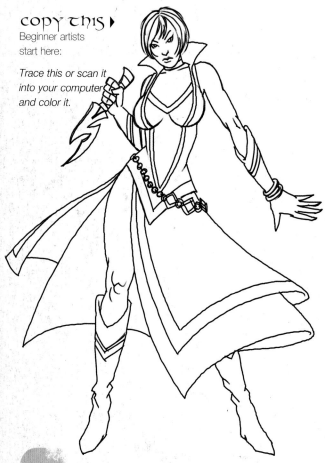

PERSONALITY

Cruel, vain, arrogant

The Enchantress provides us with another chance to explore the importance of color and shape when communicating your character's personality. She is the archetypal villain, using her skills in the black arts for her own evil ends. Clever design will make this character's personality obvious from the moment the viewer lays eyes on her.

DESIGN CHOICES

The dark colors and angular shapes of the costume are designed to show that this is a character with evil intent. Angles recur in the shape of her knife, hair, and subtly in her facial features, to further this impression and give rhythm to the design. A swirl of magical energy demonstrates dark power.

SEE ALSO

Gallery, page **12**
Rendering, page **46**

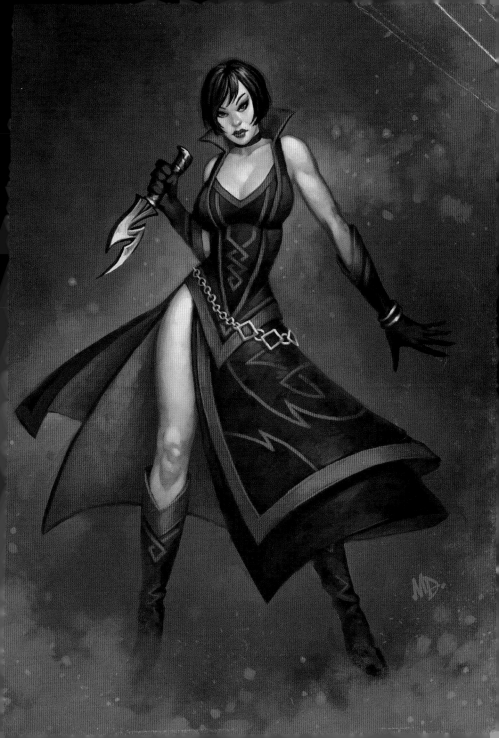

DEVELOPING CONCEPTS
ENCHANTRESS

The Enchantress is a potent character, infused with black magic. She should look strong and intimidating, yet she must also display femininity; favor dark colors and sharp, angular shapes in the design to achieve this.

FACE

Cold and cruel, the Enchantress's face should not display compassion or sentiment. Vanity is a defining trait of the Enchantress, reflected in elaborate makeup, jewelry, and hairstyles. Consider what motivates her vanity—perhaps she longs for beauty she will never have. By exploring your character's mental state and motivations, an insight into their behavior can be gained, which can then suggest useful design choices.

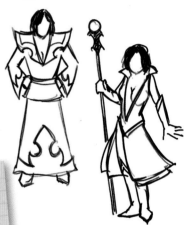

A: Features are soft and feminine, although the hairstyle is stark and the mouth has a natural curl, suggesting disgust at all she looks upon.

B: An elaborate tattoo partially covers her head. Obscuring the face like this gives the character a mysterious air.

C: The feminine face is balanced with sharp, spiky hair.

D: Exotic piercings. Maybe this body modification is part of a dark ritual.

COSTUME

Robes are usually associated with characters possessing magical powers. This makes them an obvious choice for the Enchantress's costume. Make sure her form does not disappear beneath waves of fabric, although the design should support the angular theme. Angles can be introduced in details such as collars or cuffs, or in patterns applied to the garments, or in the silhouette of the outfit where layers overlap.

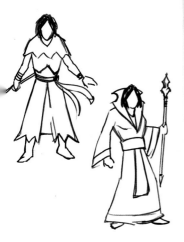

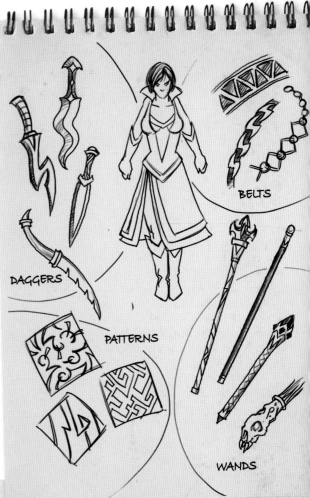

BELTS

DAGGERS

PATTERNS

WANDS

WORKING UP DETAILS

- **Patterns:** Imagine mystical patterns or evil runes that add detail to the costume.

- **Belts:** Even small details should support the theme of sharp, angular shapes.

- **Daggers:** Cruelly curved or angled blades support the overall theme. These instruments may not be practical for combat, but this does not concern the Enchantress; she relies on her magical powers in battle!

- **Wands:** Examine ways that a wand might reflect a character's personality. Vanity might motivate her to have a wand with patterns matching her outfit, or with a finial polished to a mirror-finish so she can check her appearance!

CONSTRUCTION AND DRAWING GUIDE
ENCHANTRESS

The Enchantress should be slim. Curves can be exaggerated at the hips and bosom, as these are defining areas of the female form and will help reinforce her gender. Elsewhere, her slender limbs can help support the spiky nature of the overall design.

CONSTRUCTION

Hair wraps around the Enchantress's face. This is a great device to accentuate the lines of a character's head—here the hair falls in an arc sympathetic to both the shape of the cranium and the jawline. Choosing dark hair to fall against pale flesh is another way to introduce spiky shapes to the design.

All aspects of the Enchantress are designed to be sharp and spiky, from the pointed curl of her hair to the flow and overlap of her skirts. The only exception is where the female body requires rounded forms, but even these isolated curves serve the design by firmly establishing femininity and providing a contrast which further emphasizes the angles elsewhere. Black is an obvious choice for an evil character, contrasted against pale flesh for extra impact and complemented with details in deep red—a color instinctively associated with warnings and danger.

SIDE VIEW FRONT VIEW

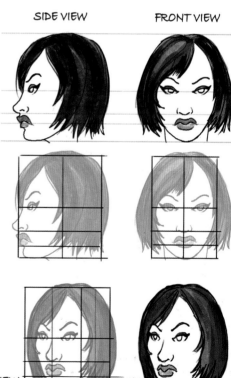

THREE-QUARTER VIEW

pose

Through her arrogance and vanity, the Enchantress is confident that she has nothing to fear from any opponent. She stands provocatively with her weight resting on one hip, dagger raised ready to strike, as she gazes into her opponent's eyes, perhaps already weaving a wicked spell.

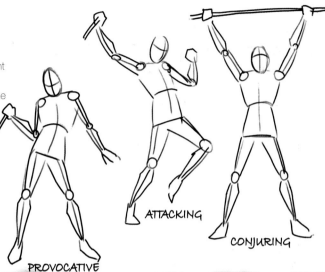

ATTACKING

CONJURING

PROVOCATIVE

ARTIST'S TIP: MAGICAL EFFECTS

Magic might manifest in any way the artist can imagine. It's a great opportunity to be creative and to add drama and interest to your work. It can also be a useful tool in the picture-making process, adding atmosphere or helping to control the focus or composition of a piece.

SEE ALSO
Composition, page **39**

Magical vapor
Abstract shapes can be created using unusual materials. Dab a sponge in paint and apply to your artwork, building up layers of color. Digital artists use black ink on white paper and scan to create custom brushes.

Electrical energy
Abstract shapes can be refined by hand to add definition. Add arcs of electrical energy, sparks, or even arcane symbols for interesting effects.

Ice-bolt spell
Magical effects need not be vaporous. If a specific kind of spell is being cast, imagine how that might influence the color or shape of the effect. This example shows how an ice-bolt spell might appear.

Paint spatter
A large paint spatter creates clouds of particles and its fine spray creates a glow. Use an airbrush, or a toothbrush dipped in paint and flicked, for a controlled effect. Digital artists use techniques such as these to create custom brushes.

WARRIOR

Tough, determined swordsman; a mainstay of fantasy worlds.

COPY THIS ▶

Beginner artists
start here:

*Trace this or scan it
into your computer
and color it.*

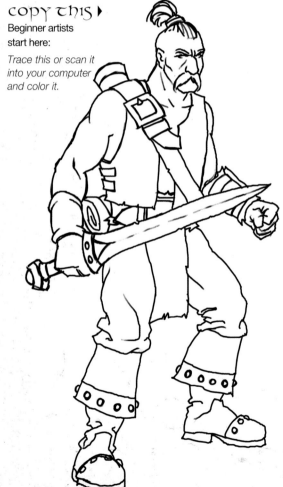

PERSONALITY

Brave, resolute, strong, capable

Most fantasy tales feature a Warrior character. He can be hero, villain, guard, or henchman. Warriors are adventurers questing for gold in dark dungeons, who then spend their treasure in firelit taverns. Such a familiar, varied personality can present the artist with many problems, not least the challenge of turning such a well-known character into something interesting.

DESIGN CHOICES

Determination and confidence are key elements of the Warrior's personality, and these are clearly shown in the pose and expression of this character. Accent colors are used to draw attention to key areas of the image—the gold sword hilt subtly suggests the significance of the weapon to this character, while bright red hair focuses the viewer on the Warrior's grim expression.

SEE ALSO
Visual language, page **34**
Rendering, page **46**

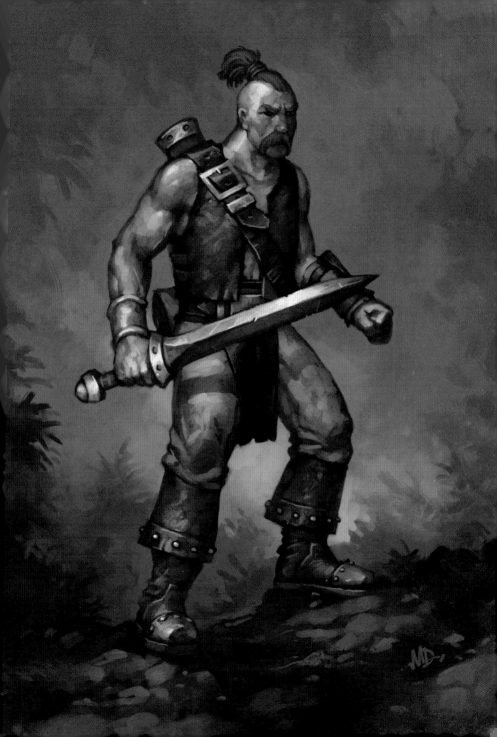

DEVELOPING CONCEPTS
WARRIOR

First and foremost, this character is a fighter. The notion that the Warrior lives and dies by his sword will feed the creative process.

FACE

This man has faced many perils, and met many foes. His face should reflect the grim, determined personality that carries him through his adventures. Consider the practicalities of the character's existence when choosing facial features—long flowing hair is inconvenient, so explore shorter hairstyles. Journeying in the wilderness means he will not often shave, so perhaps the Warrior would favor facial hair? Even the most capable fighter will receive wounds; perhaps this could be shown with a broken nose, or a few scars?

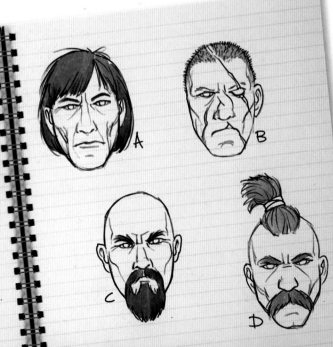

A: This face is prematurely aged and weathered from years of adventure.

B: Traces of battle are shown here. One ear is missing completely!

C: Bushy eyebrows and a long goatee beard give this face aggression and intensity.

D: A traditionally military moustache suits a combative character. The topknot adds an interesting element to the head, while remaining practical.

WORKING UP DETAILS

- **Topknot:** As the only flamboyant design element, look at ways to make the best of this eye-catching feature.

- **Equipment:** Light equipment best suits the Warrior lifestyle. Consider including items useful for survival in the wild—a blanket, bed-roll, wineskin, or knife.

- **Bracers:** Consider practical details that could be added to the simple armor: studs to help deflect blows, or a tribal engraving.

- **Swords:** A simple, realistically-proportioned sword gives the Warrior more authenticity than an elaborate fantasy weapon. Add notches and tarnish-marks to the blade, along with other signs of frequent use, to show that this guy means business. Swords should always be accompanied by a scabbard or baldric.

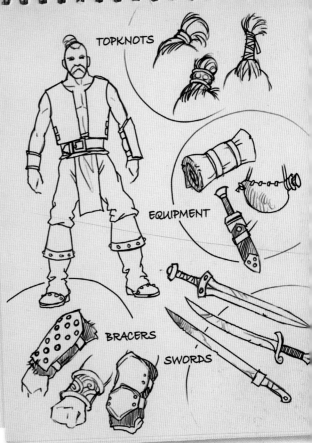

TOPKNOTS

EQUIPMENT

BRACERS

SWORDS

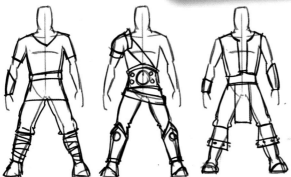

COSTUME

When designing the costume, think about the basic shapes of the clothing and how they work against each other. To explore this, sketch a simple mannequin, then block in the costume on top. Once again, consider practicalities: heavy armor will restrict movement when fighting; capes and robes can tangle. A Warrior favors robust, comfortable clothing with light armor.

CONSTRUCTION AND DRAWING GUIDE

WARRIOR

Huge muscles are not necessary for a Warrior. A heavy, weight-trainer's body is cumbersome; a broad-shouldered human frame will provide the ideal combination of strength and agility.

EXPRESSION

Thick, arched eyebrows and a heavy brow give the Warrior a fierce expression, even with a relaxed face. His mouth is hidden, but the downward arc of his moustache provides a grim demeanor, demonstrating how a suitable expression can be "built in" to a well-designed character.

CONSTRUCTION

In the front view, eye (**A**) and nose (**B**) lines contain the ears. A line drawn from the intersection of the eye and center lines (**C**) to the bottom corners of the cage locates the limits of the nostrils and moustache. Two vertical lines, drawn from the innermost point of the eyes, define the width of nose, chin, and hair.

In the side view, a second eye line intersects with the cage bottom to show where the jaw's lowest point rises to connect with the head. Where the nose line (**B**) intersects the side center line (**D**), the jaw's angle can be defined with a line drawn from the lowest point to where the nose line (**B**) meets the cage's rear.

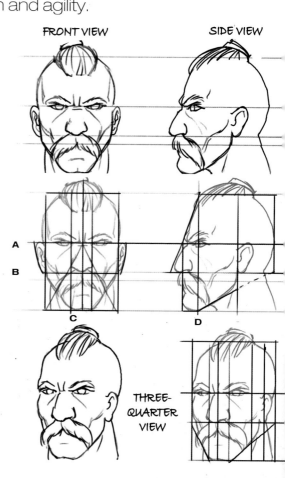

FRONT VIEW

SIDE VIEW

A

B

C

D

THREE-QUARTER VIEW

pose

The Warrior can take on many poses. Dramatic poses have impact, but showing your character's complexity can be more interesting. A fierce expression and battle-worn costume show the Warrior's toughness, no matter how he is posed. A slightly crouching body, as if preparing to pounce, suggests he is thinking; a man who fights with cunning as well as a blade.

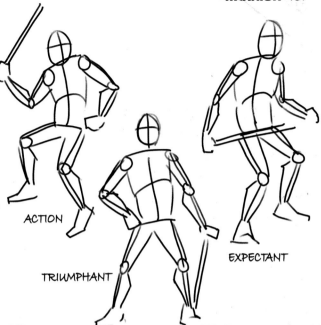

ACTION

TRIUMPHANT

EXPECTANT

ARTIST'S TIP: ACCENT COLOR

Color can be used to draw the viewer's eye. Adding a unique color to an image creates a point of interest, and is a useful tool to help control the focus.

Both versions of the Warrior character are rendered in hues of neutral browns and greens, with a bright highlight falling on the blade of his sword. This highlight is the main focus of the piece in both examples, but notice how the Warrior's red hair draws in the viewer's eye.

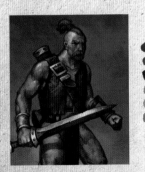

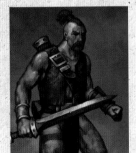

◄ Accent color

The addition of red hair as an accent color adds interest to the head, pulling it out of the background and balancing the focal points of the piece more effectively.

▲ **No accent color**

The character's head begins to merge with the background.

SEE ALSO
Color, page **44**

COMMONER

A supporting player in tales of fantasy.

COPY THIS ▶

Beginner artists start here:

Trace this or scan it into your computer and color it.

PERSONALITY

Meek, unassuming, quiet

Fantasy art demands that its principal characters are dynamic, imaginative, and engaging. But what of the incidental figures who occur in a scene or story? A lively, convincing fantasy world is populated by all manner of characters quite apart from the warriors, magic-users, adventurers, and monsters. Designing these ordinary folk requires just as much skill and invention as designing a Hero.

DESIGN CHOICES

A full-length robe was chosen to simplify the character's form. Details are placed only where important: at the neck, wrists, and waist. Muted, earthy colors help this Commoner to blend into his surroundings.

SEE ALSO

Rendering, page **46**

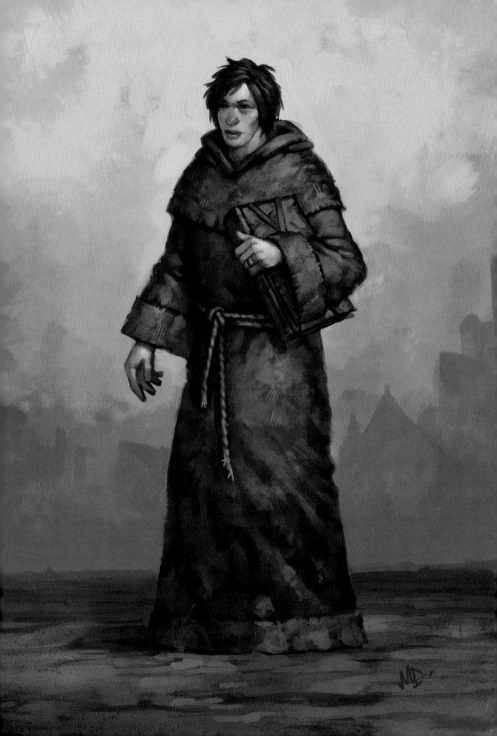

DEVELOPING CONCEPTS
COMMONER

You must measure the Commoner's design against the characters he will play against—the aim is to create a figure that will not detract attention from the main players.

FACE

Simple faces work best. Exotic features, unusual proportions, or wild skin colors distract the eye, pulling attention away from the main character. Work within normal human proportions and add interest through natural means.

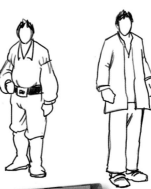

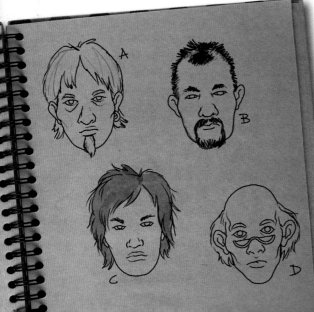

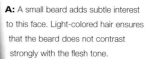

A: A small beard adds subtle interest to this face. Light-colored hair ensures that the beard does not contrast strongly with the flesh tone.

B: Beard and hair are trimmed short; long hair and beards are an uncommon sight in the real world and automatically attract the viewer's eye.

C: The eye is drawn to interesting shapes. Untidy hair falls over the ears and around the face, softening and simplifying this character's silhouette.

D: Old age adds a natural interest to the face.

BODY CONCEPTS

When thinking about the Commoner's body, stay within the boundaries of normality. Extremes in height or weight will catch the viewer's attention. Consider the body type in relation to the main characters—heroic figures should appear taller and more dynamic than those around them.

COSTUME

Keep costumes simple. Sketch thumbnails to see how different clothing affects the Commoner's appearance. Pay particular attention to the silhouette—this should be as simple as possible. Imagine an occupation or activity for your character; doing so will help suggest ideas when detailing the design.

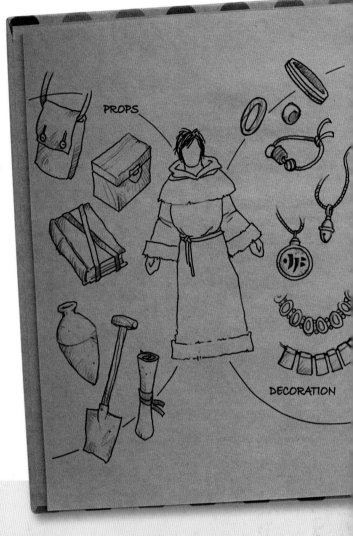

PROPS

DECORATION

WORKING UP DETAILS

- **Decoration:** Decoration should be simple. Jewels or bright metals will attract attention. Choose materials of a color and tone that will blend with costume or flesh. Do not worry that your detail will be lost—you are simply controlling the order in which elements of the scene are revealed.

- **Props:** Think about your character's occupation and what items they might carry. Although the design should be simple, choosing the right objects will add depth and interest to your character.

CONSTRUCTION AND DRAWING GUIDE
COMMONER

Unusual or striking proportions draw attention to a character. The Commoner should blend into the background of a scene, so avoid any surprising features. This character should be as unremarkable, as "normal," as possible.

CONSTRUCTION

Pay particular attention to the correct alignment and proportion of the Commoner's features. Errors here will be easily noticed. Take note of how the features align vertically—the space between the eyes is equal to the width of the nose and the corners of the mouth line up with the center of the eyes. When rendering, try to downplay the features in background characters such as this. By softening and rounding facial shapes you will reduce contrast, and send the viewer's eye to more dynamic, interesting areas of your artwork first.

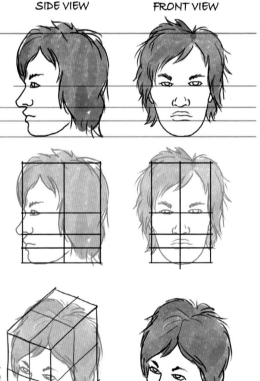

SIDE VIEW FRONT VIEW

THREE-QUARTER VIEW, LOOKING DOWN

pose

This is an ordinary character, so show him in an ordinary activity. Choosing simple poses with little movement will place the Commoner in the background. Perhaps show the character at rest enjoying a meal or a drink. Think about the Commoner's personality. Show that he is meek, with a cautious pose. The arm across the body shows that this character, consciously or otherwise, is defensive and feels the need for protection.

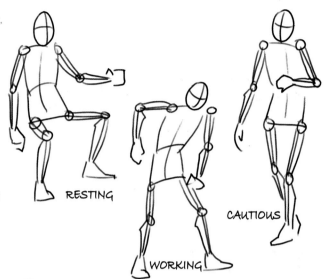

RESTING

WORKING

CAUTIOUS

ARTIST'S TIP: RENDERING FABRIC

Folds, creases, and tailoring can make fabric a very complicated surface. Keep details and texturing light so that the surface remains easy to read.

Direction of light source

1 Use a midtone to define the area to be rendered as fabric.

2 Choose a lighter tone and define the surface by blocking in illuminated areas. Allow the base color to show through to suggest texture.

3 Define shadows with a darker tone. Ensure that creases and folds are correctly modeled at this stage.

4 Fabric is a soft, flexible material. Soften the edges of the material to indicate this. Adding individual threads to the profile of the fabric will also help to establish texture.

5 Refine the surface with a highlight color. Keep highlights soft to reinforce the form. Break up the application of this color to further indicate the texture of the material.

6 To create the impression of a very coarse weave or old, weathered material, continue working into your fabric to add more texture. Don't try to define every thread—this will result in a broken surface.

SEE ALSO
Rendering, page **46**

ELF

Civilized, peaceful guardian of order.

COPY THIS ▼

Beginner artists start here:

Trace this or scan it into your computer and color it.

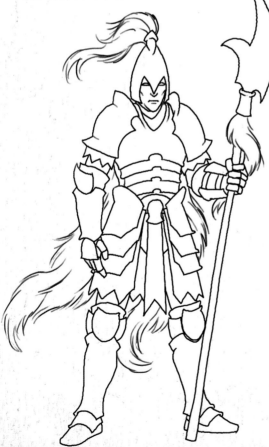

PERSONALITY

Intelligent, controlled, regal

Elves are intelligent and blessed with long life—two traits that have allowed them to develop a refined, peaceful culture far beyond any other. They are wise, kindly creatures, but they also maintain large armies to defend their way of life and to assist others whom they regard as righteous. The artist has to send a complicated mix of messages when designing this character.

DESIGN CHOICES

The elegant curve of the Elf's pointed ears provides the inspiration for this design. Although they are hidden beneath the soldier's helmet, their shape is suggested in the curves used in the armor plate, polearm, and plumes. This may not be obvious to the viewer, but if the artist consistently references a particular shape as the character is conceptualized, the final design will have a pleasing rhythm.

SEE ALSO

Constructing the figure, page **56**
Dark Elf, page **120**

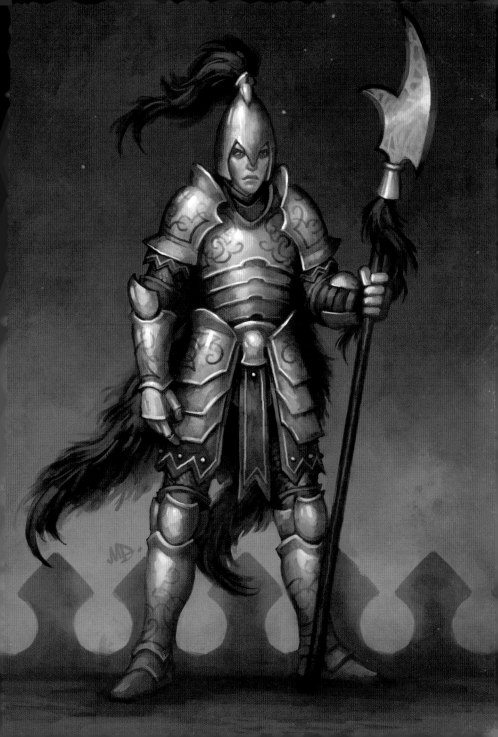

DEVELOPING CONCEPTS
ELF

Elves are tall, lean, and graceful. This demonstrates their refined nature but reveals nothing of their military prowess. Determination and strength of will must also be effectively communicated.

FACE

The Elf's distinguishing feature is pointed ears. When designing the face, use their distinctive shape as a starting point. Extreme departures from human proportions and features could make the face monstrous, so keep your adjustments subtle.

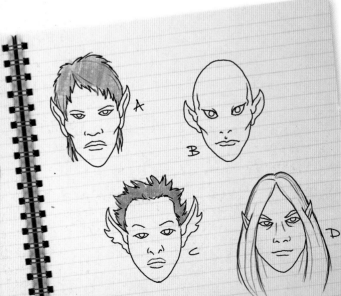

A: Eyes and chin are gently tapered, matching the pointed ears. The shape is referenced again in the feathered shapes of the hair.

B: A bald head and large eyes give this head a strange, ethereal quality.

C: The pointed ears of the Elf are iconic, but variations are possible for the creative artist. Here, multiple points were added.

D: Long, flowing hair will give the character grace. Ensure that the distinctive ears are still visible.

BODY CONCEPTS

Although typically several inches taller than an average human, the Elf's frame is lighter. The Elf's body has many similarities to a human adolescent: with narrow hips and shoulders, and long limbs; the strength and physical capabilities of the Elf must be shown using other means.

COSTUME

Costume tells us many things about a character. Armor shows not only that the Elf is prepared for battle, but that he has the physical strength to wear heavy equipment. Armor also bulks out the character's frame, and an elaborate, attractive design demonstrates the sophistication of Elf culture. Sketch thumbnails to explore your options. Concentrate on how the shapes interact with one another and the character's body underneath.

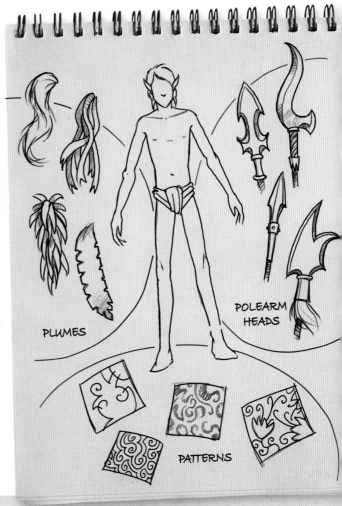

PLUMES

POLEARM HEADS

PATTERNS

WORKED UP DETAILS

- **Plumes:** Plumes, cloaks, and other flowing details add elegance to elaborate armor. Consider interesting materials: hair, feathers, ribbons, or a flag or banner.

- **Polearm:** The polearm's design should be elegant, but also substantial and practical; this is a deadly weapon, not an ornament.

- **Patterns:** Patterns add richness and refinement to the armor plate. Consider shapes that flow, or reference organic forms to hint at the character's ordered, kindly nature.

CONSTRUCTION AND DRAWING GUIDE
Elf

The Elf stands taller than the average human, at eight-and-a-half heads tall. A long and slender frame and face heighten the impression of grace and elegance.

CONSTRUCTION

Use the usual construction cage and divisions for the Elf. The further the design deviates from human proportions, the more difficult it will be for the audience to connect with your creation, and the harder your job becomes—especially when a character is required to present emotion or subtle expression.

Reserve extreme proportions or unusual placement of features for characters that you wish to appear monstrous or alien.

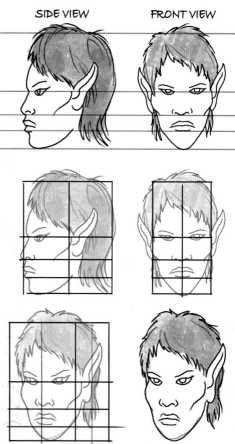

SIDE VIEW FRONT VIEW

THREE-QUARTER VIEW

pose

To help you think of poses, imagine the activities that your Elf warrior may perform. A static pose shows off the intricate design of the armor and suggests something of the controlled, deliberate nature of the character. Have the Elf costume's plumes lifted in the wind to add energy.

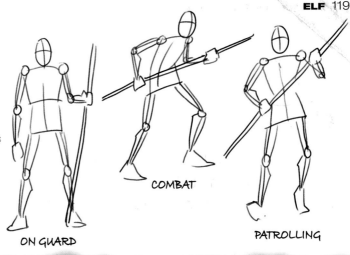

ON GUARD

COMBAT

PATROLLING

ARTIST'S TIP: specularity

When light hits a surface, some of it is reflected. If the surface is very smooth (glass, polished materials), the light is reflected in an orderly way, resulting in an obvious highlight or reflected image. A rough or textured surface (fabric, unfinished wood) causes the light to reflect more randomly, diluting the power of the reflected light and lessening the appearance of a highlight. Understanding this will help you to light your materials convincingly.

Specularity refers to the way a material reflects light. A surface with very low specular properties will not have an obviously visible highlight. A surface with high specularity will have a clearly defined, intense highlight. In practical terms, specularity relates to how shiny a material is.

Direction of light source

Matte
A completely matte (flat) surface. Though all surfaces have some specular quality, here the reflected light is too scattered to produce a visible highlight.

Diffuse
Here the highlight is very diffuse, producing a sheen across the surface of the material.

Bright
A strong highlight. Notice that the highlight becomes smaller (or "tightens") and becomes brighter as the specularity increases.

Intense
Maximum specularity. A completely smooth surface produces a tight, intense highlight.

DARK ELF

Although closely related to the Elves, the purple-skinned Dark Elf is a cruel, sinister creature.

PERSONALITY

Spiteful, superior, sadistic

The Dark Elf, or Drow, shares many physical qualities with her Elf cousin—both are tall and elegant, with delicate bone structure and pointed ears. However, their personalities could not be more different; the Dark Elf regards cruelty and greed as virtues.

DESIGN CHOICES

A dark color scheme and angular shapes give the distinct impression of a villainous character. Cool colors are also used in this painting, suggesting the cold nature of the Dark Elf. Her pose is upright—aloof and arrogant. Her snow-white hair contrasts well with the darker tones of her flesh and costume.

COPY THIS ▶

Beginner artists start here:

Trace this or scan it into your computer and color it.

SEE ALSO

Elf, page **114**
Color, page **44**

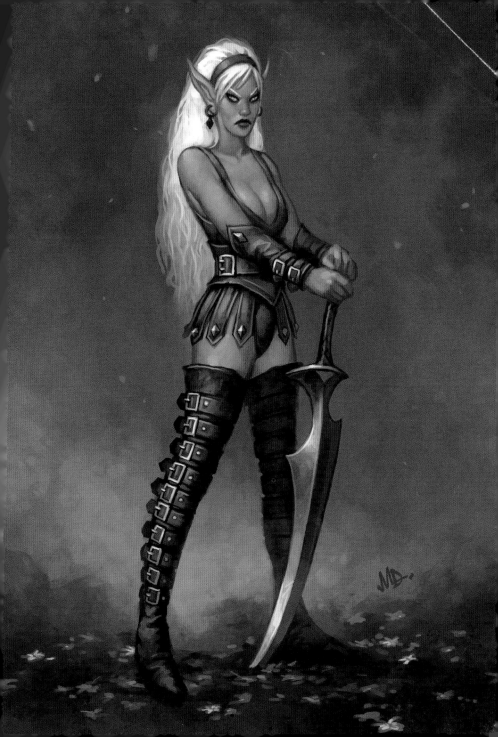

DEVELOPING CONCEPTS
DARK ELF

Referring to similarities with Elves is important. Look at how color and shape can be used to modify an Elf to project the sinister, forbidding atmosphere that surrounds the Dark Elf.

FACE

As a starting point, refer to your Elf design. The Drow must share similarities with this character. Key features are the shape of the face, pointed ears, and the narrow, pinched shape of the eyes. There is plenty of scope to alter the eyes and ears, but any dramatic change in the basic shape of the face will break the connection with the Dark Elf's relative.

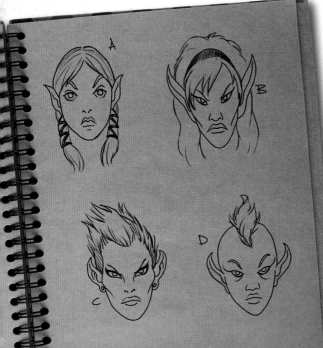

A: The small, downturned mouth and high-arching eyebrows give this face a haughty expression, fitting the Drow's personality.

B: This face uses the same basic shapes as the Elf, but the features are exaggerated for a striking, almost alien appearance.

C: Low eyebrows and the heavy, upward curling eyelashes suggest anger. The short, spiky hairstyle emphasizes this further.

D: A partially-shaved head draws attention to the dramatic curl of this Dark Elf's ears.

COSTUME

Consider costumes hinting at the Drow's unpleasant persona. Dark colors and sharp, pointed shapes will help to achieve this. The Dark Elf has a sadistic nature—fetish outfits may provide inspiration for a costume that highlights this aspect.

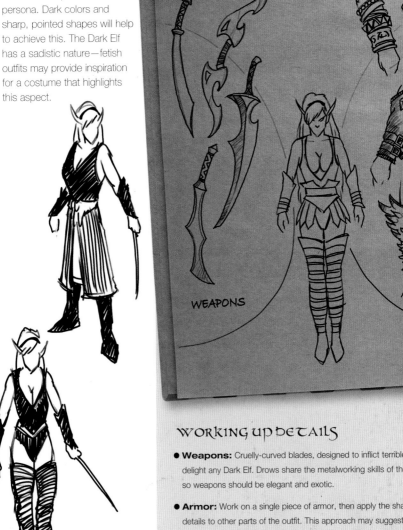

WEAPONS

ARMOR

WORKING UP DETAILS

- **Weapons:** Cruelly-curved blades, designed to inflict terrible pain, delight any Dark Elf. Drows share the metalworking skills of the Elves, so weapons should be elegant and exotic.

- **Armor:** Work on a single piece of armor, then apply the shapes and details to other parts of the outfit. This approach may suggest ideas that would not otherwise occur if tackling the costume as a whole.

CONSTRUCTION AND DRAWING GUIDE
DARK ELF

The Drow shares the Elf's body and facial proportions. Any major adjustments to weight or muscle tone will be inappropriate. Thin down the Dark Elf's frame, making her as angular as possible. This is a slight alteration, but subtle changes can have great cumulative effects.

CONSTRUCTION

Despite her severe otherworldly appearance, the location of the Dark Elf's features still fit basic human measurements—eyes, nose, and mouth are aligned along lines **A**, **B**, and **C**. Notice, however, in the front view of her head, that her face is much narrower than a human's, and that her long ears extend to the upper limit of the construction cage.

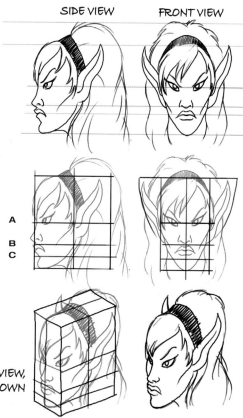

SIDE VIEW FRONT VIEW

A
B
C

THREE-QUARTER VIEW,
LOOKING DOWN

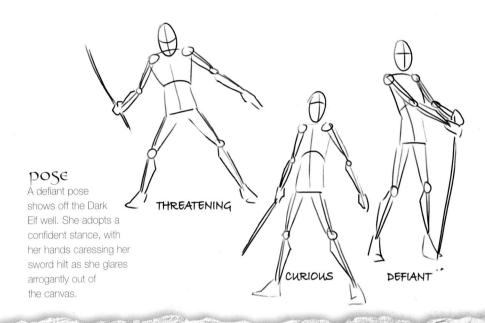

pose

A defiant pose shows off the Dark Elf well. She adopts a confident stance, with her hands caressing her sword hilt as she glares arrogantly out of the canvas.

THREATENING

CURIOUS

DEFIANT

ARTIST'S TIP: WEAPON RENDERING

Hard surfaces should look rigid and solid. In fantasy art, this is never more important than in the treatment of weapons. Armaments are a frequent focal point in fantasy art and, if held, are an extension of your character. Your creation will be weakened if he or she wields an unconvincing weapon.

A useful approach to help keep weapons regular is simply to draw the object carefully aligned horizontally or vertically. This makes it far easier to keep measurements and proportions accurate. If working traditionally, this drawing can be rotated into the correct position to be traced or used as a stencil. If you use a digital painting program, the drawing can be manipulated on a separate layer, changing the rotation or adding perspective to act as a guide.

When rendering, keep the edges of blades hard and well-defined. Compare the example renderings to see what a huge difference soft edges and even slightly irregular or misaligned lines can make.

SEE ALSO
Rendering, page **46**

DWARF

Dwarves are great miners, making their homes in majestic cities carved from solid rock.

COPY THIS ▶

Beginner artists
start here:

*Trace this or scan it
into your computer
and color it.*

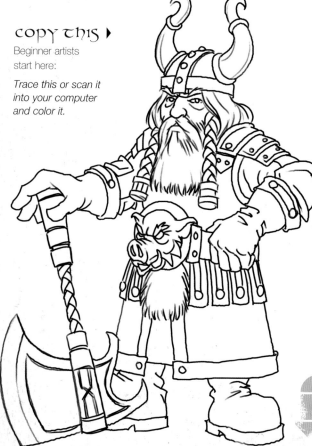

PERSONALITY

Proud, hardy, skilful

Although the bearded Dwarf only reaches four feet tall, he is full of strength, determination and, above all, is proud of his race and culture. You cannot simply draw a small human; this character must show power and personality far beyond his limited height.

DESIGN CHOICES

Heavy armor gives extra weight and presence to the Dwarf's already stocky frame. Details are added to the costume to suggest Dwarfish skill with metalwork. Pose and expression are chosen to affirm the proud, independent nature of the character.

SEE ALSO

Proportions of the body, page **52**
Relative proportions, page **54**

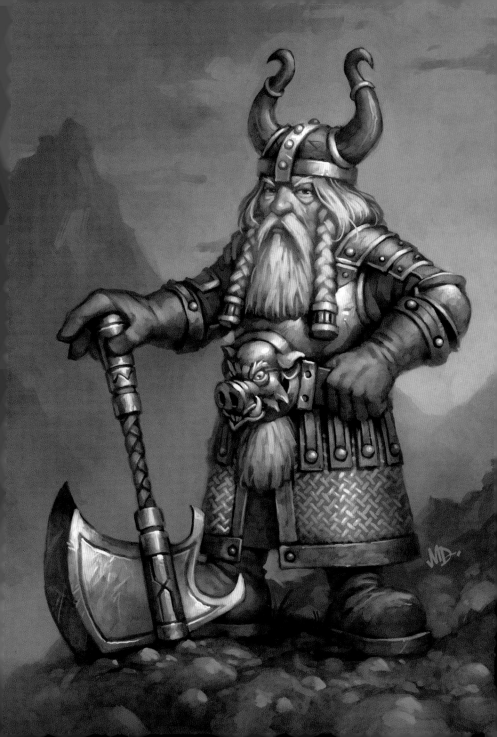

DEVELOPING CONCEPTS
DWARF

The Dwarfish talent for mining extends beyond moving earth and carving rock. Dwarves are masterful jewelers and metalworkers. This should feature in the design.

FACE

A Dwarf's thick, flowing hair and beard are his most recognizable features, and his pride and joy. To show the Dwarf's hardy nature, his face should look rugged and healthy.

A: Here the hair and beard are trimmed, revealing ears hung heavy with Dwarfish jewelry.

B: Although this Dwarf is partially bald, hair grows vigorously elsewhere.

C: A long, bushy beard is trimmed square at the end, with wavy hair gathered into thick, steel-tipped braids on either side.

D: An impressive handlebar moustache is the centerpiece for this Dwarf's elaborately-bound locks.

COSTUME

Think about Dwarfish society and your character's role. A miner or smith would wear tough, practical clothing, but he would need freedom of movement. A guard would be heavily armored, with a costume designed to intimidate. Merchants or noblemen would wear rich garments, showing off Dwarfish skill with jewels and precious metals.

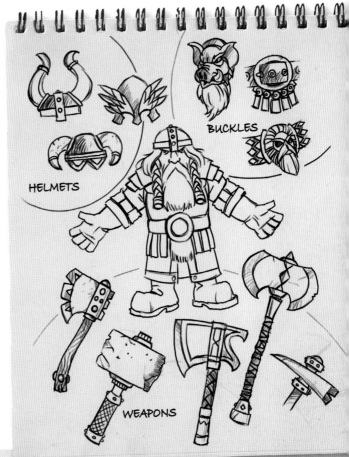

HELMETS

BUCKLES

WEAPONS

WORKING UP DETAILS

- **Helmets:** Helmets can serve two purposes: to protect or to impress. Large horns or ornaments increase the Dwarf's perceived height to intimidate enemies.

- **Buckles:** A belt buckle is a good, centrally placed feature with which to display Dwarfish metalworking skills. The design could be functional, aggressive, or opulent, depending on your Dwarf's role.

- **Weapons:** Axes are traditionally associated with Dwarfs. A broad blade and thick, short haft share similarities with the Dwarf's shape. A pickaxe or hammer would make good alternatives, referencing the mining culture.

CONSTRUCTION AND DRAWING GUIDE

DWARF

Dwarfs, Halflings, and Gnomes all belong to a category of fantasy characters sometimes referred to as "little folk." All the creatures in this group have features that conform to human standards, but the proportions of their bodies are very different.

CONSTRUCTION

The Dwarf's head, hands, and feet are human-sized. His body shares the same girth as a human; shoulders, hips, and limbs are the same width in both races. The only differences are height and proportion: the Dwarf's waist is in the middle, and his arms reach to his knees. This makes the Dwarf's body much broader compared to a human, giving him a strong, robust appearance.

The Dwarf's head is the same size and uses the same measurements as the human head. A quick sketch helps to locate key points on the body and to establish basic proportions. Standing four heads tall, the waist is central, with the knees halfway between this point and the ground.

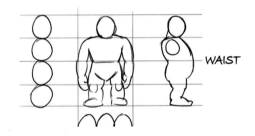

WAIST

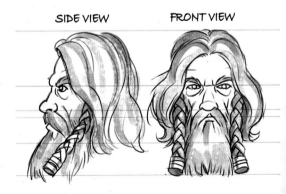

SIDE VIEW FRONT VIEW

pose

An action pose could show the Dwarf in the heat of battle or in the heat of a forge. A seated pose might suit an older Dwarf or a miner taking a break from his toil. A quiet, dignified pose effectively projects the air of pride your dwarf should display.

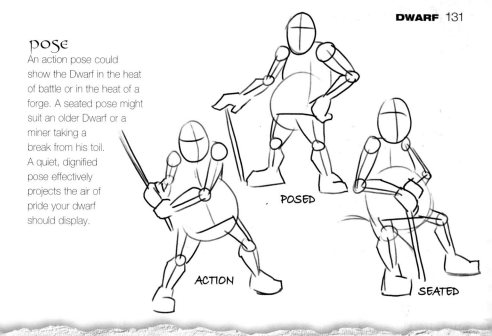

POSED

ACTION

SEATED

ARTIST'S TIP: RENDERING POLISHED METAL

Metal is used extensively in the worlds of fantasy. It appears in many forms, though the basic rendering principles apply in all cases.

Direction of light source

1 Place a mid-value base color to begin. Choose a color appropriate to the metal you wish to render. Here, a warm gray is chosen as the base for steel.

2 Using a darker tone, block in the shadow area to give the surface form. Add texture across the whole surface with a light wash of this tone.

3 Metal is a reflective surface. Consider the direction of your light source, but also the general color and intensity of light—in an outdoor scene you might select a hue tinted toward the sky color.

4 Add bounce light in shadowed areas where appropriate. This reinforces the reflective nature of the material and is a recognizable property of metallic surfaces.

5 Apply highlights. Highlights are a reflection of the light source and should be crisp and clearly visible on clean metal. At this stage, the simple metal surface is complete.

6 Add extra detail by reflecting objects from your scene. This will add to the impression of a hard, metallic surface. Be aware that strong reflections can break up the form of the object.

HALFLING

Also known as Hobbits, these small, furry-footed creatures live quiet, comfortable lives.

COPY THIS▼

Beginner artists start here:

Trace this or scan it into your computer and color it.

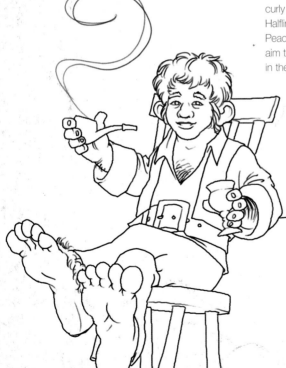

PERSONALITY

Content, friendly, homebody

Standing a mere four feet tall, the Halfling would have the superficial appearance of a human child, were it not for a pair of extremely large feet covered with thick, curly hair. The thick soles of the feet allow Halflings to go everywhere barefoot. Peaceful and relaxed by nature, you should aim to show happiness and contentment in their characters.

DESIGN CHOICES

Warm colors give this painting an inviting, friendly feel, in accordance with the personality of the Halfling. His expression is happy, and his interaction with the background elements—rocking his chair onto its back legs while resting his arm on nearby furniture—further hints at the Halfling's nature, suggesting contentment and relaxation.

SEE ALSO

Proportions of the body, page **52**
Relative proportions, page **54**

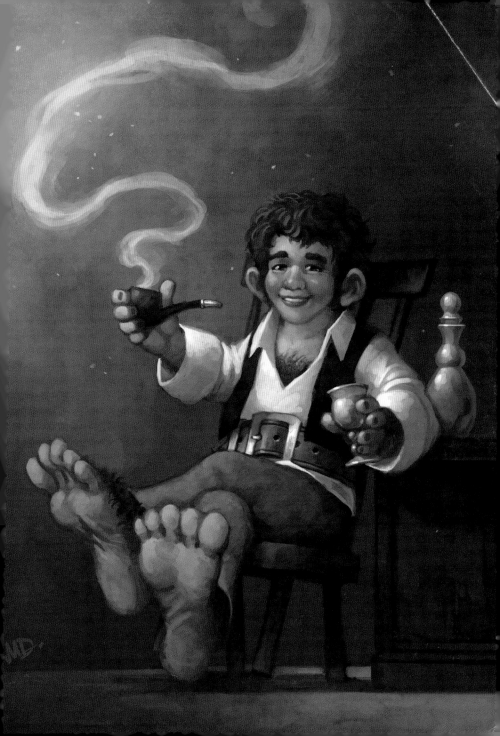

DEVELOPING CONCEPTS
HALFLING

Warm colors and soft lighting will create a cozy atmosphere in the final painting. Controlling the mood in this way means the character design does not have to work as hard to inform the viewer.

FACE

The Halfling shares more than stature with children—they have a similarly happy, carefree outlook on life. You can help your audience to make this connection by giving the Halfling's head childlike proportions. This is most easily achieved with a large cranium relative to the face. A tapering jawline and soft, rounded features will further accentuate the look.

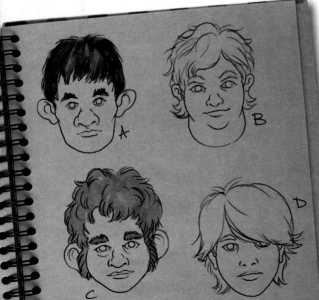

A: Childlike proportions are offset by the large ears and nose.

B: Too many breakfasts show in this face, with the jawline disappearing into a double chin!

C: Thick, curly hair exaggerates the large cranium, enhancing the childlike proportions. Large ears reinforce the tapering chin.

D: Hair falls across one eye, softening the face.

BODY CONCEPTS

The Halfling's deep fondness of food, drink, and long afternoon naps leads to a portly frame. However, as they are also active and enjoy spending time outside, they should not be fat.

COSTUME

Consider how your Halfling might occupy his time. Hobbits love nature; what gentle outdoor pursuits might suggest an interesting outfit? A long walk in the countryside might see your Halfling wrapped up in an overcoat, merrily swinging a walking stick. Well-worn gardening clothes would suit your Halfling as he tends a vegetable patch. Simple clothing might be your character's preference for relaxing around the home.

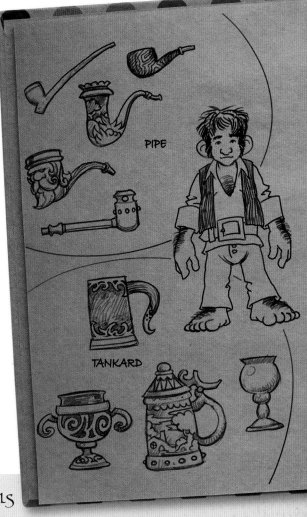

PIPE

TANKARD

WORKING UP DETAILS

● **Pipe:** When designing props for the Halfling, you have to decide whether to show the fondness for the activity with an elaborate prop, or choose a simple, homely design that might better reflect the Halfling's personality. The obvious choice may not always serve your character best.

● **Tankard:** A large drinking vessel clearly shows the character's appetite for drink and provides plenty of surface area for ornamentation. A small, plain goblet has a deeper message for your viewer—that the Halfling is more concerned about his cup's contents than its appearance.

CONSTRUCTION AND DRAWING GUIDE

HALFLING

A height of five-head-units accentuates the childlike stature of the Halfling, and you should try to emphasize this in your facial construction. Why not draw attention to his belly to suggest a love of food and drink?

CONSTRUCTION

At first, the proportions of the Halfling's head look extreme, but remember that very thick, curly hair is used to make the cranium look much bigger than it really is. The usual cage and measurements apply.

The Halfling shows very clearly how a single element of a character's design can dramatically influence the viewer's perception. Construct the Halfling without hair to see the difference this makes.

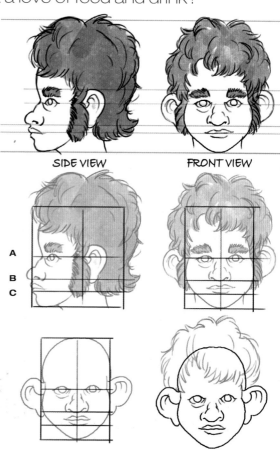

SIDE VIEW FRONT VIEW

A
B
C

POSE

With food and drink being an integral part of the Halfling's character, imagine related activities to find a suitable pose. Show your character carrying a heavily-laden tray; at first glance there appears to be enough food for three, but a glint in the Halfling's eye makes you wonder if it is all for him. Simple actions can be effective in communicating personality—there appears to be nothing unusual about pouring a drink from a large bottle, until you notice that the bottle will be emptied long before your Halfling's mug is filled! Showing your character relaxing in a reclining chair demonstrates his simple nature perfectly.

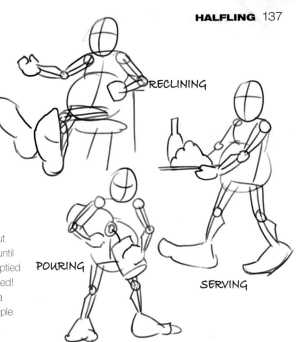

RECLINING

POURING

SERVING

ARTIST'S TIP: BROKEN COLOR

Flat surfaces need not have a flat color. "Broken color" is a technique where different hues are combined to give a more interesting appearance to a surface— adding texture, making the colors more vibrant, and giving the material more life. It is particularly effective on organic or heavily textured surfaces.

There are no rules when using broken color. Any additional color will add interest to the surface, so go ahead and experiment with your own combinations.

Broken color can be seen adding interest to the pants worn by the Halfling in the final artwork of this character.

Solid color
This example shows the pants before broken color is added.

Broken color
A warm orange is added to the green pants. The effect is subtle, but effectively adds depth of texture and color to the material.

SEE ALSO
Color, page **44**

GNOME

Clever little folk with a love of invention and technology.

PERSONALITY

Intelligent, skilled, peaceful

Gnomes have an understanding of engineering far beyond that of any other fantasy race. Their knowledge is used to fashion wonderful objects and awe-inspiring machines. This represents a different kind of fantasy "magic" and requires considered treatment.

DESIGN CHOICES

Focused lighting sets the atmosphere in this painting, suggesting a darkened, gloomy workshop. Practical clothing is contrasted against flamboyant elements to convey both the technical skill and the eccentricity of the character.

‹COPY THIS

Beginner artists start here: *Trace this or scan it into your computer and color it.*

SEE ALSO

Proportions of the body, page **52**
Relative proportions, page **54**

DEVELOPING CONCEPTS
GNOME

The practical nature of the Gnome needs to be emphasized in the character's design. Gnomes are a peaceful, insular race, and this lack of exposure to other cultures gives the Gnome a unique style.

FACE

Gnomes spend much of their time tinkering with machinery, studying, and researching to expand their knowledge. How might this lifestyle be represented in the face? Long periods in the dark or artificial light, exposure to strange chemicals or vapors, and long hours of toil could all manifest somehow.

A: A humanoid face with exaggerated features, particularly the nose. The wild hair hints at the archetypal "mad scientist," which suits the Gnome's behavior.

B: Egghead—an oversized cranium suggests a large brain. A solitary existence in dim light has left this creature pale and hairless, with underdeveloped features.

C: This design shows the negative effects of a life spent in the workshop. The nose is large to help deal with noxious fumes, and the eyes bulge from peering into the darkness.

BODY CONCEPTS

Gnomes stand about four feet
tall and are slightly built, with
short legs and long arms.
Hands are relatively large,
and should have slender,
well-formed fingers.

COSTUME

Inventing and tinkering are the
Gnome's only real interests,
and their outfits should reflect
this. Look at outfits worn in
real workshops for
inspiration—clothing should
be durable and contain
pockets for storing tools.
Perhaps safety should be
taken a step further; clothe
your Gnome in heavy armor
to protect him from explosive
experiments!

SAFETY
EQUIPMENT

TOOLS

EYEWEAR

WORKING UP
DETAILS

● **Eyewear:** Spectacles suggest
intelligence and provide different
options for adding detail: a
monocle, safety goggles, a
magnifying eyepiece—even a
simple pair of glasses perched
on the nose.

● **Tools:** Recognizable tools
such as a wrench or
screwdriver will
communicate your Gnome's
practicality quickly and
effectively. The purpose of
your own invented tools may
be misinterpreted.

● **Safety equipment:** This
will provide your Gnome with fun
props, and add authenticity.

CONSTRUCTION AND DRAWING GUIDE
GNOME

The Gnome shares basic proportions with the Halfling, though their bodies should be slender, heightening the impression of agility. Large hands make it easier for the artist to draw attention to long, dextrous fingers.

CONSTRUCTION

The Gnome's large nose requires lines on the construction cage to be drawn differently—lines should be drawn horizontally to contain the top (**A**) and bottom (**C**) quarters of the cage. These lines locate the eyes and mouth respectively. A third line (**B**), drawn just above line **C**, locates the base of the nose.

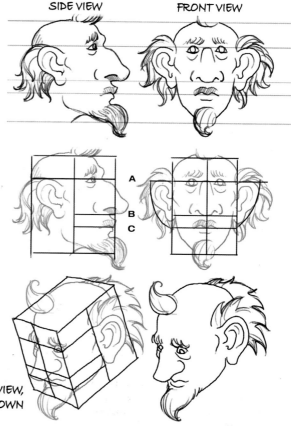

SIDE VIEW

FRONT VIEW

A
B
C

THREE-QUARTER VIEW,
LOOKING DOWN

pose

As their nature is to work intently for long hours, your Gnome should appear preoccupied with whatever task you choose to give him. Imagine a task, and think of the different actions that would be performed as the task is executed. For example, to fix a broken object, your Gnome might first study a plan, then proceed to make the repair, before finally observing the object to check his handiwork.

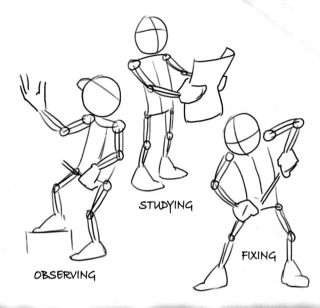

STUDYING

FIXING

OBSERVING

ARTIST'S TIP: RENDERING HAIR

Don't be tempted to render hair by drawing individual hairs. Such a concentration of detail is very distracting and difficult for the eye to decode. Instead, approach hair as a single, soft mass.

Direction of light source

1 Establish the basic shape of the hair with a midtone base color. Hair is soft. Leave soft edges to the shape to indicate this.

2 With a lighter tone, roughly block in the form of the hair.

3 Work into the hair with the base tone, adding long brush strokes to define direction and indicate texture. Add individual hair shapes to make the hair look untidy or windswept.

4 Use a lighter tone to refine the form, again adding long strokes to indicate hair flow and texture. Overlap darker marks from the previous stage to give depth.

5 Hair is partly transparent, especially when strongly lit. Choose a lighter, more vibrant tone of the hair color for this stage and work into highlighted areas. Add reflected light in the same way.

6 Dirty or coarse hair may be finished at stage 5. Give hair a sheen by introducing a final round of highlights. The brighter and harder the highlights, the shinier the hair will appear.

FAIRY

Diminutive winged humanoid, with powerful magical abilities.

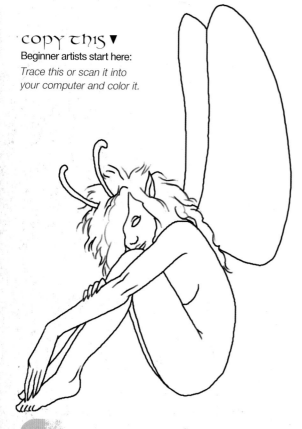

COPY THIS ▼

Beginner artists start here:

Trace this or scan it into your computer and color it.

PERSONALITY

Shy, mischievous, playful

The Fairy is a very familiar character. Fairies' small, winged appearance is instantly recognizable, and their playful character is well described in countless fairytales. Your audience will have preconceived ideas when presented with this character. You must consider this, and be very clear· on the personality you wish to project.

DESIGN CHOICES

The design should distract as little as possible from the Fairy's strong character, which will project most effectively through her expression and pose. To this end, the design is as simple as possible, with the least elaborate wings chosen—their insect-like appearance is augmented here with two antennae. A shock of bright orange hair contrasts with the cool colors used elsewhere, and draws the viewer's eye straight to the playful face.

SEE ALSO

Gallery, page **15**
Color, page **44**

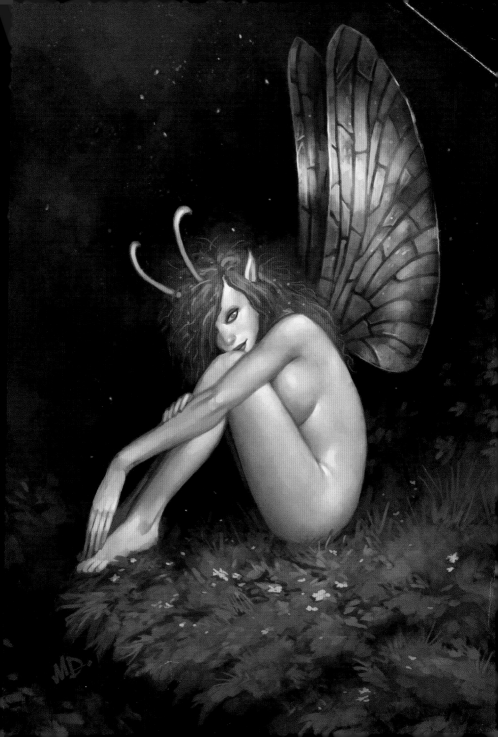

DEVELOPING CONCEPTS
FAIRY

Fairies delight in observing the reactions of other creatures as they tease them with tricks and illusions. They behave like children, and this carefree, mischievous nature should be evident in the final design.

FACE

Choose a face that will help to illustrate one or more of the Fairy's personality traits. Such magical creatures will be different from a human; try to assert this without resorting to extreme alterations to the basic features or proportions, as this might lend the fairy an unsettling or frightening quality.

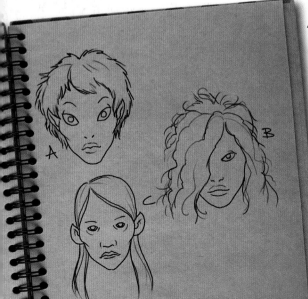

A: Pointed ears and unusually-shaped eyes affirm the exotic nature of this fairy. A large mass of hair gives the head a childish silhouette.

B: Wild, curly hair evokes the energy in this Fairy's personality. The hair falls across the face, hinting at the creature's shy nature.

C: The head shape, combined with the protruding ears, gives a childlike feel to this Fairy.

BODY CONCEPTS

Fairies stand less than four feet tall. Their flight is achieved magically, rather than with the wings protruding from their back. Nevertheless, it is important to design a frame that will not look odd when suspended in the air. The body should be delicate and slender.

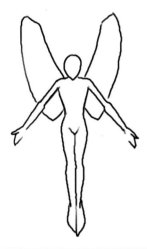

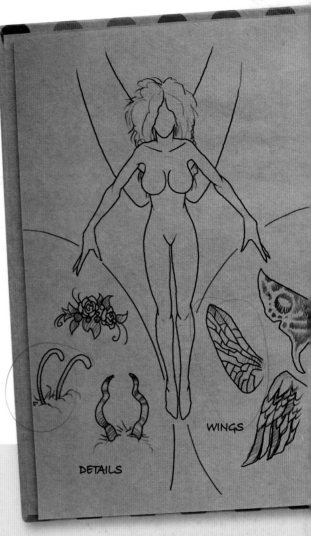

DETAILS

WINGS

WORKING UP DETAILS

- **Details:** Details stand out in a design as simple as the Fairy. Choose elements supporting the personality you wish to project. Perhaps flowers to show an affinity with nature, or horns to add an exotic touch. See if the wings you choose for your Fairy suggest details (such as antennae) that might help give the design consistency.

- **Wings:** Wings come in many forms. Take time to experiment with different shapes, referencing winged creatures in nature for inspiration. As the wings are such a prominent feature, consider how the silhouette interacts with the Fairy's body and costume.

Having considered the shape of your Fairy's wings, look at texture, pattern, and color. Butterfly or moth wings are incredibly varied, and could provide color and pattern. Insect wings are delicate, displaying subtle colors. Feathered wings give a unique appearance.

CONSTRUCTION AND DRAWING GUIDE
FAIRY

Elegance and grace should be affirmed by the design of the Fairy's body, and the slight tilt of the head. All proportions should be light and elongated, with delicate details.

CONSTRUCTION

The Fairy's head conforms to the standard measurements. Draw up the construction cage as usual, using the horizontal center line (**A**) to locate the eyes, with nose and mouth aligned along lines **B** and **C**, respectively.

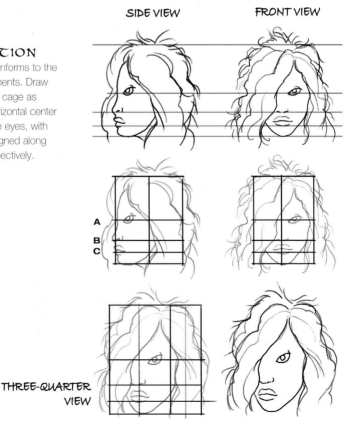

SIDE VIEW

FRONT VIEW

THREE-QUARTER VIEW

POSE

How you choose to pose your Fairy will say more about your creation than any other aspect of the design. The Fairy is free, energetic, and expressive, so the body language should be clear and vivid. Show your Fairy in flight, with limbs in a graceful pose to clearly illustrate her magical nature. Have your Fairy in stitches of laughter, amused at the results of a successful trick. Support your design choices further with your pose—show your Fairy seated, with head partially hidden behind drawn-up knees to reinforce the character's shyness. An eye fixed on the viewer and a knowing smile will make us wonder if we are being drawn into the Fairy's tricks.

AMUSED

IN FLIGHT

COY

ARTIST'S TIP: DETAIL

Details add contrast. Contrast draws the eye. Therefore, details must be added deliberately and with consideration for the focal points in your image. Properly placed, detail will support and strengthen the focus of your image. Added without thought, details can be distracting and disruptive.

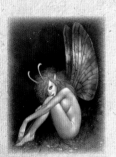

This example image has a simple focal point—the character's head in the very center of the picture. Notice how the details radiate out from this point, with the marks becoming ever larger toward the edges of the image.

Imagine a target placed around each focal point in your artwork. The greatest detail should be in the "bull's-eye," with moderate detail beyond, and as little detail as possible outside the target area.

SEE ALSO
Composition,
page **39**

SPRITE

Small Fairies leading sad, lonely lives due to their mischief and bad behavior.

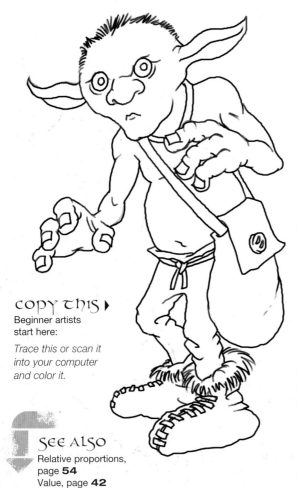

PERSONALITY
Mischievous, timid, forlorn

The Sprite delights in all kinds of troublemaking; he is not an evil creature, he simply cannot help being bad! His diminutive size and faerie magic make it easy for him to sneak into homes to steal or hide things, put out hearth fires, spoil milk, or add unpleasant ingredients to simmering stews. This terrible behavior makes the Sprite very unpopular; he is shunned by society, and forced to lead a dismal, solitary existence. The artist is challenged to design a misunderstood character that demands pity.

DESIGN CHOICES

Lighting is arranged to good effect in this painting. The light source is positioned to locate a bright highlight on the large eyes of the Sprite, drawing the viewer's attention to this important area and enhancing the startled appearance of the character. The long cast shadow makes the Sprite look exposed, further adding to the sense of surprise and vulnerability.

COPY THIS ▶
Beginner artists start here:

Trace this or scan it into your computer and color it.

SEE ALSO
Relative proportions, page **54**
Value, page **42**

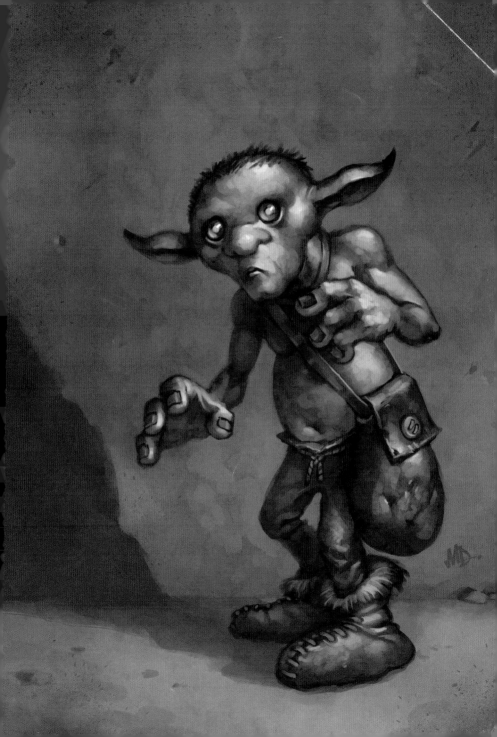

DEVELOPING CONCEPTS
SPRITE

Sad and lonely, the Sprite should appear forlorn. This character will be accustomed to beatings and other harsh treatment when discovered. This should manifest itself in a timid, cowering demeanor.

FACE

A large head gives the Sprite childlike proportions—something the viewer will warm to. Exaggerate this impression by making the features relatively small compared to the overall size of the head. The face should also clearly demonstrate the Sprite's magical nature.

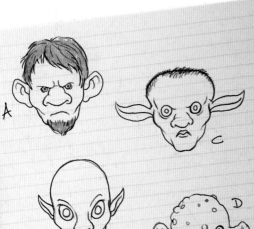

A: Abuse and repeated banishment have made this Sprite bitter. His tiny eyes are partially hidden beneath a severe brow, and his mouth is grim.

B: The small jaw and large, bald cranium give this head a childlike shape, but the features have an elfin quality, asserting the Fairy aspect.

C: This head has childlike proportions, but the shapes are distorted and ugly, reflecting the Sprite's personality. The round eyes make him appear startled.

D: A lumpy, wart-covered head gives the viewer a reason to pity this character.

COSTUME

The costume should reflect the Sprite's exile. Tailors will not deal with this troublesome character, so clothes must appear stolen or fashioned with his crude skills. Garments should be simple, perhaps badly fitting or poorly made, with rough stitching and frayed edges.

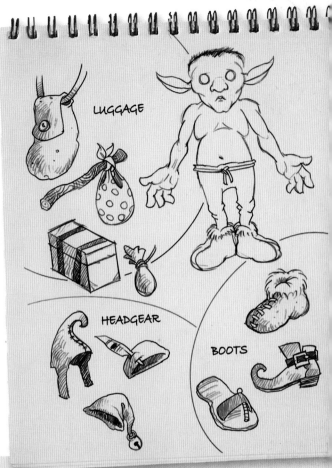

LUGGAGE

HEADGEAR

BOOTS

WORKING UP DETAILS

● **Headgear:** The costume should be simple, but a cap or hat can increase the perceived size of the Sprite's head, exaggerating his childlike shape.

● **Luggage:** Sprites carry all their possessions around with them. Luggage should have enough room for trinkets the Sprite pinches. Making this item oversized will enhance the character's diminutiveness.

● **Boots:** Rough, simple sandals or moccasins show that the Sprite is forced to make his own apparel. Alternatively, a finely-crafted pair of leather boots will clash with the rest of his costume, hinting that the footwear has been stolen.

CONSTRUCTION AND DRAWING GUIDE
SPRITE

The Sprite's body and face resemble a young child. The body and limbs have human proportions, but the head makes up one-quarter of the overall height. Unusually large hands and feet—ideal for pilfering and making hasty escapes—characterize the Sprite. The portly belly shows the effects of eating too many stolen cakes!

CONSTRUCTION

Extreme proportions are a feature of the Sprite's head, yet the usual human measurements are still applicable.

Features line up as usual along lines **A**, **B**, and **C**. Notice that the Sprite's large, angular cranium fits quite snugly within the upper half of the construction cage, and that the head is as wide as it is long, making the cage a cube. Because of the shape of the nose and heavy brow, an angle may be introduced along the front of the cage to fit to the Sprite's head more closely.

FRONT VIEW **SIDE VIEW**

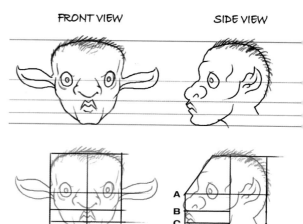

THREE-QUARTER VIEW, LOOKING DOWN

pose

Imagine the mischief that the Sprite might get into, and the poses that might result. Remember, you want the viewer to understand the sadness in this creature, and to pity his lonely life. Stealing a pie or adding hot spice to a soup will delight the Sprite, and showing him doing such things will make your viewer laugh, rather than cry. Instead, think of situations where the Sprite's sadness is apparent—fleeing from an angry baker, pleading for mercy when captured, or simply in a startled pose, filled with despair at the inevitable punishment he faces.

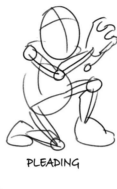

PLEADING

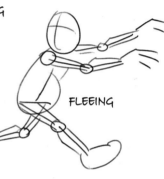

FLEEING

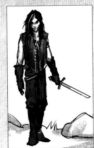

STARTLED

ARTIST'S TIP: GROUNDING

Characters and other objects must be properly integrated into a scene. Simply painting in a background is not enough; there must be some evidence that your character is "there."

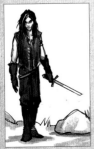

Simple grounding
The second example shows a vague shadow added beneath the character's feet—there is evidence of him interacting with the ground plane, and he becomes part of the scene. Note that the rock is integrated in the same way.

Floating
In the first of the example sketches, no attempt is made to ground the character. He appears to float on top of the simple background placed behind him.

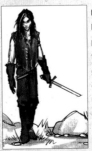

Detailed grounding
Finally, extra details are added. By placing elements behind and in front of the elements to be grounded, you establish their depth. They appear to be "inside" the scene.

DRYAD

Dwelling in the deepest, darkest forests, these tree spirits are seldom seen.

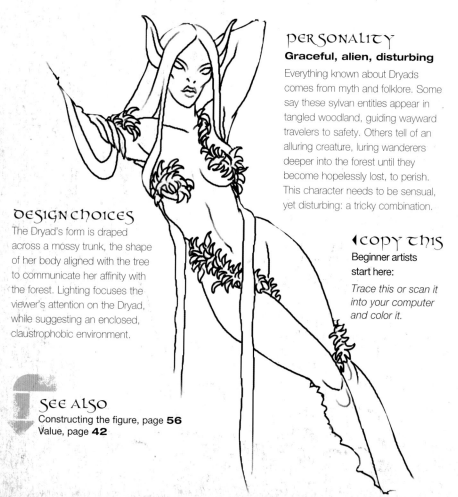

PERSONALITY
Graceful, alien, disturbing

Everything known about Dryads comes from myth and folklore. Some say these sylvan entities appear in tangled woodland, guiding wayward travelers to safety. Others tell of an alluring creature, luring wanderers deeper into the forest until they become hopelessly lost, to perish. This character needs to be sensual, yet disturbing: a tricky combination.

DESIGN CHOICES
The Dryad's form is draped across a mossy trunk, the shape of her body aligned with the tree to communicate her affinity with the forest. Lighting focuses the viewer's attention on the Dryad, while suggesting an enclosed, claustrophobic environment.

COPY THIS
Beginner artists start here:

Trace this or scan it into your computer and color it.

SEE ALSO
Constructing the figure, page **56**
Value, page **42**

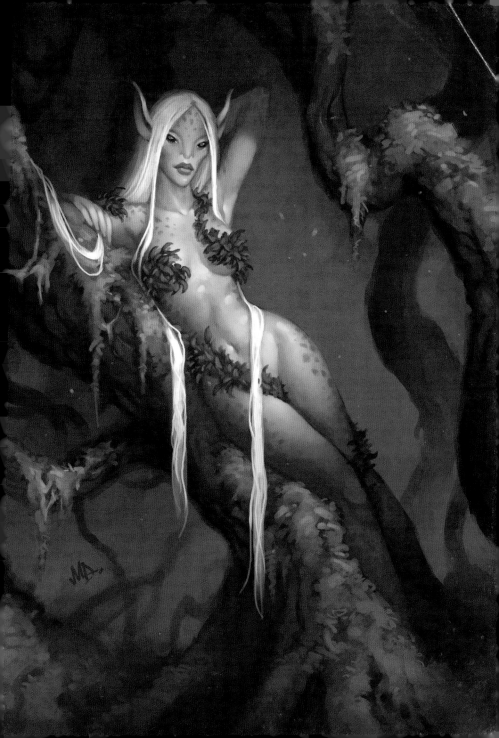

DEVELOPING CONCEPTS
DRYAD

A close kinship with nature, particularly with trees, is important for this character. Achieving an alluring female form for the Dryad will be straightforward, but the "disturbing" element is trickier to master.

FACE

It is important that the Dryad's face displays clear feminine qualities; however strange she looks, the features still need to suit her female body. Try to make the weird qualities of the Dryad's face subtle, since this will disturb the audience more effectively than something that is obvious at first glance.

A: Hair is replaced with fur. The eyes, nose, and ears have a rodent-like aspect.

B: The lower portion of the face is female, although the features are distorted. This contrasts with a strangely-shaped cranium and alien ears.

C: At first glance this face appears human, but closer inspection shows no eyebrows, and an underdeveloped nose. What first looks like hair reveals itself to be a cascade of living leaves.

D: All the features are in the correct place, but each is distorted. The exaggerations retain a feminine appearance.

COSTUME

Clothing of any recognizable kind will reduce the Dryad's alien quality. Imagine alternatives to clothing that might reinforce her connection with nature and trees. Leaves could grow from her flesh, or moss could grow on her body—most alien of all might be to remove the costume altogether, and wrap the Dryad in her own hair.

DECORATION

PATTERN

WORKING UP DETAILS

● **Decoration:** In the absence of any costume, imagine alternative ways that decoration might be added. Remember, every detail sends a message about your character. If your Dryad wears flowers in her hair, or has butterflies settling about her body, it sends a message that she is good. Maybe she saves lost travelers? Thorny vines or creepers bearing poisonous berries curling along her arms would depict a Dryad that lures wanderers to their doom.

● **Pattern:** Patterned skin will show effectively that the Dryad does not possess a human body. Experiment with patterns that reflect trees: bark, woodgrain, or dappled light through a woodland canopy.

CONSTRUCTION AND DRAWING GUIDE
DRYAD

The Dryad's body should be curvy, with generous hips and bosom, so that the femininity of her form is clear. Her limbs and facial structure should be long and slender, calling to mind the graceful shape of a tree.

CONSTRUCTION

The profile of the Dryad's face fits the construction cage well. Her ears join along the center line in the side view, but this point is hidden beneath her hair. An alternative way to find the shape and location of the ears is simply to follow the curve of the jawline.

SIDE VIEW FRONT VIEW

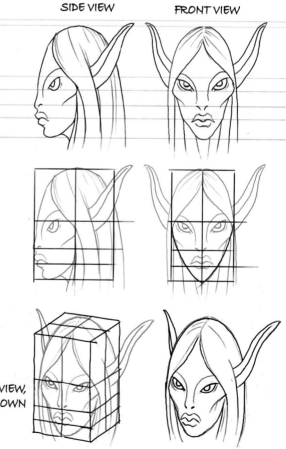

THREE-QUARTER VIEW, LOOKING DOWN

POSE

The pose can help to reinforce the Dryad's disturbing nature. Avoid anything suggesting an activity the audience might find at all familiar. Your Dryad should look like an extension of her woodland home; explore poses that reflect or harmonize with tree shapes. She could be perched on a bough, or perhaps standing among a group of saplings, with her arms elevated like branches. Ideally, her pose should play on her feminine aspect—show her reclining against a curling trunk, with her legs disappearing among the tangled roots, idly playing with her hair, waiting for the next poor wanderer to save … or savor.

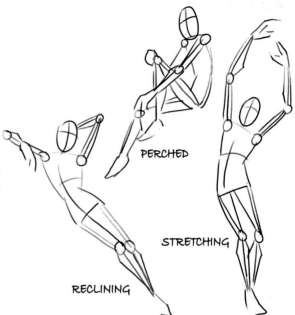

PERCHED

STRETCHING

RECLINING

ARTIST'S TIP: CONTEXT

Backgrounds are far more than an attractive backdrop to your character. They contextualize your creation, providing an opportunity for narrative and mood that can add extra depth to your concept. Consider the character in the example sketches. He's unkempt and dishevelled, and his sword appears to have a broken blade. Think about the motivation and personality of this figure—show him in context.

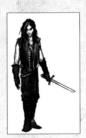

No background
This character is interesting without a background, but placing him in context can help give meaning to his appearance.

Loner
Place the character in a wilderness setting and he becomes a mysterious loner, his weatherbeaten appearance suggesting many nights spent out-of-doors.

Warrior
With a slain beast behind him, this character is a formidable warrior—clothes tattered from a ferocious battle, with the tip of his sword no doubt buried in his now-vanquished adversary.

SEE ALSO
Before you begin, page **38**

BARBARIAN

Huge, bloodthirsty tribal warrior who raids and plunders to survive.

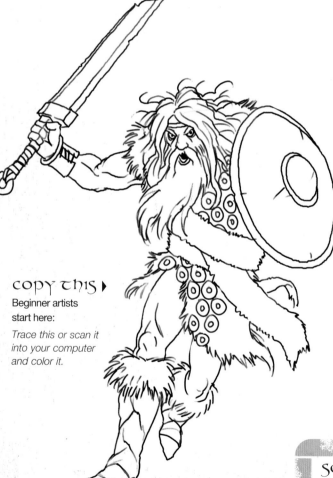

PERSONALITY

Brutal, wild, hostile

Barbarians are warlike humanoids who stand between seven and eight feet tall, and their great strength matches their size. The Barbarian's primitive nature should be reflected in his costume and props, so choose them carefully.

DESIGN CHOICES

A dynamic pose gives the Barbarian movement. This is further suggested by flying hair, and the fur and material of the costume. Atmospheric perspective is used to fade less important elements of the character, focusing the attention on the body and the fierce expression.

COPY THIS ▶

Beginner artists start here:

Trace this or scan it into your computer and color it.

SEE ALSO

Visual language, page **35**
Sources of inspiration, page **18**

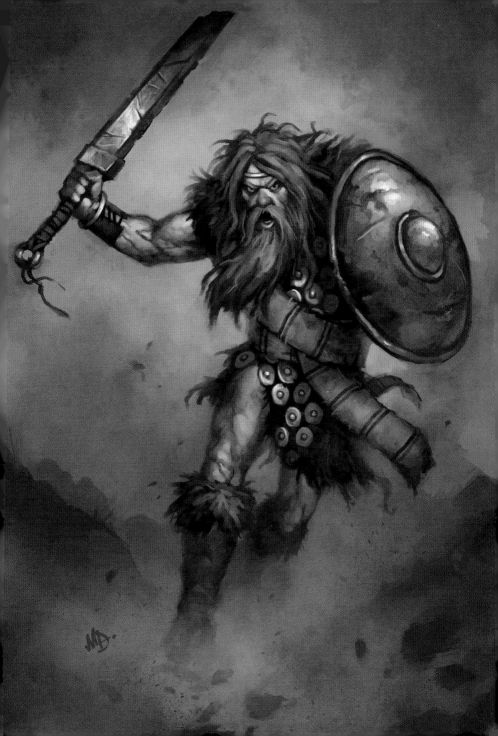

DEVELOPING CONCEPTS
BARBARIAN

Living in feudal tribes, Barbarians are as likely to war against one another as they are with the communities that they prey upon; years of warmongering should be evident in the character's design.

FACE

At first glance, the Barbarian's face should appear hostile and aggressive. The Barbarian is the most extreme humanoid archetype, giving the artist great creative freedom. But don't take the design too far, as this can result in an unconvincing character.

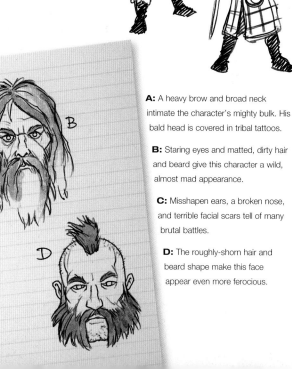

A: A heavy brow and broad neck intimate the character's mighty bulk. His bald head is covered in tribal tattoos.

B: Staring eyes and matted, dirty hair and beard give this character a wild, almost mad appearance.

C: Misshapen ears, a broken nose, and terrible facial scars tell of many brutal battles.

D: The roughly-shorn hair and beard shape make this face appear even more ferocious.

COSTUME

The costume should be simple. The Barbarian is primitive, so materials should be unsophisticated basics. His body could be wrapped in animal skins, secured with a simple belt or a rough fabric tie. Perhaps his costume is no more than a skirt of leather tied around his waist.

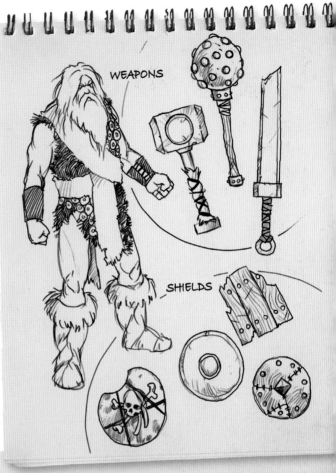

WEAPONS

SHIELDS

WORKING UP DETAILS

● **Weapons:** Although primitive, Barbarians have some metalworking skill, which they use to fashion brutal weapons and simple armor. The Barbarian relies on strength in combat, so weapons will be oversized and heavy to inflict maximum damage.

● **Shields:** Imagine how available materials could be used to fashion a shield. Metal is most effective, but a thick wooden shield also provides adequate protection. Studs or spikes would help to deflect blows and prolong the shield's lifespan.

CONSTRUCTION AND DRAWING GUIDE
BARBARIAN

The Barbarian's frame is considerably wider than a standard human's. Broad shoulders and hips combine with limbs thickly knotted with muscle and fat, creating a towering mass of flesh.

CONSTRUCTION

A heavy mane of matted hair and thick, tousled beard obscure much of the Barbarian's face. Look to previous hairy characters to overcome any construction problems this presents. With the Barbarian, what impact does hiding so much of the face beneath hair have on facial expressions?

If you take care, there will be no negative effect. Your audience can read an expression from very subtle cues in the features. For example, there's an important difference in the way the eyes are narrowed in "glee" and "anger." A smiling mouth pushes out the cheeks, which displaces flesh toward the eyes, causing them to narrow from below. An angry frown is characterized by a lowered, gathered brow, which narrows the profile from above. The difference is slight, but significant. Try covering the lower half of the barbarian's expressions to hide the mouth and see how the expressions read.

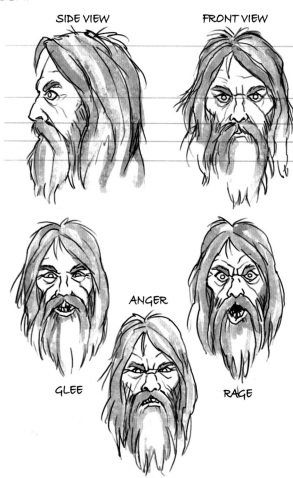

SIDE VIEW

FRONT VIEW

ANGER

GLEE

RAGE

pose

The Barbarian's fighting style is simple: hit your opponent as hard and as often as you can until he stops fighting back, then look for something else to hit. Think about how your character might behave in battle. His pose should be dynamic, emphasizing his wild nature.

Show him about to strike, with a huge weapon raised over his head, and his body twisted to deliver a powerful blow. Draw the Barbarian in an aggressive stance, body thrown forward and head titled back, as he roars a battle cry. For maximum impact, choose a charging pose, with your Barbarian running toward the viewer, sword raised and mouth open as he screams with bloodthirsty rage.

CHARGING

BATTLE CRY

STRIKING

ARTIST'S TIP: ATMOSPHERIC PERSPECTIVE

Atmospheric perspective is a technique usually employed by landscape painters. It can, however, provide a useful tool for the character artist. Air is not transparent. The more air we look through, the more color and density it appears to have. Distant objects (a far-off mountain or hill, for example) appear to "fade" into the sky.

SEE ALSO
Rendering, page **46**

A simple silhouette drawn against a flat background using no atmospheric perspective.

Atmospheric perspective is applied, fading the areas furthest from the viewer toward the background color. This gives the silhouette depth and form.

The character is fading near the ground plane, creating the impression of low-lying mist or smoke. This draws the viewer's eye to the upper body and face.

Here you can see that atmospheric perspective based on depth and height may be used together.

GOBLIN

No deed is beneath the Goblin if it will benefit from the outcome.

PERSONALITY

Greedy, devious, cowardly

The Goblin's bright green skin shows something of its slimy character; greedy and selfish, it uses its cunning to cheat and steal from others whenever it can, delighting in the suffering it causes. A Goblin fights fiercely when cornered, but is naturally cowardly, preferring to use its wits to trick or ambush an opponent.

DESIGN CHOICES

Observe how the Goblin's pose brings the shapes and angles of the limbs, sword, and facial features into alignment. This emphasizes the spiky, angular design of the creature, which communicates the cruel and unpleasant nature of the Goblin. Note that the tattoo designs support this concept.

COPY THIS ▲

Beginner artists start here:
Trace this or scan it into your computer and color it.

SEE ALSO

Comparing techniques, page **24**
Composition, page **39**

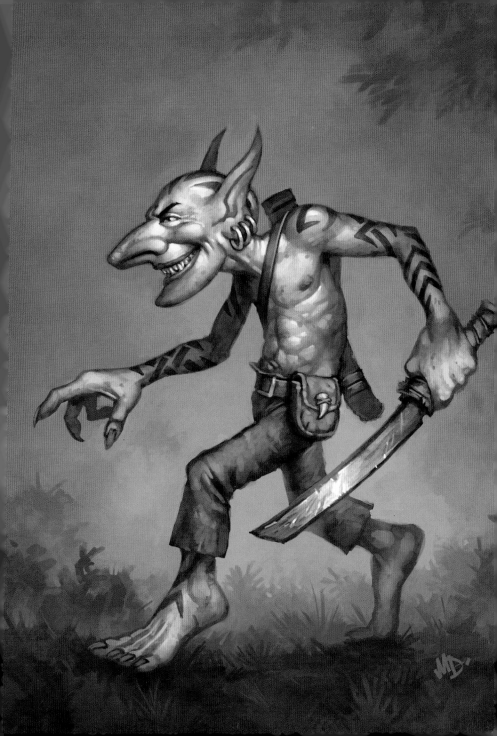

DEVELOPING CONCEPTS
GOBLIN

The Goblin is thin and wiry, but avoid creating a weak character—the devious plan no doubt hatching in its mind should be revealed with a look that conveys confidence and a sense of purpose.

FACE

Sharp, pointed features reflect the character's mean-spirited nature. The Goblin is a monster, but a grotesque or primitive head will make it difficult to suggest its sly intelligence. Instead, work with the human head as a starting point, exaggerating or deforming features to see what gives the most satisfying result.

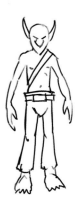

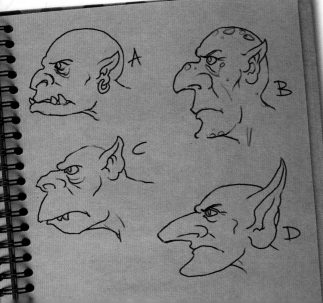

A: An elongated head suggests a large brain. Sharp, protruding fangs help demonstrate an aggressive nature.

B: A vertically-extended head, with a hooked nose and pointed chin. Scaly skin is added to show that this creature is not human.

C: The pricked-up ears and flared nostrils—the features of an alert animal—show the Goblin's curiosity.

D: The nose and chin are dramatically extended, giving the whole head a streamlined, slippery quality in tune with the Goblin's character. Large ears balance the extreme features of the face.

COSTUME

Think of the Goblin's selfish personality when designing costume. Goblins are not strong enough to carry heavy armor, and would not choose to be in a situation when it would be needed. The costume should allow freedom of movement so the Goblin can hide, sneak, and climb. However, its cowardliness means it may choose to wear light armor, just in case!

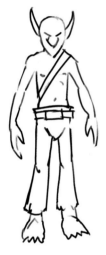

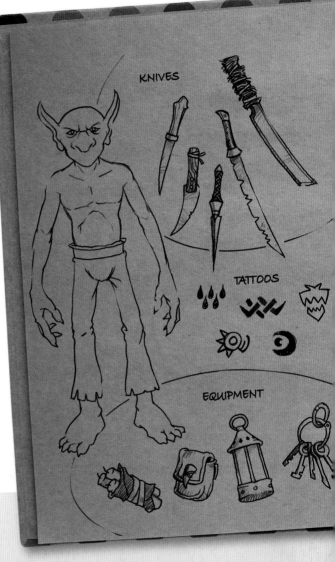

KNIVES

TATTOOS

EQUIPMENT

WORKING UP DETAILS

● **Knives:** Limited strength and a desire to avoid direct combat where possible means that a Goblin is unlikely to carry large or heavy weapons. Knives suit its personality; a small dagger kept hidden, or a long knife to make sure any stab in the back is lethal!

● **Tattoos:** Tattoos are a great way to add interest and an exotic flavor to bare flesh. Simple, stylized designs—an eye, blood drops, fanged jaws—can set a theme to be repeated over large areas.

● **Equipment:** Think of objects the Goblin might use when executing his devious plans: skeleton keys, candles, a lantern, or a pouch to carry valuables.

CONSTRUCTION AND DRAWING GUIDE
GOBLIN

A long, wiry frame enables the artist to accentuate the spiked and angled shapes that help describe the Goblin's character more easily.

CONSTRUCTION

Angled and rotated heads can be particularly challenging when the subject has features as extreme as the Goblin's. Drawing a basic cage around the head makes this task easier, allowing you to deal with a single, simplified shape.

Begin with a basic cuboid drawn to fit the limits of the Goblin's head. Mark off vertical and horizontal center lines. Corners can be removed in the side view to fit the shape of the nose, brow, and jawline.

Line **A** locates the base of the Goblin's nose. In the side view, parallel lines on either side of the vertical center line split this plane into quarters and locate the front of the mouth (**B**) and the point where the ear joins the head (**C**).

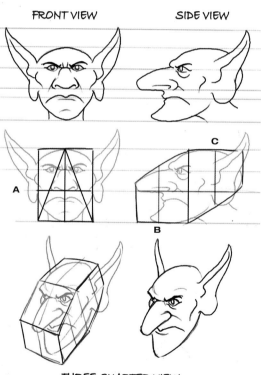

FRONT VIEW　　**SIDE VIEW**

THREE-QUARTER VIEW, LOOKING DOWN

pose

A stalking pose tells the audience all they need to know about your Goblin. Arms and legs spread wide suggest movement, indicating some purpose to his actions. The lowered head and lightly placed feet show that it is moving with care to avoid detection. The drawn knife suggests an imminent horrible deed.

The Goblin could also be shown in a sneaking pose, partially obscured behind something, but with dark intent made clear by a drawn knife, or perhaps the Goblin is emerging from a hiding place, about to sneak up behind an unsuspecting victim.

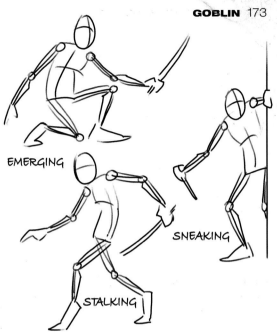

EMERGING

SNEAKING

STALKING

ARTIST'S TIP: RENDERING LEATHER

Leather surfaces can take many forms. Color, finish, and texture can vary considerably. This makes it one of the more versatile and interesting materials available to the fantasy artist.

Direction of light source

1 Choose a dark to mid-range tone as your base. This will be the darkest tone of the material. Here, dark brown is chosen as a base for a simple tanned hide.

2 Place a lighter tone to establish the form of the surface. Leather is a glossy surface that reflects plenty of light; working from dark to light helps avoid the excessively dark shadows.

3 Introduce a second hue to give the surface life and establish some texture. Vary this according to the age and wear of the hide.

4 Add reflected light. This will reinforce the glossy sheen of the surface.

5 Consider your surface when adding highlights; leather can be polished to a shine, or weathered until dull. Show some texture in the highlighted area.

6 Finally, with the basic surface and overall texture in place, add cracks, creases, and scratches where appropriate to give the hide character.

ORC

Warriors of great strength and savagery, Orcs live for battle.

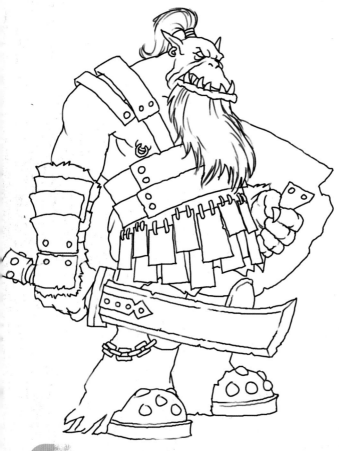

PERSONALITY

Aggressive, brutal, relentless

Orcs are familiar to everyone who knows about fantasy. A large frame and great strength make the Orc an accomplished warrior, and an aggressive, savage nature means it revels in war. It is no surprise to find they are a popular choice when evil forces recruit their armies.

DESIGN CHOICES

The Orc is heavy and powerful and the pose is chosen to support this— notice how attention is drawn to the bulk of the creature's belly and the prominent sword. Lighting is arranged so that the viewer focuses on the Orc's facial expression.

◀ COPY THIS

Beginner artists start here:

Trace this or scan it into your computer and color it.

SEE ALSO

Proportions of the body, page **52**
Value, page **42**

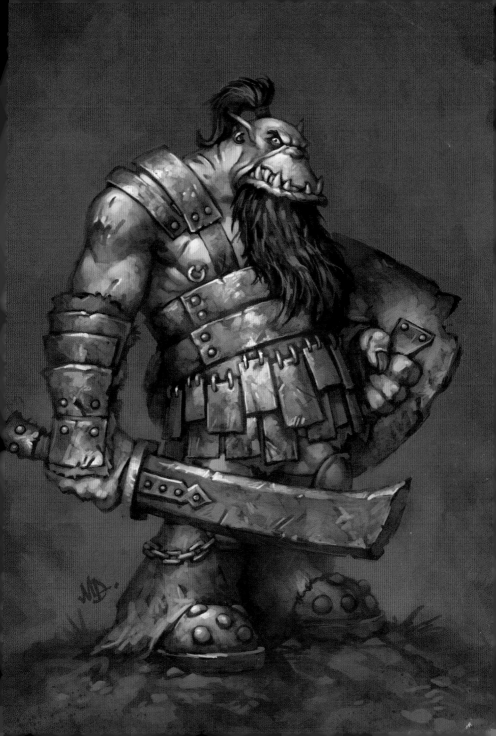

DEVELOPING CONCEPTS
ORC

Strength and aggression are the most important factors. Orc society is primitive, providing only what is necessary to sustain the population between battles.

FACE

A jutting jaw lined with sharp fangs is paired with a small, heavily-browed cranium. The Orc has few intellectual concerns outside fighting (unless briefly distracted by the opportunity to torture). Whether the artist chooses to follow designs that have gone before or create something new, working within this framework will ensure that the final creation has features that will be recognizable as Orc-like.

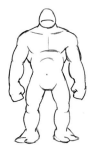

Wide shoulders, narrow waist, and well-defined musculature show strength.

Thick limbs and a low center of gravity suggest bulk and stability.

Combine these shapes to create a body with the best of both.

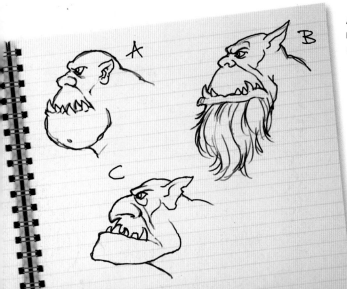

A: Fangs grow upward from a heavy lower jaw. This head is small and compact, accentuating the size of the Orc's body.

B: Irregular teeth push out from the lower jaw. A thick beard of matted whiskers grows from the chin. This closes the gap between head and chest, and adds extra bulk.

C: Pointed shapes are employed to give this face an aggressive aesthetic.

BODY CONCEPTS

Although there is variation in the height and size of Orcs, the average stands about as tall as a human. Its frame is considerably heavier though, providing substantial physical presence. Since the Orc must display both strength and bulk, think about how best to represent these traits individually.

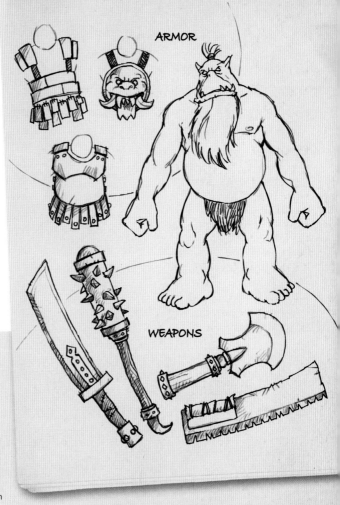

ARMOR

WEAPONS

WORKING UP DETAILS

● **Armor:** The Orc's great strength and endurance means it places the durability and effectiveness of its armor above comfort. Heavy metal plates riveted to fit, or a simple breastplate beaten roughly into shape would be ample protection for the Orc. Armor designed to cause damage to a foe as well as protecting the wearer might be favored, so consider adding spikes or blades.

● **Weapons:** Orcish weapons are simple and effective. An Orc's strength allows it to wield heavy blades or clubs to devastating effect. Details will be few—any decoration must justify its presence by having some usefulness in battle.

CONSTRUCTION AND DRAWING GUIDE
ORC

The Orc's frame and head shape combine elements which suggest bulk and strength. Take care to emphasize both elements when sketching.

CONSTRUCTION

The large jaw means that the Orc's head is widest at the bottom. The horizontal center line, (**B**), defines the base of the nose. Cut the upper half of the cage in half horizontally with a second line, (**A**), to locate the nose and base of the ear. The distance between lines **A** and **B** is equal to the distance between the base of the cage and a third horizontal, (**C**), which runs along the mouth.

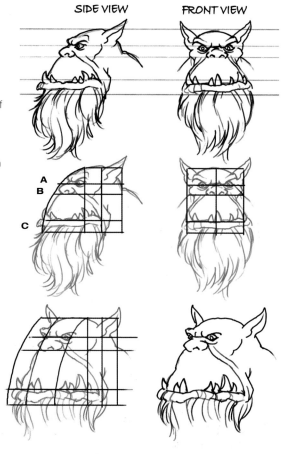

SIDE VIEW FRONT VIEW

POSE

Show the Orc's love of combat through its pose. A stance with arms held wide to expose the body demonstrates that a character feels at ease, and is showing a subtle invitation to approach. In the Orc's case, with sword and shield, the invitation is to fight, and it clearly feels confident in its ability to emerge victorious. Perhaps showing this victorious state represents how the Orc revels in battle. A cry of triumph with weapon held aloft is a classic fantasy pose. A less dynamic pose can communicate the Orc's brooding aggression. A simple stance, with the body tensed for action and the face clearly expressing the Orc's intentions tells us all we need to know about this character.

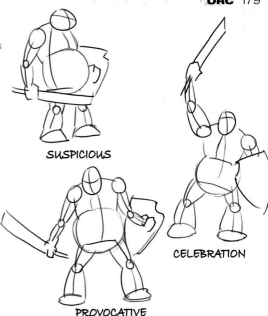

SUSPICIOUS

CELEBRATION

PROVOCATIVE

ARTIST'S TIP: DIRTY METAL

Metal is the most interesting when it shows some of its history. Whether the weathered helmet of a brave adventurer or the rusty blade of a cruel monster, it's hard to keep metal clean and shiny in the world of fantasy.

Direction of light source

1 Begin with a midtone base color. A neutral color works well for metallic surfaces.

2 Apply a second tone unevenly to introduce some texture. Use a different hue from the base to give the material some life.

3 Use a darker tone to establish the form of the surface. Be aware of any secondary light sources— though dirt and corrosion have dulled this metal, it still has some reflective qualities.

4 Add dirt. Introducing extra color makes the surface more interesting and further describes the texture of the material. Think about appropriate colors—green for slime, dark red for bloodstains, brown for rust.

5 The color and basic form are now in place. In this penultimate stage, use lighter and darker tones to further refine the form. Work into the texture of your earlier brush marks to create scratches and dents.

6 Introduce highlights. In the previous stage, the surface is matte—adding tight highlights gives the material its metallic quality.

SEE ALSO
Rendering, page **46**

TROLL

SEE ALSO
Before you begin,
page **38**
Composition, page **39**

A mysterious, solitary creature known to inhabit remote mountainous or forested regions.

PERSONALITY

Suspicious, bad-tempered, secretive

A useful technique to help the design of a creature is to picture its behavior and habitat, then imagine how the creature might have evolved to adapt to those circumstances. It's possible that Trolls would live in caves, so some evidence for this should be visible in the design. You may wish to suggest a mystical quality, to support a solitary existence and remote habitat.

DESIGN CHOICES

A simple background places the Troll in context, immediately suggesting an evocative atmosphere to the viewer. Muted tones are used in this painting, highlighting the Troll's affinity with his mountainous environment. Focus is carefully controlled to lead the audience's eye toward the character's face.

COPY THIS ▶

Beginner artists start here:
*Trace this or scan it into
your computer and color it.*

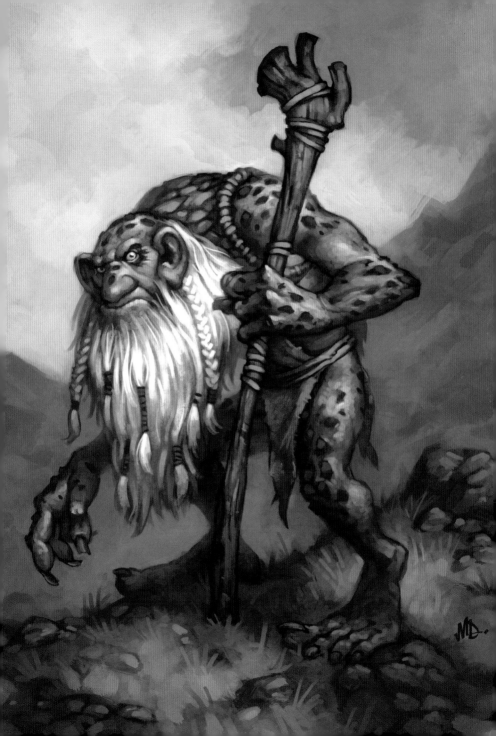

DEVELOPING CONCEPTS
TROLL

Imagining that the Troll's cave dwelling may be cramped and prone to falling debris, you should start by exploring skull structure and body shape before considering the details, like clothing.

FACE

This head design was chosen partly because the heavy brow and jaw already begin to project the correct expression—a sense of suspicion and bad temper. These are subtle emotions, so dramatic contortions of the features aren't appropriate. The brow is gathered toward the bridge to suggest anger. Combine this with a raised brow over one eye to evoke a curious, questioning expression. Give the mouth a gentle downward curl to reinforce the displeasure on the Troll's face.

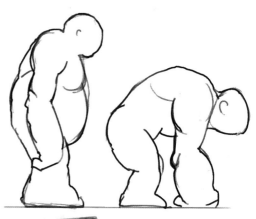

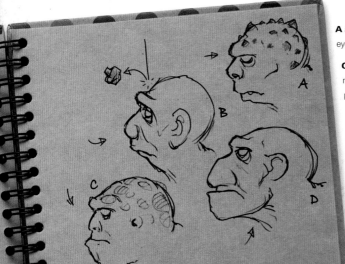

A and **B:** Heavy brows shield the eyes and other features.

C: Brow protects the eyes and nose. Large jaw armors the lower part of the head.

D: Large nose covers the mouth, which is further protected with a heavy jaw. The design calls to mind the stereotypical "grumpy old man," which seems to fit with the creature's personality.

BODY CONCEPTS

The artist's first impulse is to give the Troll a heavy build and a boulderlike body to blend with its surroundings. Perhaps such a body wouldn't be practical for crawling through tunnels and clambering over rocks? So how about giving him a stoop to help him move around in underground spaces? And what about long, wiry arms to assist in climbing? The third example, pictured directly below, shows the two previous postures combined in a gorillalike pose.

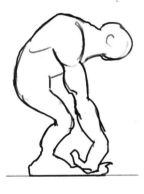

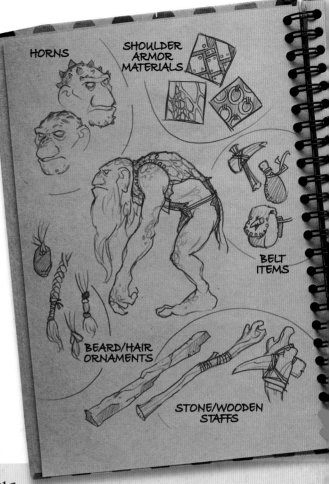

HORNS

SHOULDER ARMOR MATERIALS

BELT ITEMS

BEARD/HAIR ORNAMENTS

STONE/WOODEN STAFFS

WORKING UP DETAILS

- **Beard:** A beard adds interest to the creature's head and helps to soften the otherwise harsh angle of its jutting jaw. Perhaps the beard is a symbol of status among Trolls? Dress the beard with ornaments or trophies. Showing evidence of a wider culture, even in such a subtle way, can deepen a character's personality.

- **Staff:** A simple staff completes the design. In fantasy, staffs are often associated with magic, so its inclusion here introduces a mystical flavor.

- **Clothing:** Keep it simple and light, so it doesn't impede the creature's movement when climbing or caving.

- **Armor detail:** On top of a simple animal-skin tabard, shoulder armor details are added.

CONSTRUCTION AND DRAWING GUIDE

TROLL

Project the simple cage technique—along with eye and center lines—into three dimensions and apply the measurements illustrated below to locate the principal features of the Troll's head. Once you've mastered the head, have a go at posture.

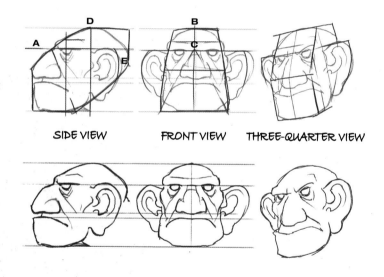

SIDE VIEW FRONT VIEW THREE-QUARTER VIEW

CONSTRUCTION

The eye line (**A**) locates the base of the brow and the top of the ear.

Where the front center line (**B**) crosses the eye line, a tangent (**C**) may be drawn to the corner of the cage base, along which the nostrils, cheek, and corner of the mouth align.

The ears connect to the head along the side center line (**D**), and the shape of these can be contained with an arc drawn to meet the base of the cage (**E**).

pose

Extreme poses suit extreme emotions or expressions, which isn't in keeping with the Troll's suspicious nature, so choose a neutral pose. The side of the Troll's body faces the viewer, as if the creature is turning away, and the left arm covers the body in a guarded gesture. This isn't a friendly presentation, a point exaggerated further by the raised foot that suggests the Troll has already begun to move out of the frame.

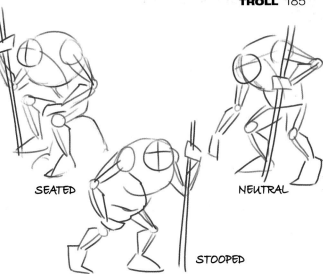

SEATED

NEUTRAL

STOOPED

ARTIST'S TIP: EDGES

Edges are referred to as "hard" and "soft." Hard edges are crisp and defined, while soft edges are blurred. Edge strength is also determined by the degree of contrast between two areas. The treatment of edges has a subtle yet powerful influence over the viewer's perception of form and focus within an image.

Hard edges tend to suggest smooth, rigid surfaces, while soft edges suggest materials that are textured or organic. Hard edges also introduce contrast, which tends to draw the eye, so harder edges should be favored in areas of interest. Softer edges suit dimly-lit or shadowed areas of your artwork.

Examine the Troll painting and identify different edges:

Eye: The eye is surrounded by crisp, high-contrast edges, helping to make this area a focal point for the viewer.

Beard: Soft, low-contrast edges are used on the Troll's beard, since hair is perceived as a soft material.

Staff: The solid wooden staff has hard edges, helping to suggest the rigidity of the object.

OGRE

A revolting, bloated monster with a gigantic appetite.

PERSONALITY

Ravenous, simpleminded, unhygienic

The Ogre's sole motivation is to eat. It views all living things as a potential meal, and what this beast lacks in brain power it makes up for with its massive bulk and incredible strength: a hungry Ogre is a force to be reckoned with. Adding depth to this simple character is the artist's main challenge.

DESIGN CHOICES

Setting this character against a bright background color draws attention to the Ogre's considerable size, giving the character increased presence and weight. Flesh tones are chosen to make the Ogre look unhealthy, emphasizing the character's unpleasant diet.

COPY THIS ▶

Beginner artists start here:

Trace this or scan it into your computer and color it.

SEE ALSO

Proportions of the body, page **52**

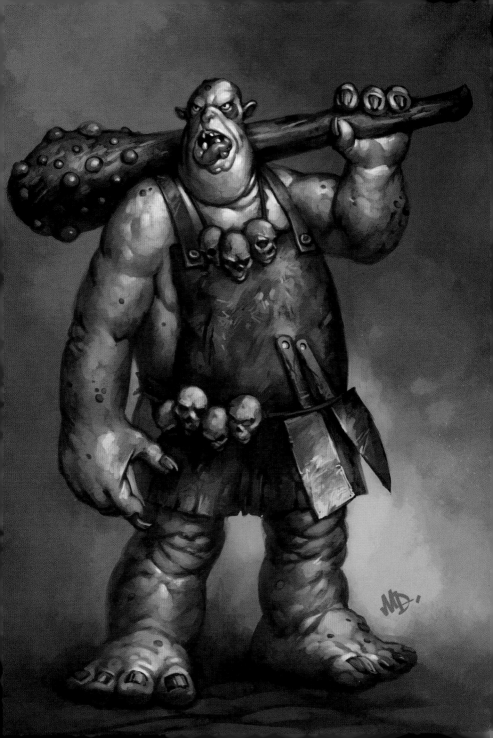

DEVELOPING CONCEPTS OGRE

A real-world archetype can help you make design decisions. Since the Ogre likes to eat, a stereotypical chef or butcher could be a starting point.

BODY SHAPE

The Ogre is an exceptionally bulky beast—almost a solid mass of flesh. Use a simple shape as a guide when sketching out the body to prompt interesting design ideas. See how the different shapes influence how the bulk of the Ogre is perceived.

Triangle: The body tapers toward a narrow head, reinforcing the idea that the Ogre is stupid. The belly is rounded, but the feet and legs are broad, so the overall impression is weighty and solid.

Circle: The repeated curves of this shape make the Ogre appear very fat. The exaggerated belly is wider than the hips and shoulders, suggesting awkwardness.

Square: Squashing the Ogre into a square accentuates the shoulders, giving this design a hunched, gorillalike appearance and suggesting strength.

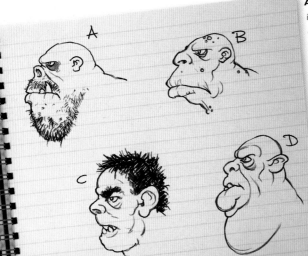

A: The bulk of the Ogre is evident even in the head, with the thick neck and drooping jowls. Patchy whiskers add to the brutish demeanor.

B: A wide mouth suits the creature's huge appetite. The effects of a revolting diet show on the spotty skin.

C: This design mocks the human face, but with the bone structure exaggerated for a monstrous appearance.

D: The unpleasant bloating of the Ogre's body is demonstrated in the face, with a swollen lower lip and huge double chin.

WORKING UP DETAILS

Imagining the Ogre as a bad-tempered, oafish chef or butcher immediately suggests interesting behavior: gruesome food preparation, revolting condiments, or unpleasant hygiene rituals.

- **Utensils:** Reference the butcher archetype by including threatening kitchen utensils.

- **Ingredients:** Further details can be added in the form of crude ingredients which the Ogre might like to add to his food—perhaps powdered spices in jars, or vegetables. Add a gruesome edge with a string of shrunken heads.

- **Weapons:** Even a large weapon can call to mind items used in food preparation: a meat tenderizer or pestle, for example.

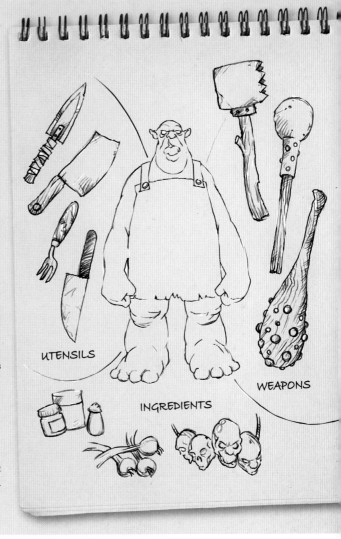

UTENSILS

INGREDIENTS

WEAPONS

FACE

A huge body establishes the Ogre's gluttony. The most important aspect of the face is its stupidity. Small eyes, a heavy brow, and a small cranium all suggest low intelligence. A primitive impression is enhanced by irregular features such as bad teeth, lopsided nose or ears, and a generally unkempt, dirty look.

CONSTRUCTION AND DRAWING GUIDE
OGRE

The huge mass of the Ogre's body is the most important aspect of this design. Concentrate on establishing weight and bulk from head to toe.

CONSTRUCTION

Because the creature's face is lopsided and asymmetrical, accurate measurements are difficult. Luckily, the soft, fleshy forms of the Ogre's head do not require particularly accurate measurements. A rounded cone provides the cage for the head. Horizontal lines drawn across the center of the cage, and halfway between here and the top of the cage (**A** and **B**), mark the limits of a "belt" around the cage that contains eyes, nose, and ears. A third line (**C**), drawn below the horizontal center, forms a second belt of equal width to the first, which locates the mouth.

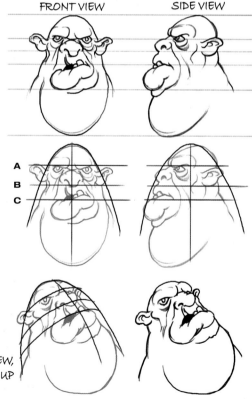

FRONT VIEW SIDE VIEW

THREE-QUARTER VIEW, LOOKING UP

pose

The pose should support an aspect of the Ogre's personality. Show the beast lumbering along, arms partly outstretched to help balance the weight of its belly. Have the creature staring hungrily out of the page, his weapon raised up ready to strike, giving your viewer the impression that the Ogre regards them as lunch! A static pose, suggesting the body has come to a halt while the Ogre's tiny brain is busy, will show off its stupidity very effectively.

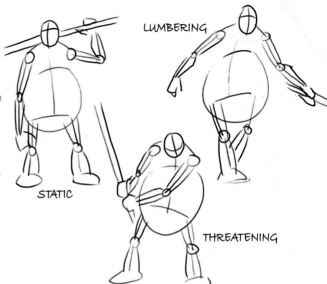

LUMBERING

STATIC

THREATENING

ARTIST'S TIP: Rhythm

Rhythm in music refers to a recognizable, ordered repetition of beats. A good rhythm is pleasing to the ear. The same principle applies in art — shapes have rhythm that the artist can manipulate to be pleasing to the eye.

Look at the character in the example sketches. His body is broad and heavy, constructed from large, rounded forms. The same rounded shapes are repeated in his boots and in the texture of his costume. The design has rhythm and the chosen weapon must complement this.

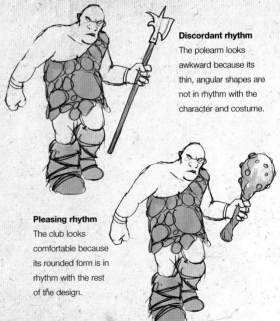

Discordant rhythm
The polearm looks awkward because its thin, angular shapes are not in rhythm with the character and costume.

Pleasing rhythm
The club looks comfortable because its rounded form is in rhythm with the rest of the design.

DEMON

Evil embodied in a terrifying physical form.

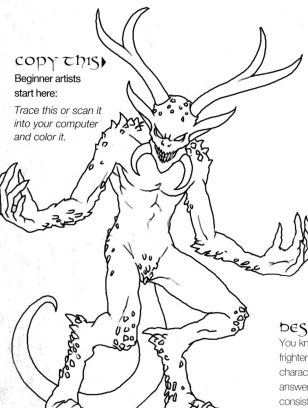

COPY THIS ▶

Beginner artists start here:

Trace this or scan it into your computer and color it.

PERSONALITY

Wicked, spiteful, frightening

The Demon is a servant of pure evil, summoned from another plane of existence by dark magical rites. There are no rules to govern a Demon's appearance, and they need not conform to the limits of the fantasy world to which they have been called. This gives the artist complete creative freedom—potentially this is a problem.

DESIGN CHOICES

You know the Demon should be frightening, which begins to shape the character. Choosing a theme will help answer questions and keep the design consistent. The theme could be an emotion, activity, or element that the Demon is associated with. A Pain Demon? Perhaps a War Demon? These themes suggest ideas to make your creation interesting. This Demon will be themed on an element: fire. •

SEE ALSO

Before you begin, page **38**
Color, page **44**

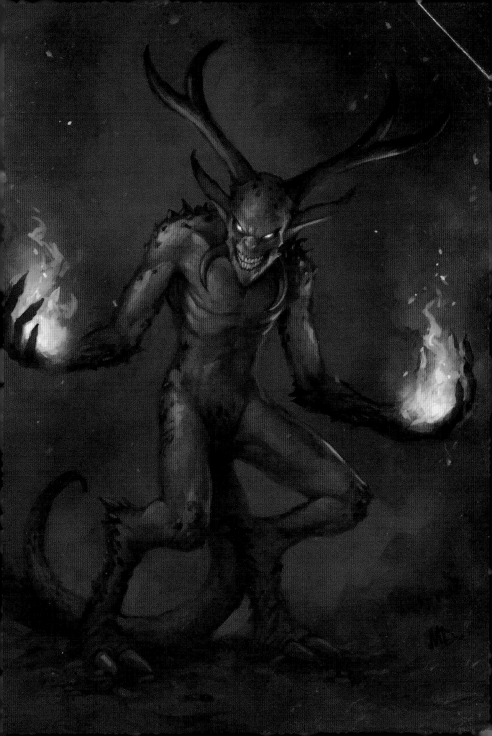

DEVELOPING CONCEPTS
DEMON

When your character can take any form, it can be difficult to begin your design. To ensure that different aspects of the Demon work well together—a key factor in producing a convincing character—you will need to limit your freedom.

BODY CONCEPTS

Assume that the Demon conforms to a rough humanoid shape. A familiar starting point can help your creativity flow, and distorting a recognizable form is an effective way to give your Demon a frightening shape. First, draw a simple line. Try to "feel" this line as you sketch, repeating it as often as possible. The lines will create a rhythm and suggest some great body shapes.

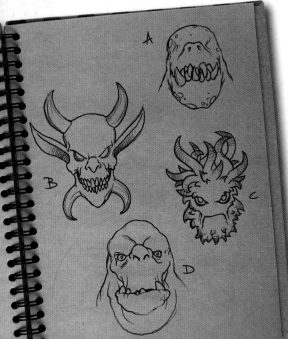

Zigzag: The sharp zigzag shape suggests flames and gives this body an insect-like feel.

A: The snout and sharp, protruding fangs give this face a frightening appearance, exaggerated further by the absence of any obvious eyes.

B: The human skull is a frightening image. Long, pointed ears and horns demonstrate that this face is more than human.

C: This face is a mass of horns, twisting into shapes inspired by a dancing fire.

D: No subtle interpretation of the fire theme here. This monstrous face is designed to terrify.

Steps: This body is given a craggy bulk by the step shapes. The rocky crust of this Fire Demon could be cracked to reveal glowing lava underneath.

Swirl: Curves and swirls evoke smoke wisps and give this body a strange elegance, perhaps suitable for a Demon taking a feminine form.

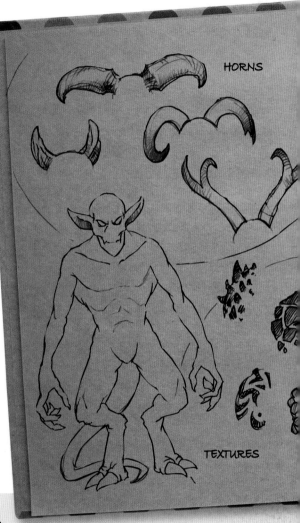

HORNS

TEXTURES

WORKING UP DETAILS

● **Horns:** Horns come in many shapes and sizes. Look at real animal horns for inspiration. However, Demon horns can take any shape. Let your imagination run wild.

● **Textures:** Adding texture to the Demon's hide is a great way to add detail. All the textures are inspired by fire—thorny deposits of ash, heavy scales like the cracked surface of cooling lava, splits in the skin revealing flaming runes beneath, and lumps of burn scars.

CONSTRUCTION AND DRAWING GUIDE
DEMON

Be sure to reference human anatomy when constructing creatures such as Demons—a basis in recognizable, realistic anatomy will make your creation more convincing.

CONSTRUCTION

The Demon's skull face allows the artist to employ the standard construction lines. The eyes sit on top of the horizontal center line (**A**), with nose and mouth located where they would be on a normal human head, along lines **B** and **C**, respectively. The side center line (**D**) defines where the ear is attached to the side of the head—the ears run to the top of the construction cage.

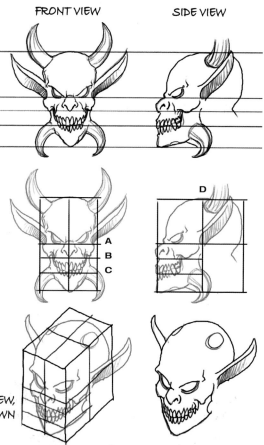

FRONT VIEW

SIDE VIEW

A
B
C

D

THREE-QUARTER VIEW,
LOOKING DOWN

poses

Do not give too much away in your chosen pose. Your creation will be all the more frightening if his evil is apparent, but his intentions are not. A confident pose, with the character facing the audience with arms to the side shows off your finished design well and suggests that the Demon is anticipating its next wicked act.

Since fire is suggestive of anger, show the Demon in a rage, offering up a hellish roar to the skies—you could even show flame, or smoke escaping from its wide-open mouth. A crouched stance, perched like a bird of prey, gives the Demon an ominous appearance.

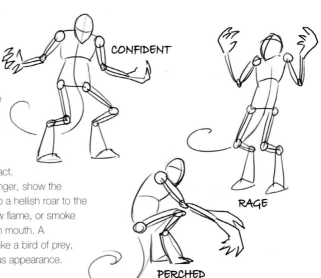

CONFIDENT

RAGE

PERCHED

ARTIST'S TIP: REFLECTED LIGHT

Turn on even a weak light source in a darkened room, and every surface is illuminated. This happens because light rays collide with every surface, then bounce off. This is easy to demonstrate by bringing a neutrally colored object near a brightly colored surface; whatever the specularity of the neutral object, some of the bright color will be seen reflected in its surface.

Understanding this allows you to portray more realistic and interesting lighting. These examples show how a simple gray sphere behaves when subjected to reflected light.

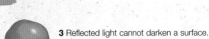

1 Near a bright pink swatch, this dull-surfaced object receives a small amount of reflected colored light. The surface appears more lifelike, and interest is added to the shadowed portion of the object.

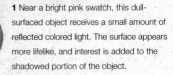

2 Increased specularity affects how the surface responds to reflected light. Think of the brightly colored swatch as a very weak light source.

3 Reflected light cannot darken a surface. This example is wrong.

4 However bright the source of reflected light, it can only lighten the surface on which it falls. Here, the gray sphere is lighter than purple, so there is no visible effect.

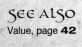

SEE ALSO
Value, page **42**

BEASTMAN

Driven into the wilds by civilized races, these creatures hold a grudge.

COPY THIS ▶

Beginner artists
start here:

*Trace this or scan it
into your computer
and color it.*

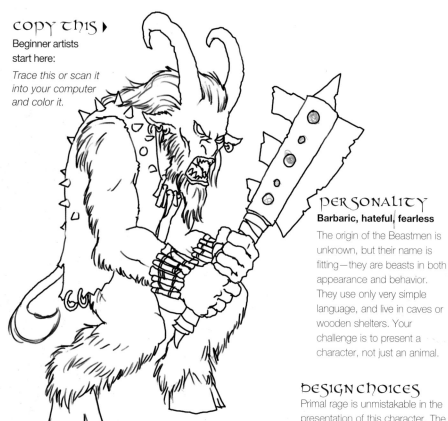

PERSONALITY

Barbaric, hateful, fearless

The origin of the Beastmen is
unknown, but their name is
fitting—they are beasts in both
appearance and behavior.
They use only very simple
language, and live in caves or
wooden shelters. Your
challenge is to present a
character, not just an animal.

DESIGN CHOICES

Primal rage is unmistakable in the
presentation of this character. The
body is tense and hunched like
an animal preparing to strike, while
the mouth is open in a cry of
anger, lips drawn back to show
intimidating fangs.

SEE ALSO

Proportions of the body, page **52**

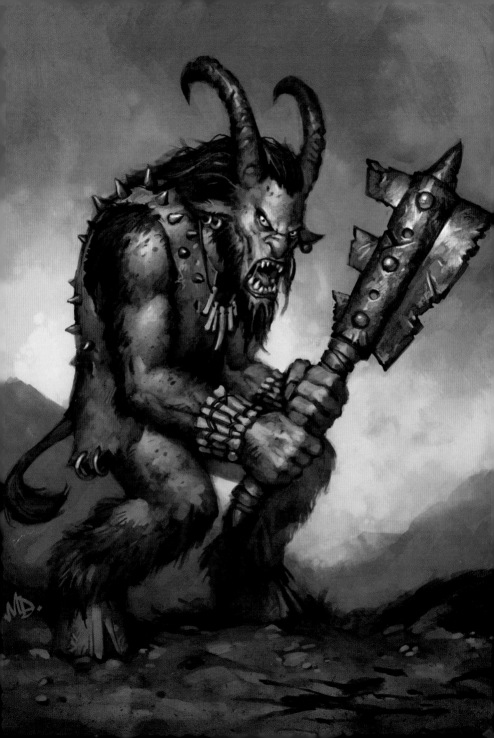

DEVELOPING CONCEPTS
BEASTMAN

Such primitive characters can be difficult. If a character's culture is too simple to help answer design questions, consider the history of the race. Beastmen are resentful and angry, particularly toward their persecutors.

COSTUME

Beastmen have neither the ability nor the requirement for any kind of craft: food is consumed raw; they do not build houses. Clothing and equipment is found or, more often, stolen on raids into civilized territory to avenge their banishment. Even stolen clothing has little practical use to the Beastmen, and is worn as a trophy. These unpleasant creatures' lifestyle means any garments will quickly become dirty and damaged.

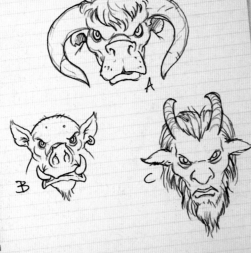

A: A bull is used as the basis for this head. Long horns are an interesting feature, but such a large head may not sit easily on a humanoid body.

B: Elements are taken from a wild boar, giving this face an aggressive appearance.

C: Traits from a goat are combined with the Human. Human proportions are retained for all the main features, allowing for a more complex expression in the final artwork.

BODY CONCEPTS

Beastmen are generally of similar size and proportion to Humans. However, there is great variety in these creatures, which can lead to extremes of size and shape. All are of muscular build. They stoop or hunch as if standing on two feet instead of four is unnatural.

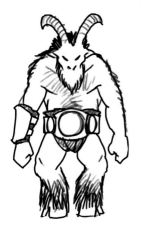

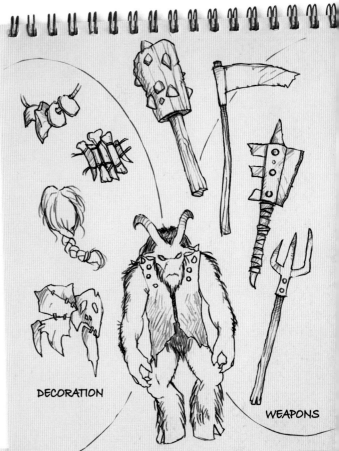

DECORATION

WEAPONS

WORKING UP DETAILS

● **Decoration:** While the Beastmen see no value in decoration, they may adorn themselves with souvenirs to increase their standing with other tribe members. Trophies taken from oppressors—teeth, bones, scalps, or even flayed skin—would be particularly prized.

● **Weapons:** Beastmen make and use only the most basic of tools. A sophisticated weapon of their own making would be little more than a heavy wooden club, perhaps with sharp rocks embedded in its surface. Most weapons will be stolen, and perhaps not initially intended as weapons at all—farm tools, such as pitchforks or scythes, for example. Any weapon falls swiftly into disrepair when owned by a Beastman.

CONSTRUCTION AND DRAWING GUIDE
BEASTMAN

Beastmen appear to be half-human, half-animal. Within a single Beastman tribe there are no two similar individuals. This gives you plenty of opportunity for creativity, when constructing the head and figure.

FRONT VIEW **SIDE VIEW**

CONSTRUCTION

Despite its bestial appearance, the features of this character align with the standard construction cage. Line **A** locates the eyes, line **B** the nose, and the mouth falls between line **B** and **C**. Note that the flat profile gives the impression of an elongated face.

A
B
C

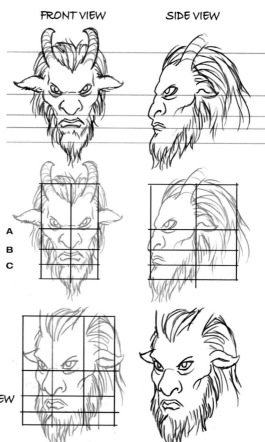

THREE-QUARTER VIEW

POSe

The Beastman's savage nature is best shown with an expression of rage. Picture the scene as your Beastman sights an adversary, then enters into combat. To begin with, your Beastman might bellow angrily at his foe, readying himself to attack. Next, he launches himself forward, raising his weapon. Finally, your Beastman strikes, swinging his weapon toward his prey. This simple action provides a number of possibilities when looking to pose your character—even more so if you imagine the action from different viewpoints.

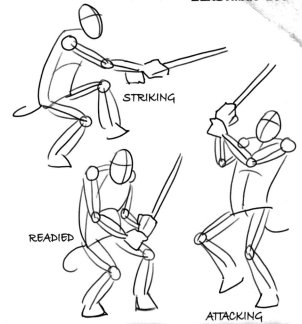

STRIKING

READIED

ATTACKING

ARTIST'S TIP: ADDING TEXTURE

Texture adds interest and realism to your artwork. It's particularly useful if you're trying to capture a gritty, dramatic fantasy world. A great way to add texture to your work is to use found or improvised objects—a toothbrush, wadded-up tissue, or a leaf dipped in paint can create effects that could never be drawn.

Texture effects are best added once the basic form and color of your material is established. Carefully apply the paint using your chosen object, then continue to work as normal. Render around the results to bring the texture to the fore, or work over it for a more subtle effect.

Digital artists don't have to be left out of the fun. Make marks with your found objects using black paint on white paper and scan the results. Most digital paint packages will allow you to create custom brushes from your scanned marks, or the raw scan can simply be overlaid on to the appropriate part of your artwork.

Direction of light source

TOOTHBRUSH SPONGE PAPER

Ghoul

Horrible nocturnal beast that feeds on dead flesh.

PERSONALITY
Reclusive, timid, opportunistic

Few creatures are more appalling than the Ghoul. Thankfully, the Ghoul's nocturnal existence and preferred habitat means that it is seldom encountered. The sight of one of these wailing horrors, particularly if disturbed while feeding, can chill the blood of the hardiest adventurer.

DESIGN CHOICES

This painting is arranged to focus maximum attention on the horrific face of the Ghoul. Lighting is placed to locate strong highlights on the creature's head, which will catch the viewer's eye. Limited details are applied to the body and background to increase the focus on the head.

◄COPY THIS
Beginner artists start here:

Trace this or scan it into your computer and color it.

SEE ALSO
Value, page **42**

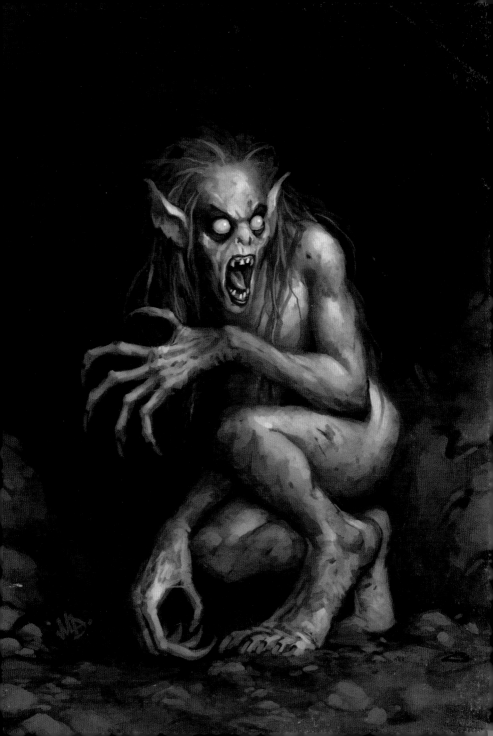

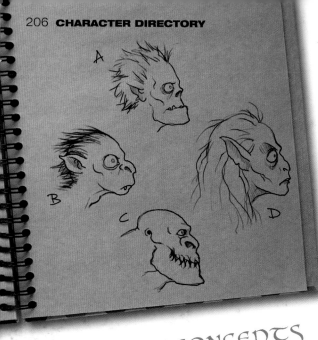

A: Sunken cheeks and eyes and a lantern jaw give this face a skull-like appearance. A short snout completes the effect.

B: Cave-dwelling rodents are the inspiration for this face, with large batlike ears and bulging eyes adapted to the darkness.

C: This face has features reminiscent of a skull, although here the jaw is greatly exaggerated, forming a hideous grin. The heavy jaw may have evolved to help the Ghoul crack its prey's bones.

D: Imagine how a human might evolve if left to live alone in a dark cave—enlarged eyes and ears to heighten the function of those senses, and long hair with pale, discolored skin.

DEVELOPING CONCEPTS
Ghoul

Ghouls are truly abhorrent. They shun the light by hiding in caves or tunnels and when night falls they emerge to feed—any carrion will do, but human flesh is their favorite and so Ghouls are most commonly found near graveyards.

BODY CONCEPTS

Ghouls are a little shorter than an average human. They are thin but muscular from clambering through caves. Long hands have fingers tipped with sharp, strong claws to help the Ghoul rip its food into mouth-sized pieces.

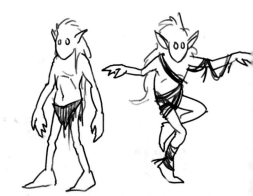

COSTUME

The Ghoul has no use for clothes. Its victims however, are wrapped in cloth, and the Ghoul will attempt to copy this behavior. Ill-fitting clothing stolen from corpses—torn and dirtied by the attack—might be worn. The Ghoul is more likely to wrap itself in what it finds than wear garments properly. Rags would give the Ghoul a ghostly look, and a shroud pulled around the body leaves the viewer to imagine what horror is hidden beneath.

WORKING UP DETAILS

- **Tools:** Perhaps the Ghoul employs simple tools to use in its gruesome activities, such as a heavy rock or tree branch to smash open a coffin, or a sharpened piece of bone to tear flesh. Perhaps the Ghoul has seen a key used to open a door, and carries one, believing it to be some kind of magical device?

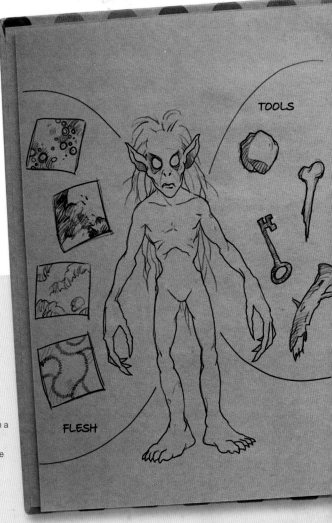

- **Flesh:** As with any character showing naked flesh, texture or patterns can be a useful way to add detail. The Ghoul provides numerous opportunities here: bulging sores from a hideous disease; bruises or cuts from conflict with another nocturnal predator; scars from a previous affliction; or patterns under the skin left by burrowing parasites.

CONSTRUCTION AND DRAWING GUIDE

Ghoul

A slender, spiky frame and angular skull construction allows you to pose the Ghoul in any number of horrible shapes and heighten the unsettling atmosphere that surrounds this character.

CONSTRUCTION

The Ghoul's head fits within the standard construction cage. To find the lower edge of the ears, draw a line from the vertical center in the front view, beyond where line **B** meets the edge of the cage. Hair can change the form of the head dramatically, so remember to discount this when you construct the Ghoul. Deal only with the hard masses of your creature's anatomy, adding hair only after construction is complete.

SIDE VIEW

FRONT VIEW

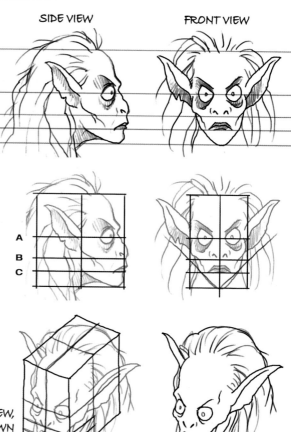

A
B
C

THREE-QUARTER VIEW, LOOKING DOWN

pose

The Ghoul provides many opportunities for interesting poses. Its thin, wiry body lends itself to dynamic, complex positioning, and the large hands with long fingers can be very expressive. Show the Ghoul climbing over uneven rocks to demonstrate how nimble it is. Represent the act of feeding to repulse your audience; the Ghoul can be shown tearing wildly at the meat in a stomach-churning frenzy. Have the Ghoul cowering away from a light source to show something of its timidity. For maximum effect, combine this with an expression of spite on the Ghoul's face.

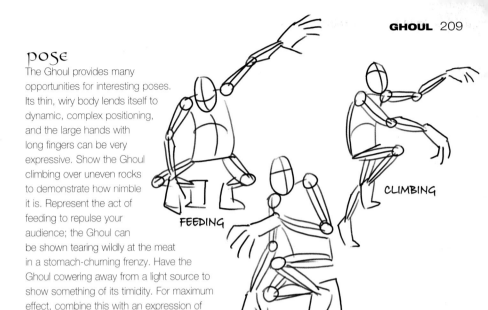

CLIMBING

FEEDING

COWERING

ARTIST'S TIP: RENDERING STONE

Vary the process below depending on the type of stone or rock you are dealing with, and whether it is natural or worked.

Direction of light source

1 Block in the area of stone with a mid-toned base color.

2 With a darker tone, work over the entire surface of the stone using strokes of varying length and weight to introduce texture. Apply this tone more heavily in shadowed areas to establish form.

3 Select a lighter tone and apply highlights, working with the texture established in the previous step.

4 Refine the surface of the stone. Strengthen edges to give the surface an angular or faceted appearance and add details.

5 Add a final round of highlights, picking out details and further defining the texture of the surface, to complete the material.

6 With the basic material, form, and texture defined, you can add interest to the stone with extra details—moss, lichen, mold, and so on.

VAMPIRE

Powerful beings whose supernatural abilities are fuelled by blood.

COPY THIS ▶

Beginner artists start here:

Trace this or scan it into your computer and color it.

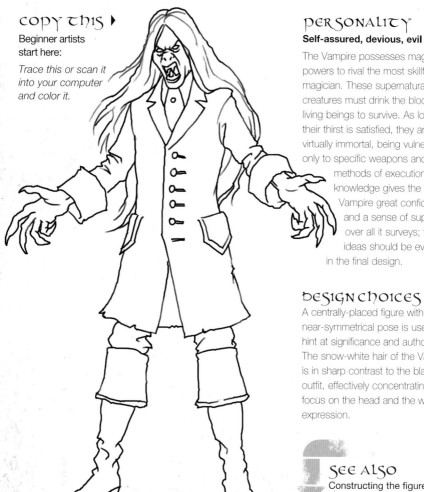

PERSONALITY

Self-assured, devious, evil

The Vampire possesses magical powers to rival the most skillful magician. These supernatural creatures must drink the blood of living beings to survive. As long as their thirst is satisfied, they are virtually immortal, being vulnerable only to specific weapons and methods of execution. This knowledge gives the Vampire great confidence and a sense of superiority over all it surveys; these ideas should be evident in the final design.

DESIGN CHOICES

A centrally-placed figure with a near-symmetrical pose is used to hint at significance and authority. The snow-white hair of the Vampire is in sharp contrast to the black outfit, effectively concentrating focus on the head and the wild expression.

SEE ALSO

Constructing the figure, page **56**
Constructing the head, page **62**

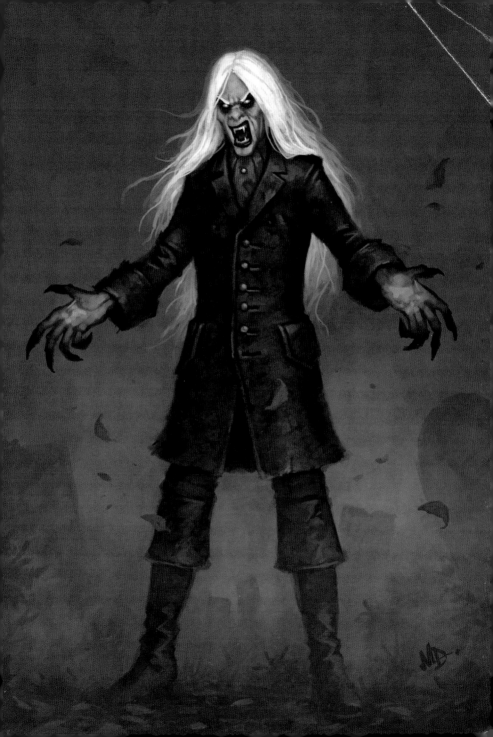

DEVELOPING CONCEPTS
VAMPIRE

The Vampire must have a demeanor of total confidence—all elements of the design must support this for the character to be successful.

FACE

Which aspects of the Vampire's personality or behavior can be shown in the face? The messages sent to the viewer must be subtle, and this should be carefully considered.

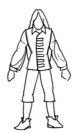
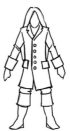
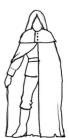

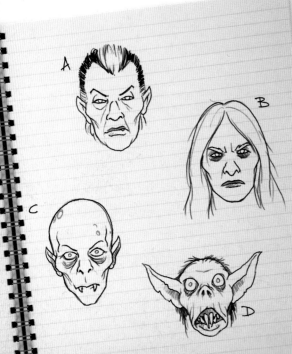

A: The face is humanoid, with only pointed ears and the protruding tip of a fang hinting that the face is Vampiric. Hair is tidy and well-groomed, a subtle indication that this character appreciates control and order.

B: A younger face. No obvious indications of this character being a Vampire. Long silver hair nods to the Vampire's long life. Darkened lips and eye sockets contrast with pale flesh.

C: Both age and Vampiric attributes are more obvious here. The sunken cheeks, delicate jawline, and bald head give a ghostly look to this face.

D: The pointed ears and fangs associated with the Vampire are taken to the extreme here. The rest of the face is distorted to create a monstrous visage. This look will make it difficult to communicate the self-assured nature of the Vampire.

BODY CONCEPTS

Vampires appear as unusually tall humans. Pallid flesh, large hands tipped with clawlike nails, and long fangs reveal their true nature.

COSTUME

In popular culture the Vampire is often shown in formal dress. In a contemporary setting this may serve to place the creature out of time, in acknowledgment of its long life, but it also ensures that the Vampire is the best-dressed character in the scene. This simple device gives the character *gravitas*, a superior appearance, and commands our deference. This is applicable in all settings, including fantasy. The Vampire is a power-dresser. Sketch out costumes referencing layered or fitted historical styles.

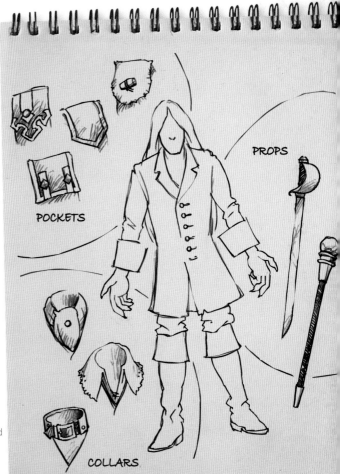

POCKETS

PROPS

COLLARS

WORKING UP DETAILS

- **Props:** The Vampire relies wholly on his potent magic. No props or weapons are necessary. Certain objects may be carried as part of the character's overall outfit, however; a walking cane or dress sword might sit well with a finely tailored suit.

- **Pocket:** To add detail to the Vampire's jacket (or other garments), initially choose a single element to work with. Develop the details in a single, simple area, such as a pocket flap, before reusing it in other areas of the garment.

- **Collar:** With an outfit in a single color, the jacket's open neck allows for an interesting focal point. Choose a contrasting color or flamboyant shape to grab the viewer's attention. Perhaps the Vampire might wear some protection against decapitation—one of the few methods of bringing about its death.

CONSTRUCTION AND DRAWING GUIDE
VAMPIRE

Your viewer should be in no doubt that the Vampire is a force to be reckoned with. This impression must be created without the use of extravagant props or extreme physical or facial distortions since neither is appropriate.

CONSTRUCTION

The proportions of the Vampire's head are identical to the human and therefore they conform to the measurements of the standard construction cage. Turn back to page 70, where the Hero is addressed, to remind yourself how to mark up the face proportionally.

FRONT VIEW

SIDE VIEW

THREE-QUARTER VIEW

pose

Stance is very important in communicating the
Vampire's self-assured nature. This character will
be calm and calculated at all times. Even when
provoked to anger, the Vampire's response will
be deliberate. Symmetrical poses are an
easy way to give balance, and therefore
hint at a sense of control and deliberation
in your character. Symmetrical poses
are also unnatural-looking, as people
will rarely adopt such a stance
unless prompted.

Outstretched arms, particularly
if draped in a cloak, give the
impression of wings: an iconic
Vampire image. Show that your
Vampire exercises control, even during
extreme emotion, with a symmetrical
pose as he screams in
anger. Twist the viewpoint
slightly to add interest.

ICONIC

ANGER

WALKING

ARTIST'S TIP: ATMOSPHERE

"Atmosphere" is an elusive
quality which relies on many
factors, not least the
expression of your character,
the setting, and the lighting.
Weather and other
atmospheric effects are
particularly evocative, and are
a very effective way to build
atmosphere in your artwork.
They add interesting visual
elements to your image, but
also suggest sounds, smells,
and other sensations to
your viewer.

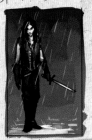

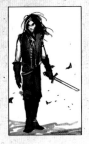

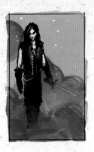

Rain at night or under
stormy clouds creates
an oppressive,
ominous atmosphere
and wet surfaces
produce dramatic
lighting effects.

Wind suggests a wild
energy. Dynamic
shapes are possible
where characters
have flowing hair or
robes. Reinforce the
presence of wind with
airborne particles
such as leaves.

Where a character is
partially hidden in
smoke or other vapor,
an air of mystery is
created. Smoke can
also add drama,
particularly if
contrasted against
fire. Flying embers or
soot add energy.

SEE ALSO
Value, page **42**

MERMAID

Aquatic character with a fascination for land dwellers.

PERSONALITY

Inquisitive, cautious, alluring

The Mermaid is a popular figure in myth, and is featured in many stories. You must be aware of relevant folktales and mine them for information to inform your design.

DESIGN CHOICES

The classical appearance of the Mermaid in fairytale forms the basis of this design. Subtle untraditional changes—extremely long hair and an unusual, fishlike face—add interest to the character here, but your viewer will still be able to identify this fantasy archetype easily.

◀ COPY THIS

Beginner artists start here:

Trace this or scan it into your computer and color it.

SEE ALSO

Constructing the head, page **62**
Practical applications and stereotypes, page **33**

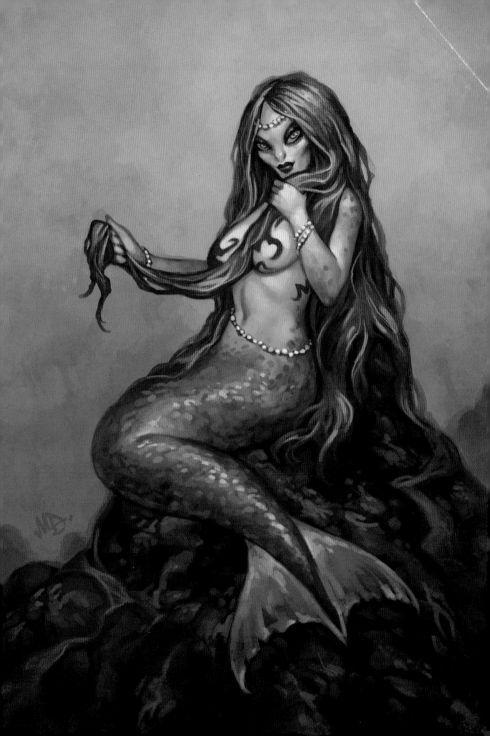

DEVELOPING CONCEPTS
MERMAID

Are Mermaids solitary creatures, or part of a wider society? Finding answers to questions like this will help to build a picture of your character's background and understand her personality.

FACE

How do Mermaids survive beneath the water? Are they fish, mammals, or a strange hybrid? Your design can answer such questions for you. See how different answers to this question might influence the Mermaid's appearance, and choose the option with the strongest visual appeal.

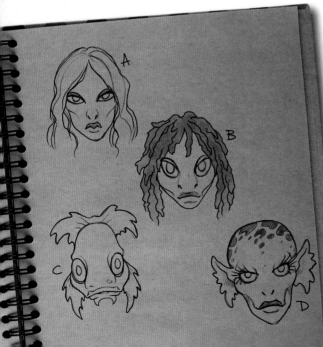

A: The human face is slightly distorted, and made fishlike. The nose is undeveloped, the eyes are large and set wide apart. This face looks as if it belongs to a mammal, though gills could be hidden beneath the flowing hair.

B: Fishlike features are more pronounced, with rounder eyes, wide mouth, and a reduced jawline. Hair has the appearance of kelp.

C: The metamorphosis is complete. Hair is replaced with elaborate fins, which retains some femininity—but this design could easily become asexual.

D: The facial proportions are humanoid, but aquatic creatures inspire the details.

WORKING UP DETAILS

- **Decoration:** Reinforce your Mermaid's connection with the ocean by choosing decorative details that relate to the sea. Shells, coral, or pearls might be fashioned into jewelry. Anemones or starfish can provide an alternative to flower garlands.

- **Patterns:** Aquatic life is varied and often beautiful. Examine the scales and markings of exotic fish and coral—even the play of light on the ocean floor—to inspire patterns for her body.

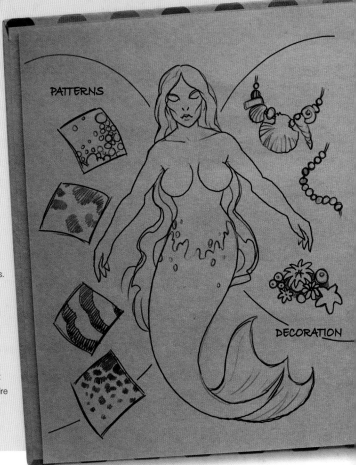

PATTERNS

DECORATION

BODY CONCEPTS

What draws Mermaids to the surface? If we assume the Mermaids' curiosity is driven by their similarity to humans, it is important that this relationship is clear. The Mermaid's upper body should closely resemble a human female. Consider what can be done to make the lower body design interesting. The traditional image of the Mermaid shows her with the tail of a fish, but there are many other sea creatures that could provide an elegant lower body. Sketch thumbnails to explore different ideas, favoring shapes that will support the Mermaid's femininity.

CONSTRUCTION AND DRAWING GUIDE
MERMAID

Merfolk exist beneath the sea, where their civilization lies undisturbed by land creatures. Mermaids, however, are drawn toward activity above the waves—no doubt they see the similarity between humans and themselves. This should be represented in your design decisions.

CONSTRUCTION

The eyes are located along the horizontal center line (**A**). Although small, the nose is slightly elongated, so the tip, rather than the base, aligns with line **B**, on the standard construction cage. The mouth is located along line **C**. Take care to keep the jawline delicate and to exaggerate the tapering chin, as this will make the eyes appear larger.

SIDE FRONT

A
B
C

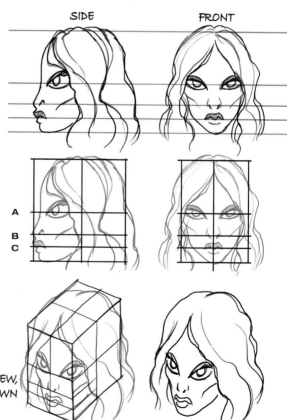

THREE-QUARTER VIEW, LOOKING DOWN

pose

How would the Mermaid behave when observing humankind? Answering this question will help decide on a suitable pose. Simple curiosity may be shown by placing the mermaid in a relaxed pose on a rock—perhaps partly hidden to show that she is unsure of the creatures she watches. Mermaids are intelligent creatures and would certainly have noticed that the curiosity between species is mutual; this could motivate other behavior. Show the Mermaid leaping from the water in order to see the humans' reaction to the spectacle, or idly teasing her hair as she casts coy glances at passing seafarers.

LEAPING

IDLING

SEATED

ARTIST'S TIP: RENDERING PATTERNS

Patterns can quickly overpower the shape of an object, flattening the illusion of volume. Always ensure that the form of your object is clearly established before adding surface detail.

Direction of light source

1 Render the surface according to the material type.

2 Add the pattern (tattoos, markings, body paint) in transparent layers to allow the tones of the surface below to show through. Take care to mold the shape of the pattern around your object to support the form.

3 With a flat pattern established, extra detail may be added if required. Work into the patterned areas to give different material properties or relief (remembering to adjust the profile of the object where appropriate).

4 Even simple details can add interest to a surface. Adding a subtle highlight to the edges of the patterns gives the impression that the pattern is indented.

WITCH

An ancient crone with mysterious powers and sinister intent.

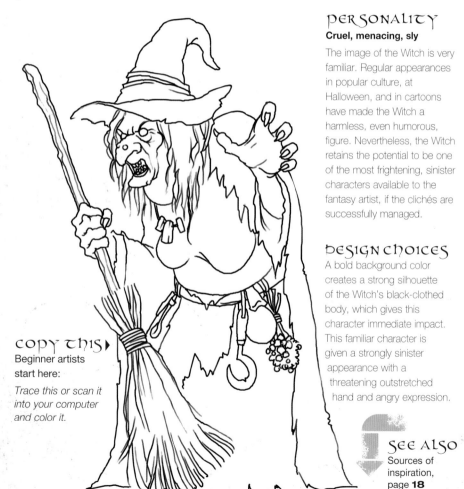

PERSONALITY
Cruel, menacing, sly

The image of the Witch is very familiar. Regular appearances in popular culture, at Halloween, and in cartoons have made the Witch a harmless, even humorous, figure. Nevertheless, the Witch retains the potential to be one of the most frightening, sinister characters available to the fantasy artist, if the clichés are successfully managed.

DESIGN CHOICES

A bold background color creates a strong silhouette of the Witch's black-clothed body, which gives this character immediate impact. This familiar character is given a strongly sinister appearance with a threatening outstretched hand and angry expression.

COPY THIS▶
Beginner artists start here:

Trace this or scan it into your computer and color it.

SEE ALSO
Sources of inspiration, page **18**
Color, page **44**

DEVELOPING CONCEPTS
WITCH

The archetype of the scary old woman has great resonance. Beyond her frightening appearance, we are afraid of her without knowing why. This air of mystery is a key part of the design.

FACE

Your Witch does not need to be visibly old or grotesque; she can take any form you choose. However, setting boundaries before you begin to design helps to focus the conceptual process, so start with the archetype of the Witch as an old woman. Even within this limit, there is much to explore.

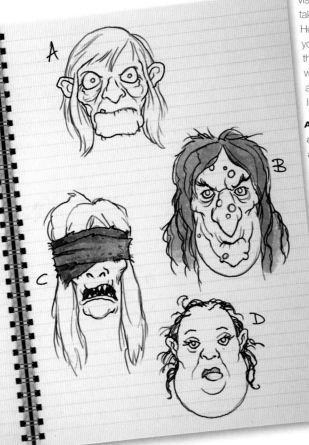

A: The face is thin, distorted by old age. Large, bulging eyes give the witch an alarming stare.

B: Here, age affects the face in a different way—the cheeks are sunken, whereas the neck is horribly bloated. Warts, along with a pointed nose and chin, are iconic features of the Witch.

C: An ancient face is partly obscured beneath a bandage covering the eyes. Hiding the face adds mystery, and suggests some unsettling ritual or punishment that the character may have endured.

D: Another old face, but this time the witch is swollen. Thinning, tousled hair gives a dirty, unkempt aesthetic.

WORKING UP DETAILS

- **Staff:** The broom is a classic Witch's prop, but other items may also suit—a simple wand or a staff hung with totems, for example.

- **Items:** Objects on the Witch's person give the viewer clues to her behavior. A sickle, spoon, and bunch of dried herbs suggest that she has been foraging for ingredients for a spell.

- **Hats:** Think about how a hat will interact with the Witch's head: a bonnet creates mystery by obscuring her profile; a skullcap made from pale material provides a good contrast against her dark, dirty hair.

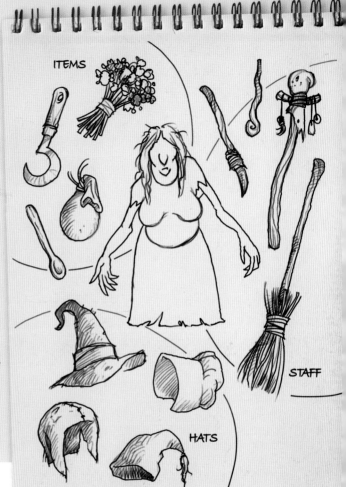

ITEMS

STAFF

HATS

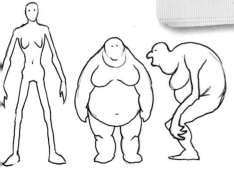

BODY CONCEPTS

The Witch's great age should show in her body. Stance and proportions should match her face in grotesqueness. Discolored, dirty flesh will add to her unpleasant appearance. Illness, diet, and immobility can cause extreme results—swelling of the body or atrophied muscles. Either of these states would be suitable for the Witch, but a combination of the two is more effective; a bloated, hunched body is more unpleasant when coupled with skeletal limbs!

CONSTRUCTION AND DRAWING GUIDE
WITCh

The Witch's malformed body is hidden beneath her dirty clothing, so concentrate your efforts on the head and face to begin with. To prevent her body becoming shapeless and confusing, ensure that you present recognizable anatomical details.

CONSTRUCTION

The usual measurements apply, even with a face as extreme as this. Beneath the twisted features, there still lies a rigid skull; the soft tissue may distort, but the bone beneath will not. Imagining the rigid structure beneath the face can help to prevent unrealistic exaggerations.

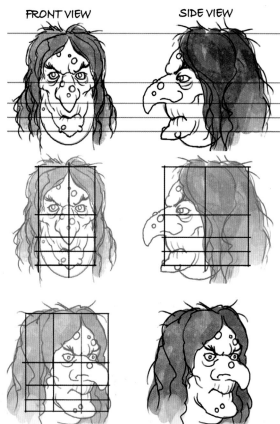

FRONT VIEW

SIDE VIEW

THREE-QUARTER VIEW

pose

A grasping hand reaching out from the page shows clearly that the Witch wants to catch the viewer! This sits well with childhood fears about Witches. A Witch could be depicted foraging for ingredients or show a wild, angry temperament by having her arms thrown up, with her face contorted into a cry of rage. This would allow you to draw attention to the Witch's disfigured body, and create a frightening image.

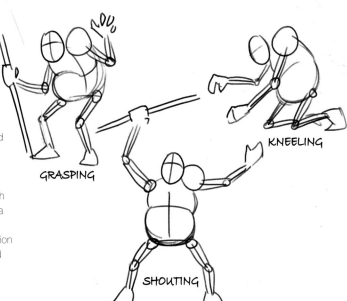

GRASPING

KNEELING

SHOUTING

ARTIST'S TIP: Focus

Understanding how to control the focus of your images is an essential skill. The viewer's eye will be drawn to the areas of greatest contrast in your artwork. You should plan your composition, design, and lighting with this in mind.

▲ **1** Contrast is uniform throughout this image. There is no clearly defined focal point.

▼ **2** A stronger light source is introduced, positioned so that a bright highlight is placed near the character's hairline. This is the strongest contrast in the image and becomes the focal point.

▲ **3** An image may have several focal points. Highlights are introduced on the axe, and strengthened throughout the image. The white of the eye is introduced.

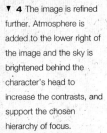

▼ **4** The image is refined further. Atmosphere is added to the lower right of the image and the sky is brightened behind the character's head to increase the contrasts, and support the chosen hierarchy of focus.

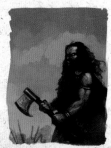

TREEMAN

Strange creatures dwelling in deep forests, far from civilization.

COPY THIS ▼

Beginner artists
start here:

*Trace this or scan it
into your computer
and color it.*

PERSONALITY

Gentle, mysterious, wary

Little is known of the Treemen.
They are rarely seen and,
though apparently kindly in
nature, they avoid contact with
other creatures. They prefer
to stay hidden in forests among
the trees with which they share
a deep connection. This
character design demands
that you work outside a
humanoid framework.

DESIGN CHOICES

A neutral pose suggests the
slow, deliberate movement of the
Treeman. It's important that the
similarity between this character
and a tree is obvious, so this
design places the significant
elements—the foliage and
trunk—where the viewer
expects to find them.

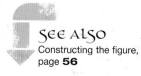

SEE ALSO

Constructing the figure,
page **56**

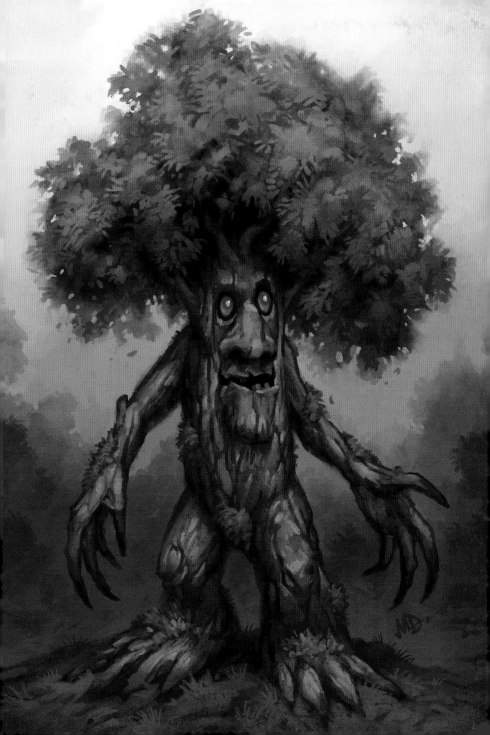

DEVELOPING CONCEPTS
TREEMAN

Treemen look like trees. At first, this seems to be a straightforward premise on which the artist can work, but trees are hugely varied, and finding a place to begin the design process can be a daunting task.

FACE

Make a start by considering the face. However the concept progresses, this creature must have a recognizable face to communicate an expression, so the viewer must recognize that it is a living being. The face will help shape the rest of the design.

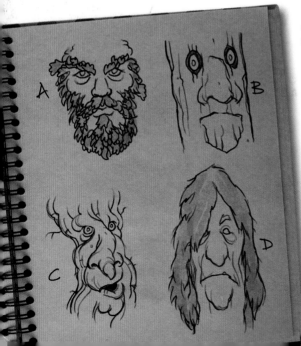

A: A simple approach. The beard here is replaced with foliage, but integrating this face convincingly with the form of a tree may prove difficult.

B: Recognizable features emerge from the bark of this regularly shaped trunk.

C: A face appears in the abstract, twisting forms of this ancient tree trunk.

D: Here, a humanoid face is distorted into treelike shapes. The features are elongated, with deep creases to create the appearance of bark. Hair is arranged in thick, matted clumps to look like moss or drooping foliage.

WORKING UP DETAILS

- **Vegetation:** Add details of natural elements to your Treeman. Heavy moss or creeping vines can be placed to appear as hair or a beard, or simply to add interest. Flowering vines can accent your design with color and suggest a friendly, peaceful nature.

- **Bark:** Choose a bark that fits the shape and design of your Treeman—a heavy, craggy surface for a large, bulky tree, or a smoother patterned bark for a slender design. The surface should be interesting, but not busy enough to distract from the overall design, or hide the Treeman's face.

BARK

VEGETATION

BODY CONCEPTS

Just as the face is important to show that the Treeman is alive, the body must have clearly visible limbs so that the viewer knows this character can move. The finished design must be more than a tree with a face stuck on it, so avoid making arms and feet too similar to branches and roots; the limbs must be recognizable. Expand on the designs for the Treeman's face to see how they influence the body. Sketch thumbnails using the shapes and ideas you have established in the faces to give the Treeman a trunk and limbs.

CONSTRUCTION AND DRAWING GUIDE
TREEMAN

Such a simple figure can easily appear comical or awkward. Avoid that possibility by following the same principles established with more traditional characters to create convincing poses and expressions.

CONSTRUCTION

Constructing the Treeman's face is simple. His trunklike body is basically a cylinder, and three equidistant lines drawn horizontally around this shape will locate the eyes, the base of the nose, and the bottom of the chin.

FRONT VIEW　　　**SIDE VIEW**

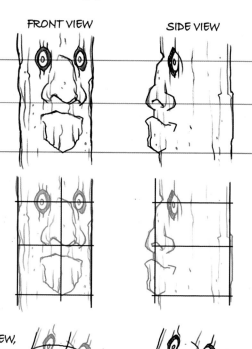

THREE-QUARTER VIEW, LOOKING UP

POSES

Imagine how a living tree would move.
Fast, flexible actions do not suit this
design. The Treeman's lack of neck
and waist mean his gestures
would be stiff and jerky, and his
movement slow. Choose
poses that support this.
Walking shows that this
creature is mobile, and
presents an opportunity to
show his stiff movement. To
illustrate the Treeman's mobility,
choose an action that he would find
difficult, such as stooping. Carrying a
heavy weight results in naturally slow
and stiff gestures, so draw the Treeman
lifting a boulder.

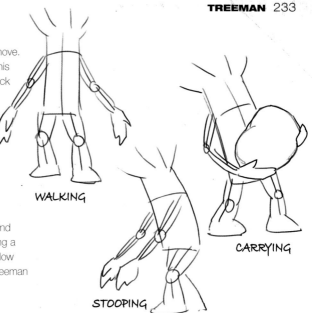

WALKING

CARRYING

STOOPING

ARTIST'S TIP: RENDERING WOOD

Wood may appear in a wide variety of colors and finishes. Its soft surface is
easily worked or damaged to produce interesting textures. An obvious grain
is the easiest way to tell your viewer that a surface is made of wood.

Direction of light source

| **1** Begin by laying down a mid- to dark-tone as a base. | **2** Use a lighter tone to illuminate the surface and establish the basic form. | **3** Select a tone slightly darker than the base color to apply wood-grain patterning. Applied uniformly, this will flatten the form, so apply lightly in illuminated areas, and more heavily in shadow. | **4** Choose a tone lighter than that used in step 2. Further refine the form by working into illuminated areas. Indicate texture depending on whether your wood has a smooth finish or an open grain. | **5** Unfinished wood has a dull surface, but will still reflect some light. A simple wooden material is complete at this stage. | **6** If wood is finished—varnished, lacquered, or simply polished through use—a highlight needs to be added. The tighter the highlight, the smoother and glossier the surface will appear. |

GIANT

A towering humanoid, feared for its great size.

COPY THIS ▼

Beginner artists start here:

Trace this or scan it into your computer and color it.

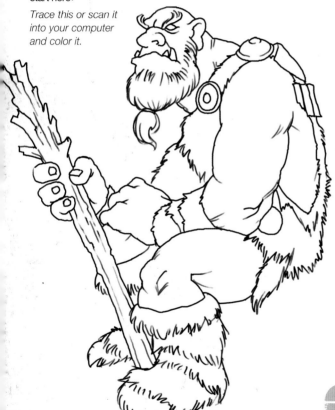

PERSONALITY

Independent, curious, bad-tempered

The Giant is a classic fantasy character. Giants take many forms and their nature may be kindly, cruel, or indifferent. One factor unifies all Giants: their tremendous size. Whatever appearance you choose for your Giant, and however he behaves, you must consider methods to firmly establish the scale at all stages of the design process.

DESIGN CHOICES

Great size and mass are the defining characteristics of this character. A pose is chosen which overlays all the Giant's limbs to bulk out his form on the canvas. Scale is established by the shields attached to his costume and by the birds in the scene.

SEE ALSO

Proportions of the body, page **52**
Before you begin, page **38**

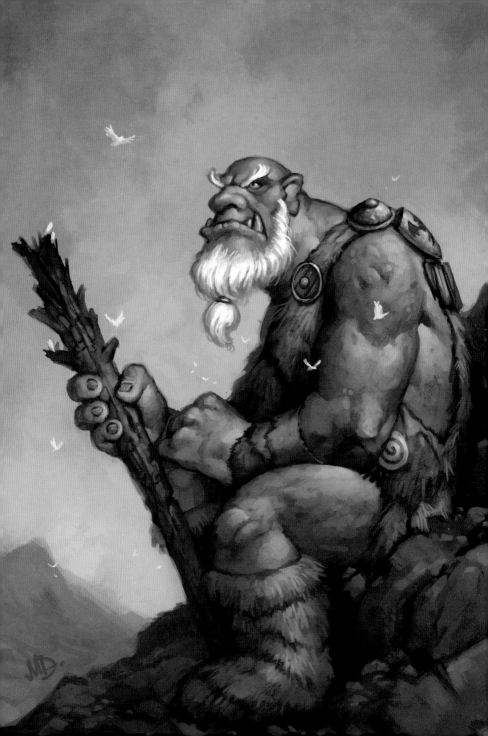

DEVELOPING CONCEPTS
GIANT

All Giants are solitary creatures, spending long periods alone—perhaps in their lairs, perhaps wandering their lands. They are profoundly thoughtful and curious about other creatures.

FACE

Because of their size, Giants are feared by many smaller beings and are often considered to be aggressors. Think about the Giant's feelings and how this might show in his face. Human features will make subtle and convincing expressions easier to achieve.

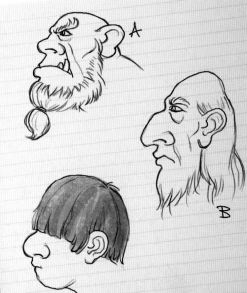

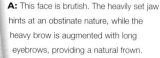

A: This face is brutish. The heavily set jaw hints at an obstinate nature, while the heavy brow is augmented with long eyebrows, providing a natural frown.

B: An attempt to indicate the Giant's size by showing subtle effects of gravity on its features. The large, fleshy features—nose, ears, and lips—all have a slight downward droop. This downward flow is accentuated by the flowing hair and beard.

C: The face and features are rounded, giving the impression of youth. Perhaps this Giant is a juvenile? Hair falls over the face, obscuring the eyes—this detaches the Giant from the viewer and suggests something of its solitary, insular nature.

COSTUME

The Giant's costume is an excellent opportunity to establish his scale. The Giant must be clothed in garments of its own making. Swaths of material wrapped around the Giant's body serve its purpose but do little to show the character's scale. Instead, show garments made from recognizable items associated with scale: a patchwork vest made of clothes belonging to humans, or a costume of animal hides stitched together, for example.

BODY CONCEPTS

Giants may stand 20 feet tall or more and have considerable girth—the Giant's body will be almost as wide as it is tall. Broad limbs and a large gut give an impression of weight.

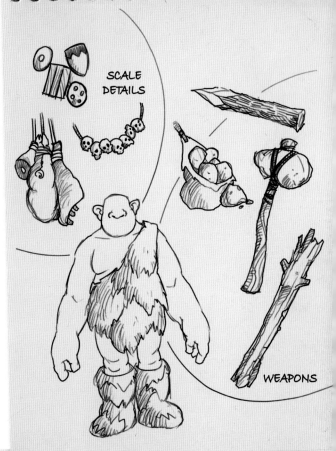

SCALE DETAILS

WEAPONS

WORKING UP DETAILS

- **Scale details:** Choose details in your design that communicate the scale of this character by showing how familiar items relate to the Giant's size: the shields of potential Giant-killers might be worn, meat (maybe whole animals!) could be carried, and skulls or bones may be worn as decoration.

- **Weapons:** The Giant's size and strength will determine what weapons are appropriate. As with the costume, these will be objects the Giant constructs for itself, but even crude objects will be effective in such powerful hands. A bag of throwing boulders may be carried. A tree trunk may have many uses: sharpened to form a stabbing weapon, tied to a huge rock to make a hammer, or used as a bludgeon.

CONSTRUCTION AND DRAWING GUIDE
GIANT

The head on its own does little to communicate the Giant's scale. Remember that the Giant is a bulky creature from head to toe, and this will help you design a suitable pose.

CONSTRUCTION

To construct the Giant's head, divide the construction cage into quarters. The center line (**B**) lies at the base of the nose and defines the lowest point of the ear. The upper line (**A**) locates the eyes. The lower line (**C**) falls between the lower lip and chin.

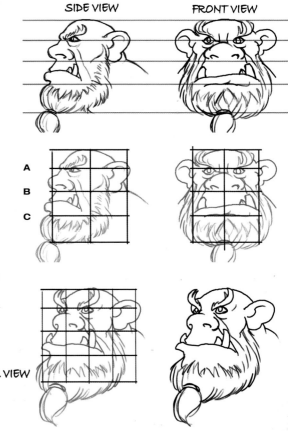

SIDE VIEW

FRONT VIEW

A
B
C

THREE-QUARTER VIEW

pose

Although a Giant will fight when pressed, this says little of its true character, so avoid combat when choosing a pose for this creature. Set the creature off against background objects to show its size. Have the Giant sleeping in its lair, perhaps surrounded by objects collected from smaller beings. Show it traveling, using its huge weapon as a walking stick as it strides through a forest with the treetops at its waist. Or, place the Giant in a deserted setting—seated on a rocky outcrop on a mountainside—to illustrate its solitary existence. Birds flying near the creature can also establish scale.

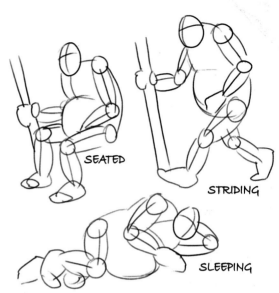

SEATED

STRIDING

SLEEPING

ARTIST'S TIP: RENDERING FUR

Fur and short hair can be handled in the same way. Vary the lengths of your brush strokes and details to give different lengths and textures.

Direction of light source

1 Lay down the basic shape of your fur using a mid-tone color. Leave a soft edge to indicate that the material is soft.

2 Use a lighter tone to establish the form of the surface. Apply this color with short, broken strokes to indicate texture. Leave the base color showing through in areas, giving the surface depth.

3 With the base tone, refine the form. Work into the texture established in step 2 to define clumps of fur. Add details to the profile of the shape.

4 Choose a lighter tone to further refine the surface, again using short brush marks to indicate texture. Overlap the darker marks from the previous stage to add depth.

5 Fur transmits light well, and tends not to display dark areas of shadow. Help to further define the form, and reinforce the softness of the material, by adding reflected light where appropriate.

6 Dirty or dull fur is complete at step 5. For fur that is oily, shiny, or wet, add a final round of highlights. Work sparingly into the texture you have already established, so as not to break up the form.

DRAGONKIN

Believing themselves to be superior, these reptilian humanoids avoid contact with other races.

PERSONALITY

Authoritarian, suspicious, cold

Dragonkin look down on all other creatures. Considerable strength and intelligence combine to give these creatures a sense of physical superiority over other races. They consider other societies to be decadent and chaotic. Dragonkin live in walled cities, shut away from the savages. that surround them. This is a complex character for the artist to tackle effectively.

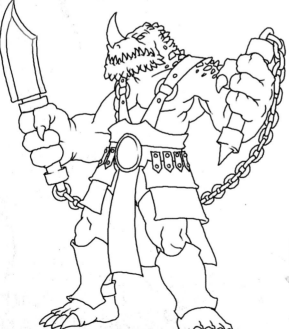

DESIGN CHOICES

A variation on the Japanese nunchuck was chosen to be the Dragonkin's weapon. A large blade makes it clear this is dangerous armament, but how the twin chain-linked batons might be employed in combat is not immediately obvious—this increases the likelihood of the viewer imagining a flamboyant and exotic fighting style. Large armor plates suggest weight and subtly increase the character's bulk.

◀ COPY THIS

Beginner artists start here:

Trace this or scan it into your computer and color it.

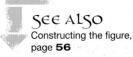

SEE ALSO

Constructing the figure, page **56**

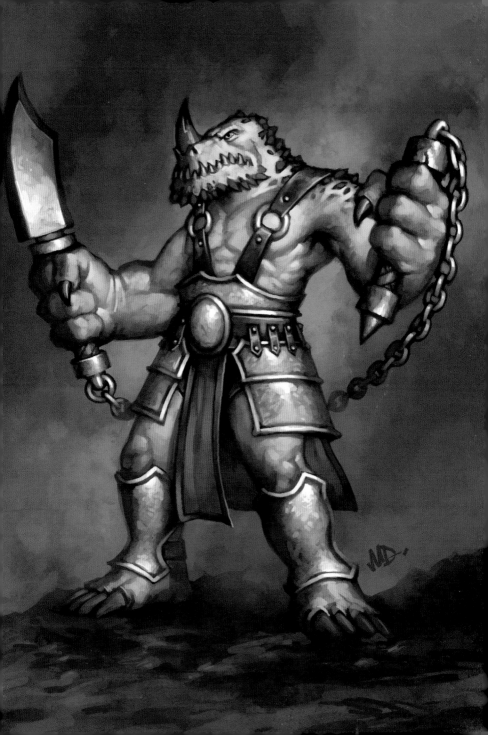

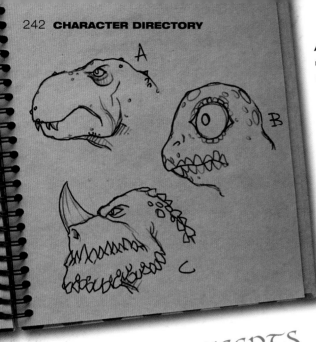

A: Dinosaurs are easily recognizable reptiles. The head of the Carnosaur is associated with strength and danger. However, an equal relationship with savagery, unsuitable for the Dragonkin, might be difficult to overcome.

B: Large eyes denote intelligence—an obvious way to show the reptilian influence.

C: Protruding scales and sharp teeth give this head an aggressive appearance. The shape of the head and the placement of features are subtly humanoid. This prevents the head appearing too animal-like, and shows that this creature is intelligent.

DEVELOPING CONCEPTS
DRAGONKIN

Dragonkin feel little emotion. They deal purely in logic and are concerned only with practical matters. This can help inform aspects of the design, particularly props and costume.

BODY CONCEPTS
Dragonkin are taller and more powerfully built than an average human. Though Dragonkin do not seek conflict, they are capable warriors. Show power and agility with broad shoulders and a narrow waist. The arms naturally fall away from the body, and appear to be flexed, ready for action. Sketch out thumbnails to see how this shoulder and waist combination might work with different body types.

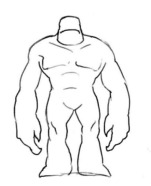

FACE

As the head of any creature will almost certainly draw the eye first, this is the best place to show a reptilian influence in the Dragonkin's design. Study reference material of real reptiles. Try to identify distinct characteristics and features commonly associated with reptiles which can be incorporated into your creation.

WORKING UP DETAILS

● **Weapons:** Assert the exotic aspects of the Dragonkin's culture with unique weapons. Avoid swords or axes. Instead, design weapons with strangely shaped blades, or which imply an unusual fighting style.

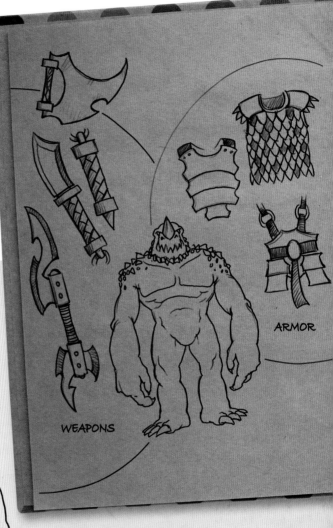

WEAPONS

ARMOR

● **Armor:** Remember the Dragonkin's practical, logical nature. Unusual designs suit the Dragonkin, but function is of paramount importance and unnecessary frills or ornaments are inappropriate. Think how a reptilian flavor might be introduced here, with armor plates arranged like lizard scales.

CONSTRUCTION AND DRAWING GUIDE

DRAGONKIN

The strongest reptilian features of the Dragonkin character are all contained within the head. Take care to pose the character to emphasize this important aspect of the design.

CONSTRUCTION

The Dragonkin's features are easily located using a construction cage, split horizontally into quarters. The eyes align along the uppermost split (**A**), with the nostrils sitting just above the horizontal center line (**B**). The third split (**C**), represents the mouth.

FRONT VIEW

SIDE VIEW

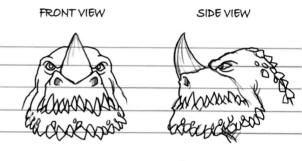

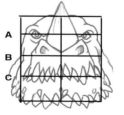

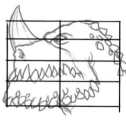

THREE-QUARTER VIEW, LOOKING DOWN

pose

Posing such a complex character presents problems, particularly when only showing one figure. Depicting the creature leaping into battle can show the Dragonkin's physical power. Presenting a large airborne frame will deliver a sense of energy and anticipation. Illustrate the controlled, calculating mind of the character by selecting a symbolic pose, suggesting some cultural or religious ritual. However, both these poses show only one aspect of the Dragonkin. More subtle devices must be employed to show greater depth of personality. Combine both of these aspects by drawing the Dragonkin in a pose that is static, yet tense. The stillness of the pose reflects clarity of mind, while the tensed muscles and raised weapon show that action is only a split second away.

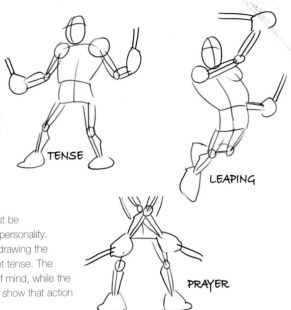

TENSE

LEAPING

PRAYER

ARTIST'S TIP: cbain

Chains of various types feature regularly in the costume and weaponry of fantasy characters. As a rule of thumb, chains should be simplified so that alternate links are aligned in the same way.

Simplifying the links creates a pattern which is much easier for the viewer to decipher and gives a more pleasing, elegant line, particularly when the chain hangs in an arc.

 X

Showing some twist to the chain can enhance its appearance, but this should be used sparingly, since too many variations in the orientation of the links can cause confusion.

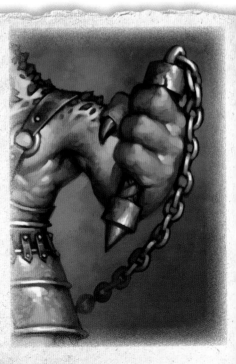

IMP

Small, simple-minded creatures bred as slaves by evil sorcerers.

COPY THIS▼

Beginner artists start here:

Trace this or scan it into your computer and color it.

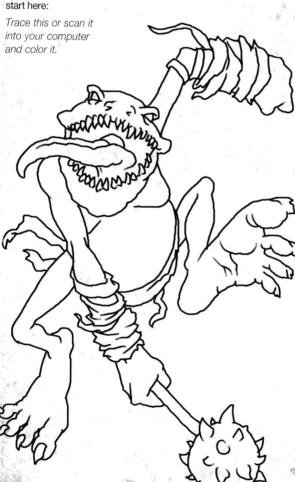

PERSONALITY

Frantic, obsessive, fearless

Imps are hyperactive, quarrelsome, permanently hungry, and very, very noisy. Because of their diminutive size, a single Imp is no more than an irritation to a capable Warrior. However, a pack of these shrieking, frenzied creatures can overwhelm even a party of hardy adventurers. Here, you must show a creature that is wild, driven only by its master's usually unpleasant bidding.

DESIGN CHOICES

Choosing similar shapes for the head and belly gives the design rhythm. The spiked ball of the mace helps this further, picking up the shapes of the teeth and stomach. The long, thin limbs allow for a dynamic and expressive pose that represents the Imp's frantic nature.

SEE ALSO

Composition, page **39**

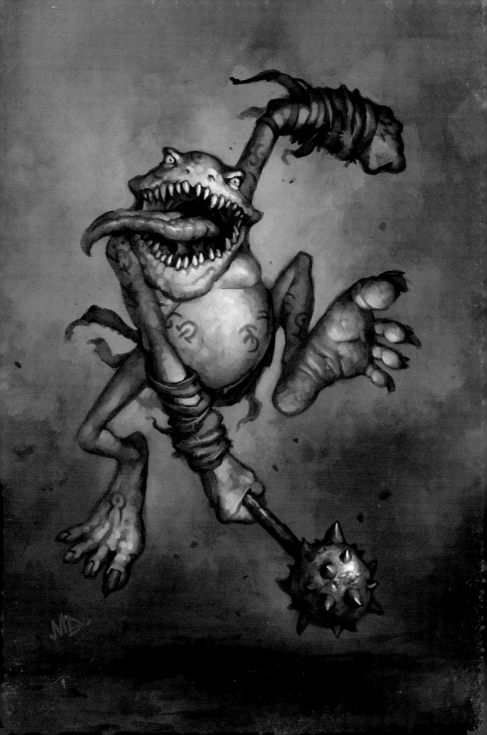

DEVELOPING CONCEPTS
IMP

The Imp's small mind can cope with only one task at a time. Once an instruction is given, it will not stop until its job is complete. Imps have few skills beyond loyalty to whoever fills their hungry bellies and a frenzied delight in causing pain; this makes them ideal slaves to evil magicians who need guards or soldiers.

FACE

A simple design best suits this simple character. The Imp has no subtlety, no hidden depths. Avoid humanoid traits in the head's design, since that might suggest intelligence, or complex emotions. Features should be bold and brash, in keeping with the Imp's behavior.

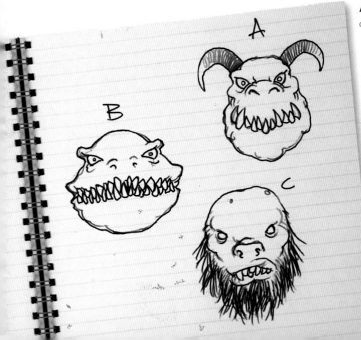

A: A large jaw and small cranium give this head a brutish appearance, with an aggressive edge provided by the sharp fangs, and pointed horns.

B: Base the design around a single feature of the face for an extreme design. Here, a wide, toothy mouth dominates the head.

C: Small eyes, placed widely apart, denote stupidity. Large teeth protrude untidily from thick lips, furthering the impression of a simple, animalistic character. A short, spiky beard adds a wild, bestial flavor.

WORKING UP DETAILS

- **Weapons:** Imps are not sophisticated fighters, and their weapons should reflect this. Bludgeons or crude bladed weapons are best. Weapons will almost certainly show signs of damage from previous frenzied attacks.

- **Markings:** Consider the Imp's evil master. How might his behavior affect the appearance of this creature? Perhaps the Imp's flesh is tattooed with magical runes to enhance its strength or control its behavior? Or maybe the Imp is branded as his master's property?

BODY CONCEPTS

Imps are small—no more than three feet high—though their limbs are strong. Their hyperactivity gives them a perpetual hunger. This can help solve the design of the creature's body. In visual terms, size equates to importance, so the oversized mouth establishes a great interest in food. Head placement is a major factor; the more prominent the head—and therefore the mouth—is in the silhouette, the more it stands out. A large stomach or layers of fat imply regular feeding habits. A round belly balances the head shape, but fat limbs make the Imp look heavy and slow.

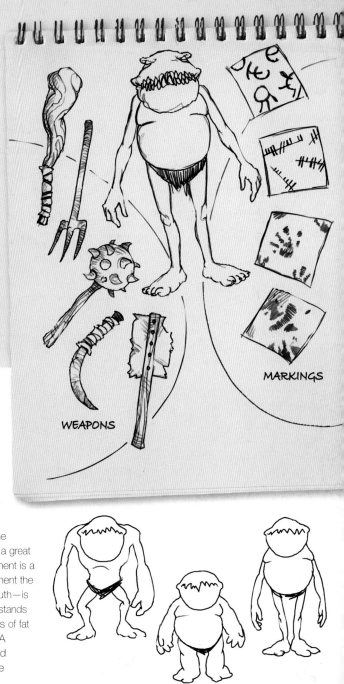

MARKINGS

WEAPONS

CONSTRUCTION AND DRAWING GUIDE

IMP

The Imp's design emphasizes the head with its oversized mouth. Choose your Imp's pose and expression to accentuate this further.

CONSTRUCTION

Construction of the Imp's head is relatively easy. An ellipse quickly defines the limits of the head. Split this horizontally into two equal halves, then divide the upper section into half again. The upper line (**A**) locates the eyes, with the mouth aligning along the horizontal center line, (**B**).

FRONT VIEW SIDE VIEW

A

B

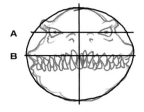 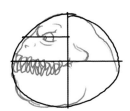

THREE-QUARTER VIEW

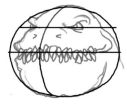

pose

The Imp is a creature whose actions are not constrained by concerns for personal safety or conscience. Its pose should project as much energy as possible. Choose a static stance to give contrast and extra intensity to a dynamic aspect of the body—a good example would be a wide, shouting mouth opened to the very extreme, with a stiff body. Show energy through speed. Have your Imp running, with arms and legs flung out wide. Direct the Imp's energy toward the viewer; draw your Imp leaping right out of the page, with gaping mouth, and eyes looking out.

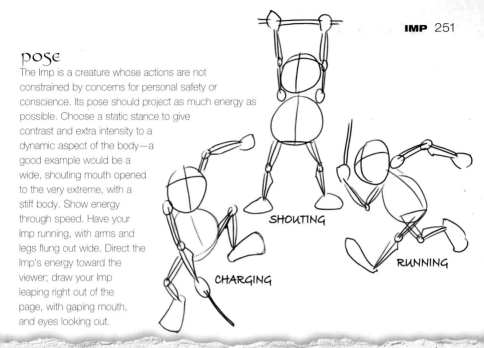

SHOUTING

CHARGING

RUNNING

ARTIST'S TIP: RENDERING FANGS

The rendering technique in this example can be adapted for bone, horn, claws, hooves, and similar organic materials.

Direction of light source

1 Block in the base color using a suitable mid- to dark-tone.

2 Define the form of the surface by painting in the illuminated areas using a lighter tone. Use strokes of varying opacity to allow texture to build up where the base color shows through.

3 Select a second color of a similar tone, but different hue. Apply this in the same way as shown in step 2. Using a variation in color rather than tone, at this stage allows a subtle texture to build up.

4 Using a tone slightly darker than the base, add details to the surface. Where details meet the profile of the surface, show indentations.

5 Complete a basic bone material by adding highlights. Pick out textures and details established in the previous steps.

6 Further detail can be added if appropriate. Highlights can be tightened and brightened to show areas that are polished, sharp, or worn smooth. Dirt, stains, or the remains of flesh can be added.

1NDEX

1NDEX

CREDITS

Quarto would like to thank and acknowledge the contributing artists for kindly submitting work for inclusion in this book.

Page 18–19: Shutterstock
Page 26 top: Shutterstock

Scott Purdy www.scottpurdy.net
Howard Lyon www.howardlyon.com
Anne Stokes www.annestokes.com
Johnny Duddle www.duddlebug.co.uk
Kelly Hamilton www.junglestudio.com
Grey Thornberry www.greystudio.com
Eric Lofgren www.ericlofgren.net
Kieran Yanner www.kieranyanner.com
Myrea Pettit www.fairiesworld.com

All other images are the copyright of Quarto Publishing plc. While every effort has been made to credit contributors, Quarto would like to apologize should there be any omissions or errors— and would be pleased to make the appropriate correction for future editions of the book.

FOR DEL, CALEB, AND AMY.